The Africa Diaries

*An Illustrated Memoir
of Life in the Bush*

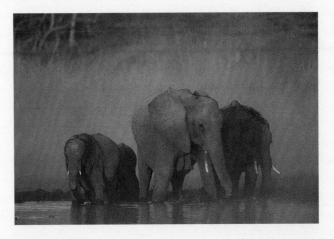

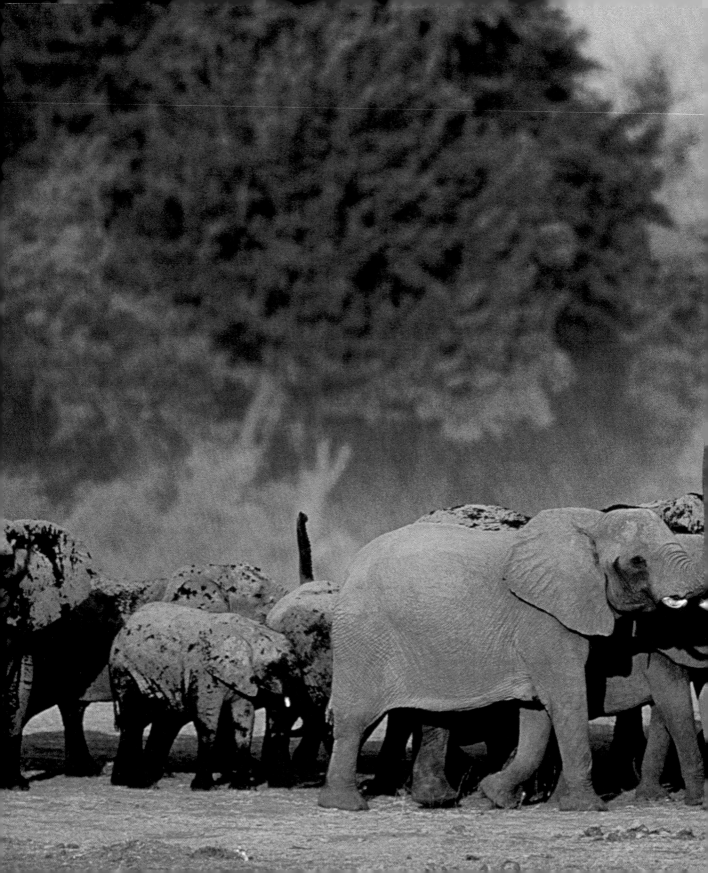

The Africa Diaries

An Illustrated Memoir
of Life in the Bush

WRITTEN BY
Dereck Joubert

PHOTOGRAPHS BY
Beverly Joubert

ADVENTURE PRESS
NATIONAL GEOGRAPHIC
WASHINGTON D.C.

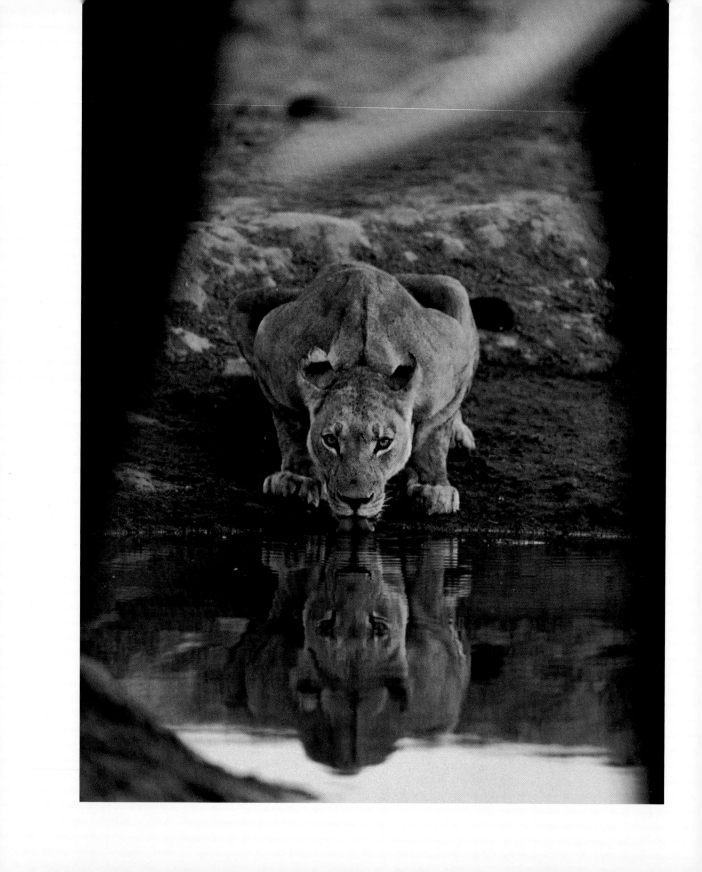

Contents

*A lioness from the Setari pride
drinks at the Savuté waterhole, with
an elephant towering above her.*

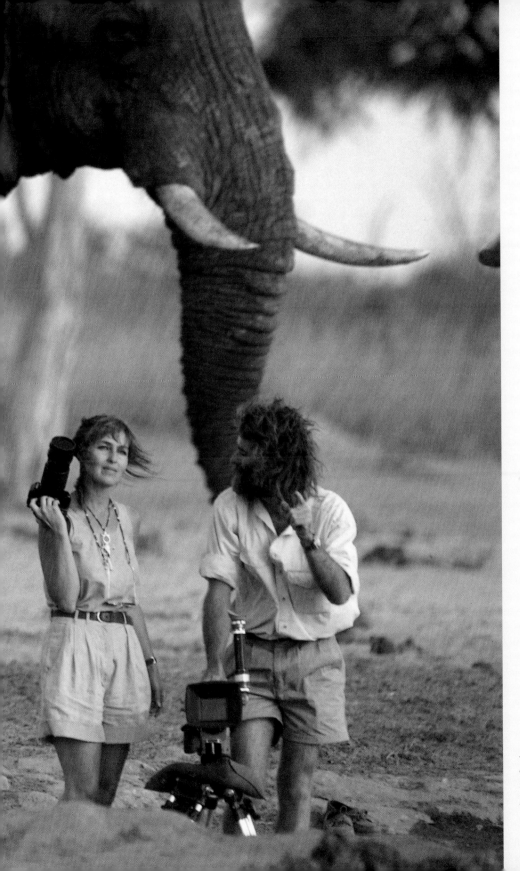

Elephants have become almost as much a part of our lives as breathing. It's comforting to know they're there, so close by.

NAMIBIA'S
CHPRIVI STRIP

ZAMBEZI
RIVER

CHOBE

Our Linyanti camp
(1988 – 1992)

Savute Channal

Chobe
Rese
(1981

Savute area
of Chobe

Zibadianya Camp
(1992 – 1999)

Our Savute "fly" camp
(1990 – 1997)

Chobe National Park

Rough scale
0 20 40 60 80 km.
TN

CHOBE NATIONAL PARK AND OUR CAMPS BETWE

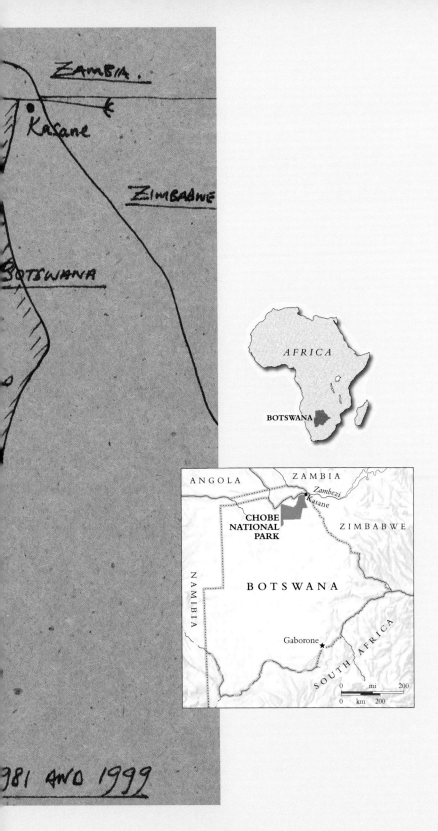

ZAMBIA.

Kasane

ZIMBABWE

BOTSWANA

1981 AND 1999

AFRICA

BOTSWANA

ANGOLA ZAMBIA
 Zambezi
 Kasane
CHOBE
NATIONAL
PARK ZIMBABWE

NAMIBIA

BOTSWANA

Gaborone
 SOUTH AFRICA

0 mi 200

0 km 200

*Next pages: The tall ones of
Africa, giraffes always look good
for some reason, as if they had
a built-in elegance of style.*

9

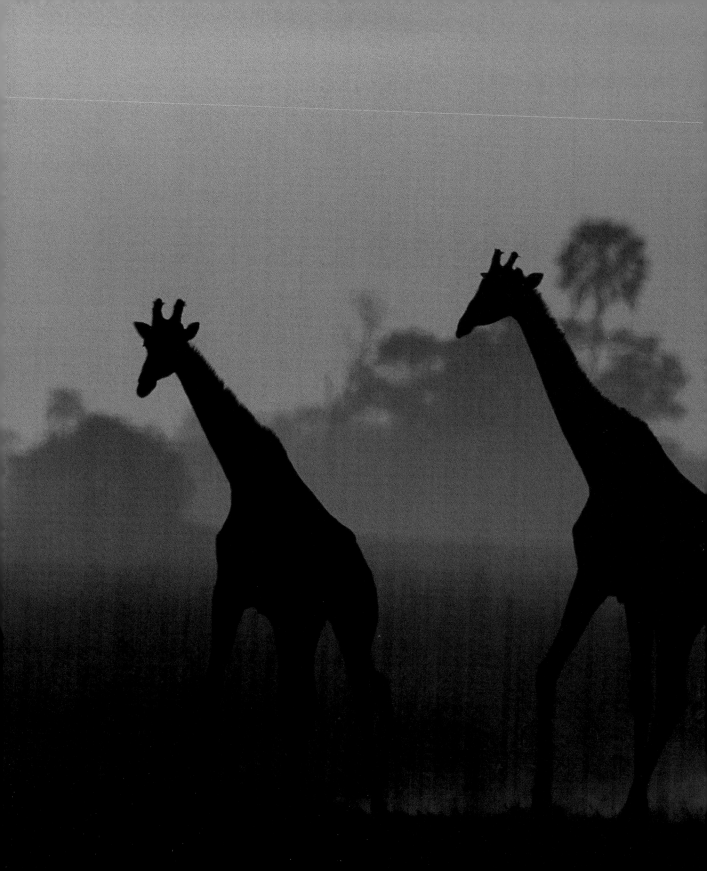

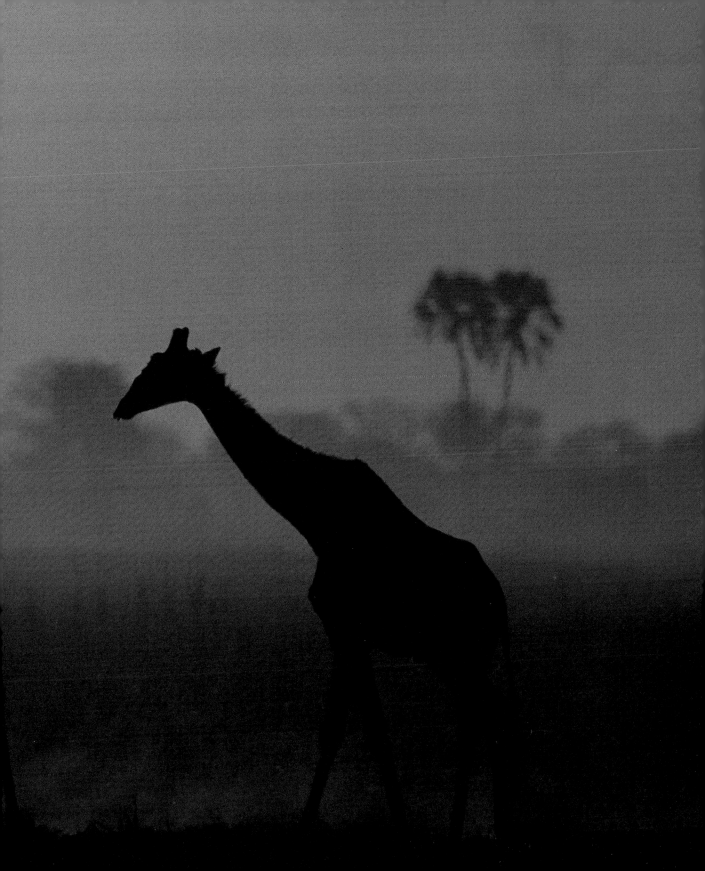

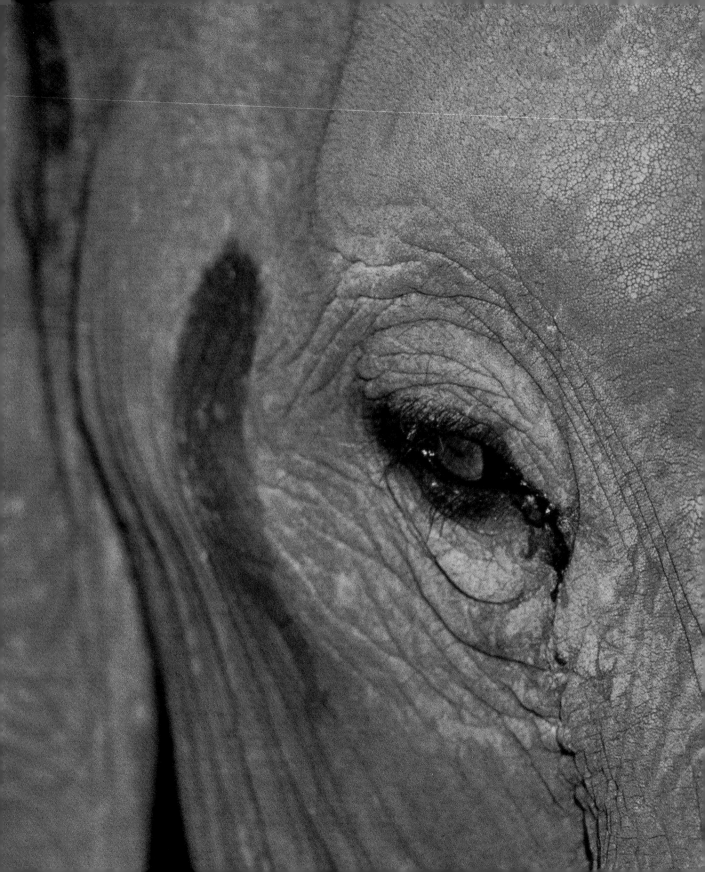

Prologue

It was going to be one of those days.... I was up to my knees in a thick mixture of mud, elephant urine, and maggots. I couldn't move myself; but in fact I was pretty sure that I *was* moving…deeper. Unfortunately, as I collapsed through a dry, razor-thin crust, I got a dozen or so small cuts on my legs—and they were starting to burn like hell from either the urine or the decaying maggots on the nearby rotting rhino carcass. To make matters worse, Beverly was nowhere to be seen. I tried to pull myself out, but the mixture sucked in my hands. I was on the brink of a serious sense-of-humor failure.

"I could really use a little help here…."

Nothing

"Sooner than later would be good."

Nothing.

Oh, well….

Then I heard it, the familiar sound of the motor drive and the cascading mirth. By craning my neck around, I could see Beverly collapsed in a fit of giggles, struggling to keep a steady lens. I had been trying to creep out onto the bone dry (or so I thought) pan to take a closer look at the dead rhino stuck up to its neck in mud, horn missing, obviously chopped off…. What could possibly drive me to investigate such things? Some deep-seated macho-(ex)game-ranger gene, perhaps? Had I been alone, I would have likely ended up in the same maggoty condition as the rhino. Oddly enough, as I struggled there in the muck, pathetically immobile, I had fleeting thoughts of just how often Beverly and I have come close to a "sticky end" (appropriate in this case). Beverly, meanwhile, snapped a few more photographs of me for her collection, *then* using a piece of wood and a shovel to distribute her weight, she crawled out to help me—while I endured her sniggers…this time.

This incident started us thinking about the need to keep more elaborate journals, if only to illustrate to some later reader just how foolhardy an occupation this is; how we get ourselves into some truly weird situations…and why. Some may

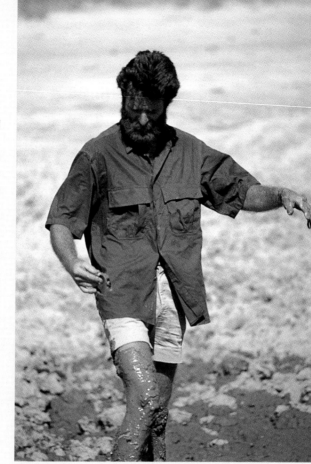

Previous page: At first it's hard to detect an elephant's emotions, but after working with them awhile, you begin to know how they're feeling. Their eyes show everything from sadness to joy, from mischief to fear.

Right: The crust on the surface of a mud hole is too fragile to support the weight of a fair-size animal, like a filmmaker.

Far right: Chobe elephants at the end of the day have it all— water, protection from hunters, and the prospect of a cool night.

see in our lives a great adventure, but when we began we were basically romantics wanting to elope to places unknown, to embrace life for what it is, to see and experience some wildness. We were convinced that out there somewhere, we could get closer to truth. But we have never quite gotten at the naked truth, the complete understanding that we search for—still, we enjoy the seduction as Nature turns and looks at us over her shoulder and, each time we think we understand her, she convinces us we most certainly do not. But we continue to follow her, and to tell her story.

There is, I realize, a certain arrogance that comes with the assumption that someone else may want to read our daily entries; and ever cautious of that, I apologize in advance. This book is meant more in a spirit of fun than solemn self-importance, because what we have been doing for the last two decades of the 20th century has not been particularly important—unless you consider it important to care passionately about the look in an elephant's eye, the cries of a newborn cheetah cub, or the thunderous rumble of a lion roar bouncing off the moon.

So…our diaries—to you.

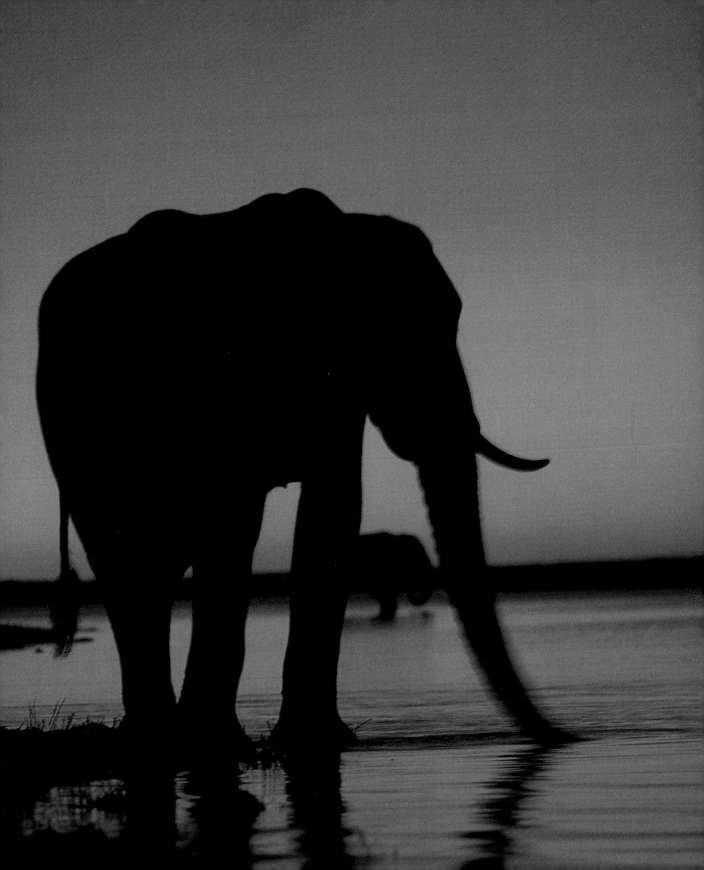

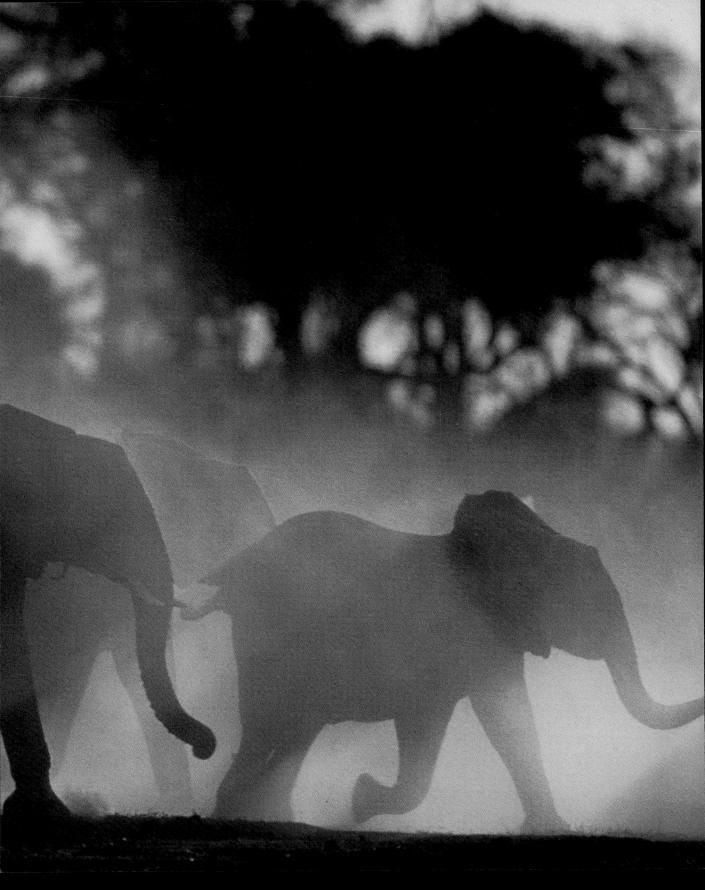

Whispers in the Bush

Beverly is a twin, or half a twin to be accurate. She has a brother who chased her wildly with slimy frogs and beat her half silly with a saucepan. She in turn helped him blow himself up with a chemistry set and talked him into an embarrassing attempt at ballet. It was a childhood surrounded by family, literally dozens of birds, and stray dogs and cats that her mother couldn't bear to see wander the streets. At the same time, it was a little life in a mining town that closed in on her and made her long for escape, not from the love of family, just escape to…well, the unknown.

I began as a reluctant traveler. I went to nine schools, as my father, in a rapid career-promotion phase, moved us from town to town, state to state, house to house. Sometimes this life on the move was pretty good. I sort of outran my enemies; and I learned that any place was as good as any other, so I should have fun now and not dwell on the past. My brother, it turned out, wasn't an accidental traveler. He is eight years older and was a tough act to follow. Usually in trouble one way or the other, he would go off on safaris of unknown duration, leaving me to be the good son when all I wanted was to be in trouble, too. I tried hard to hold the fort while he was gone by infuriating my more than tolerant parents, but I could seldom do it as well as he could. Each time my brother returned in a cloud of dust, often silent but at other times bubbling over, he would tell stories of such strange places as Angolo and Mozambique and of how he lost a Land Rover in the surf north of Vilanculos, or was put in jail in a faraway northern Africa state for some minor permit issue. And each time he settled down at home again, between trips, he'd begin to paint. I spent hours silently watching images flow miraculously from his mind onto canvas—and my own imagination blossomed, dreams flowed.

It was in high school that I met Beverly, but it wasn't until after I had left school and reluctantly entered the armed forces of the South African regime—a time of peak apartheid and the service was a compulsory addition to my young life I could have gone without—that I was fortified enough to ask Beverly out on a date. I was fairly damaged and bitter from being enlisted to fight a war I desperately didn't believe in, so it's a wonder that she ever accepted a second call from me, but

Following the scent of water, elephants race along ancient animal paths that crisscross miles of Botswana.

Since 1976, I've been shooting close-ups of southern Africa's elephants, some of the biggest tuskers in the world.

perhaps it was a dry time for her. On her 21st birthday I asked her if she would come with me on a great adventure…well, not too great—but each journey starts with the first step, right? And I knew just where we were going…to the bush.

It was early 1978 and my bride-to-be (we married eight years later) and I began a journey that we have been on ever since. We headed for a camp north of Johannesburg, the Timbavati Game Reserve, to run a tourist lodge:

APRIL 1978 • *Sohebele Game Lodge, South Africa*

Warthog decided today that a dip in the guest swimming pool might be a good idea. Problem is…warthogs have a tendency, despite the perception of being fat and floatable, to sink like stones. Fortunately the ever-observant Beverly, flashed across the lawn like a superhero and dived in to rescue the sinking pig.

Once on dry land, Beverly looked down at the victim, who had at this stage stopped breathing, The thought of mouth-to-mouth resuscitation passed immediately as she looked down at a face that can only be described as uuuuugly. But what is a superhero to do? She closed in to do mouth-to-mouth. As she leaned on the little pig's chest, trying to figure out a way to plug its nostrils with her fingers, the warthog coughed—and water suddenly gushed from it's mouth. Confronted at such close quarters by what to a warthog must have been as uuuuugly a face as he had ever seen, he head-butted Beverly and raced off without even a thank-you.

Not that he wasn't grateful, of course. Warthog became "our warthog," and came by every day, eventually adopting us as his own. Then one day, as he sat at my feet looking like a grotesque bulldog and I tickled his coarse, hairy back, our warthog's family left for their burrow. "Hey, buddy. Better get going," I urged, but this fell on very content, deaf ears. It was around sundown when he looked up at the setting sun and waddled off into the bush.

Beverly in 1981 goes barefoot in the park— Chobe National Park, that is.

JUNE 1978

Last night our warthog ran off after his family and disappeared into the gully. We heard a terrible growl and the all too familiar sounds of our local lion pride. This morning warthog is a wet spot on the grass and two tiny tusks....

Taming wild animals never really works out. Wild animals should remain wild. I often refer to "our lions" or "our warhog," but I use this possessive only because phrases like "the lions we have come to know" or "the warthog that has become accustomed to us" are so clumsy. Every time I am possessive about "our" animals, I remind myself, often aloud, that "these are South Africa's warthogs. Botswana's lions. Botswana's elephants…" But in truth I know now that they aren't that either. The place does not possess the animals. Botswana and the lions, Botswana and the elephants are one and the same. Today this is still true in Botswana, where there is a diversity and abundance of wildlife that, elsewhere in Africa, is fast disappearing. Great herds of elephants, still traverse their ancestral ranges from the deep interior to the permanent rivers, over hundreds of miles, year after year.

AUGUST 17, 1986 • *Savuté, Chobe National Park*

It had been a sweltering hot afternoon, only slightly better at midnight. Botswana was in suspended animation. Nothing moved, everything that needed air desperately sucked on it with each breath. Cicada beetles suddenly started up, buzzing a deafening din in the forest.

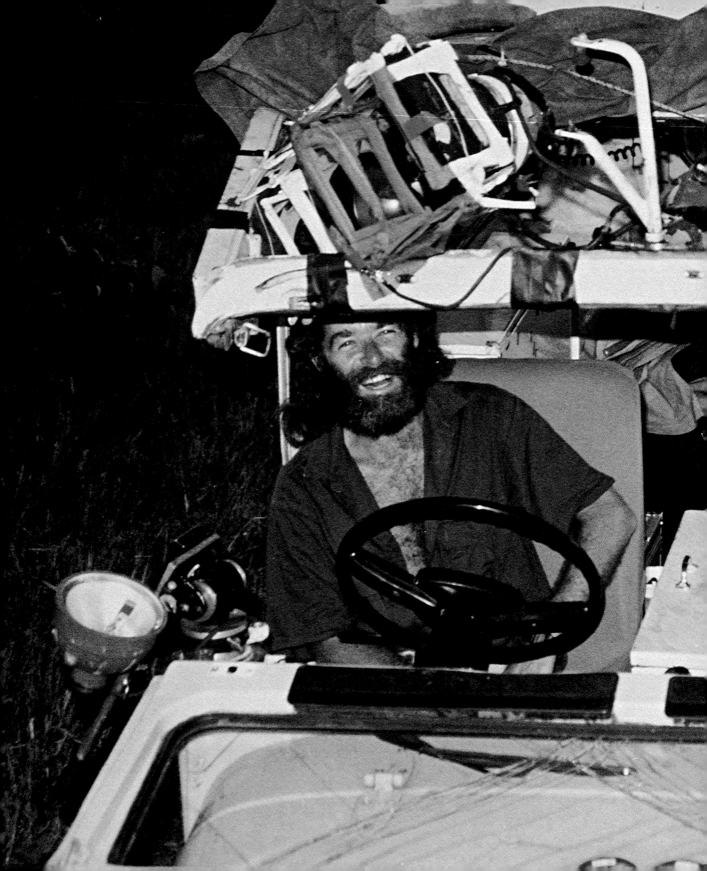

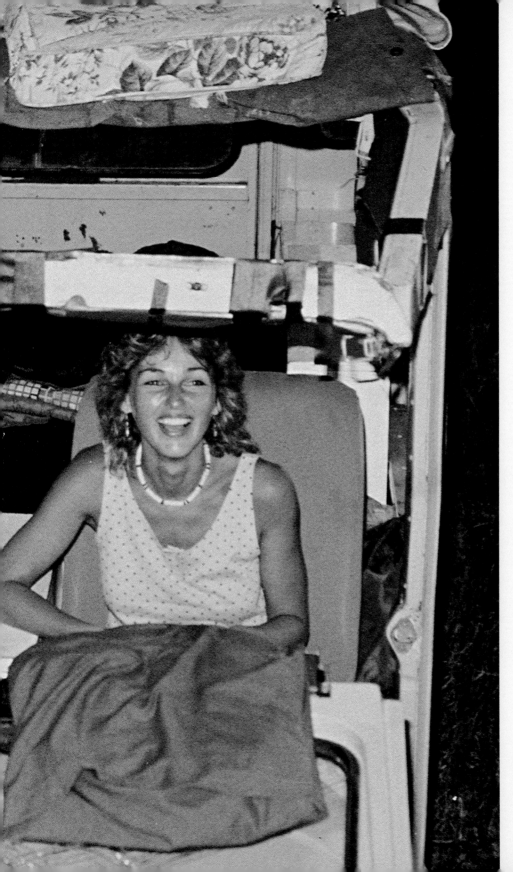

One of our first elephant attacks
bent us out of shape and made
chaos of our usually orderly
vehicle, but we were giddily
grateful just to have survived.

We were both as flattened by the heat as was everything else. At this time of the year, the glare burns, and the sand is so hot that it sizzles through the soles of your shoes. Suddenly Beverly slapped down on her leg hard. Mosquito. At least some earthly creature had the energy to move. We had been with the lions most of the day, but it was just after they had finally scavenged a kill after nightfall and noisily fought over it in the dark that we decided to drive off and tuck ourselves away for some well-earned rest.

Usually this involves a very quick unrolling of a sleeping bag in the back of our vehicle—a well-equipped, specially modified Toyota Land Cruiser. As we lay down and were trying to doze off, we both heard something stir.

"Is that you?" Beverly asked.

"No."

"Oh."

Then we heard a loud shuffling noise. I hoped Beverly wouldn't hear the alarming sounds, but, alas, this was too much to hope for and I looked out into the darkness.

As my eyes adjusted, I saw her: a big female, her gargantuan ears spread out in a typical threat display, and she was kicking sand at us. We've had elephants charge at us, and most often it's been our fault—or simply a case of being at the wrong place at the right time, but we couldn't figure this one out. Here we were minding our own business.

Then I saw it: no bigger than a large warthog, two feet tall. The calf wobbled onto its feet and stepped up to our vehicle, positioning itself almost under my nose as it pressed up against the side of our truck. Then right on cue, the calf stepped aside, and the adult elephant ran straight at us. I only had time to say "Uhhh, hold tight" before she hit us. It was a solid blow, but nothing compared to what she was about to lay on us.

Then the calf rubbed the side of the Toyota and seemed to locate a position. It raised its mouth and licked...for milk? We were in real trouble now. The calf, it seems, had just been born, and before fully imprinting his mother's image, smell, and sound onto its blank mind and senses, it had stumbled around the bush to a very peaceful (yet clearly inadequate) surrogate mom...us.

We had bonded with a newborn calf and riled a very large mother. I believe the only reason the mother had not yet waged an all-out attack on us was because she would have flattened the baby, too.

Inside the vehicle, equipment was flying everywhere, and Beverly and I were being bashed together with each of her attacks. I jumped to the front of the vehicle to find one of the only two weapons we ever carry, an ax and a spotlight. (We never carry firearms.) I decided on the light.

As I got to the spotlight cable in the dark, the elephant hit us again. It was pitch-black and we were only able to brace ourselves at the last moment. I felt my neck bones click from the impact; the light flew out of my hands. She had changed direction and was now crunching in the front of the vehicle, bashing us repeatedly. In the chaos of equipment, I found the light again and switched

it on. The night was suddenly ours again, but just as I caught her in the light beam, she hit us again, her huge head extending right over me. With the beam in her face now, she turned away, and, facing away from us, she came to a stop. Immediately, I switched off the light. I didn't want to chase her away. But with the light off, she found her anger again and hit us one more time. She pushed into the vehicle, smashed the windshield, and buried her tusks into the bodywork. The vehicle rocked up on two wheels and was on the verge of toppling over. I used the light again, and this time she ran for the trees. It was over.

Nearly. The mother was gone, but we had the baby.

Once again we had to think quickly and face a dilemma we've experienced many times before: whether to intervene or not. Do we take over the baby or abandon it in an area rife with lions? Young elephants are seldom raised by humans successfully. We decided to leave him (we had figured out by now that it was a male) to an uncertain future rather than a certain death. I started the vehicle, and it worked, to our surprise. We drove off. The calf, however, had decided otherwise.

His two mothers had battled it out—and the elephant mom had not won. The calf was with us now. I tried to drive away, but the little guy was determined not to be abandoned. I stopped and

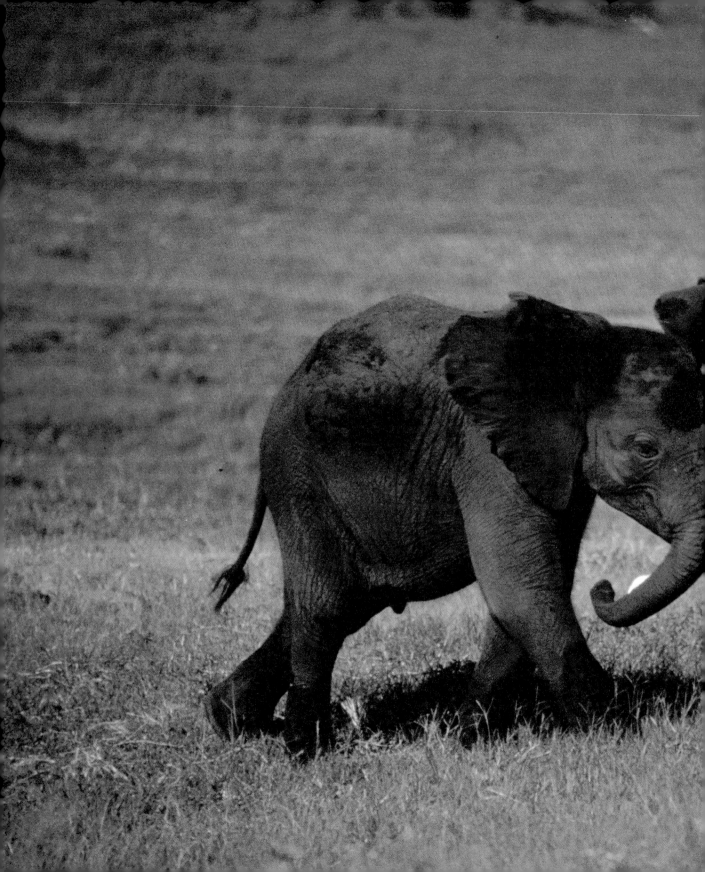

Practicing its charge, a young elephant will take on anything.

he caught up. What on earth were we going to do with a 200-pound newborn? I searched the horizon with the light. Hiding in the tree line, we saw her—our only hope.

I started the vehicle and drove at high speed directly toward the mother. The baby reacted obediently and ran at full speed behind us. Because of the bashing we received, the tailgate of the Cruiser unlatched and fell open. Looking out the back, Beverly saw an image that she will remember forever: the little elephant trotting along at high speed with his huge, almost transparent ears, still pink at the edges, flapping around like loose, wet rags.

I had other things to concentrate on.

I steered in the dark, with no headlights, to where I thought the female was. All I could make out was the tree line. I visualized the mother waiting there, and as I imagined her backing away from the charging vehicle, I swung the wheel hard right and floored it again, then cut the engine and waited in the dark.

In a cloud of dust, a very confused baby elephant brought up the rear and stopped. He looked around. We all waited for a very long minute, then heard the crunching of feet again. In the dim glow of the starlight, we could just make out the dark shape of the mother as she glided out of the trees and up to her baby. She seemed calm again, perhaps realizing that we were not trying to steal or harm her calf.

I don't know if we ever saw the mother and calf again, but somewhere in our minds the story of a little elephant was born. Almost a decade later, we began filming that story, *Whispers: An Elephant's Tale*. It is the story of what life must be like from a baby elephant's point of view.

In a moment of self analysis, Beverly and I have asked ourselves, "So what? What does it lead to, where does it go—this journey day to day, year to year, from region to region, film to film?"

As we stumble around the cluttered room of our experiences together, we keep tripping over a common and growing appreciation of the individuality of animals and their rights to their own ways, to exist on their own terms, to have their own point of view. Whether we are filming a warthog mother defending her offspring against marauding jackals or we are standing up at a meeting protesting the senseless culling of elephants, we have been advocating the same message for years. And as filmmakers, a central theme has emerged, partly by design and partly because of our growing conviction. The animals we see—a zebra in a massive migration, a faithful dog at our side, a protective elephant mother defending her calf—are all individuals with differences, personalities, characters; all are filled with conflicts,

feelings, associations, their version of love and hate and deep longings. They experience moods and feelings of loss, have a sense of past and hopes for the future. We all know this in our hearts, and yet we still find pleasure in their domination. People feel elevated and powerful kicking a dog; self-esteem is boosted by hanging the stripped skin of a once magnificient male lion on our walls. We would better understand these lives if we look beyond the confusing stripes on their skin or if we listen deeply to the cacophony of wildebeest bleats, if we look far into the eyes of individual animals—behind which lies the path to understanding their personality and the insights into what makes them like you and me.

Such simple truths have created much conflict in our human societies; it is what Beverly and I have spent the greater part of our lives trying to reveal through the stories we tell: Motsumi, a lioness, tries to defend her cubs against a snake but fails; an abandoned elephant calf is taken in by a strange herd; a zebra mother angles her body so that her newborn calf sees only her unique stripe pattern; a male lion focuses on a hyena with intent to kill. These stories are not unlike our own; and both our stories and theirs are a celebration of uniqueness, the individuality of all life.

We believe that stories of animals' lives are metaphors for our own. Animals in parables and children's stories fill the world's literature. Life struggles and deaths within the animal world quietly prepare us for own physical and emotional struggles. But when our children see us use animals, claiming dominion and ownership over them, watch us kick a dog, we teach them that it is okay to mistreat things that aren't exactly like us. It is no wonder that racism runs deep; no surprise that generation after generation of men secretly claim ownership of their women. The crooning "You belong to me" of love songs is an unpalatable insult "And God gave man dominion over the animals…." Given the present state of affairs and what it has done to us, I'm willing to bet that manifesto is due for a rewrite.

Tracking lions is one of my favorite things to do, and Savuté is one of those places where lion tracks filigree the ground.

28

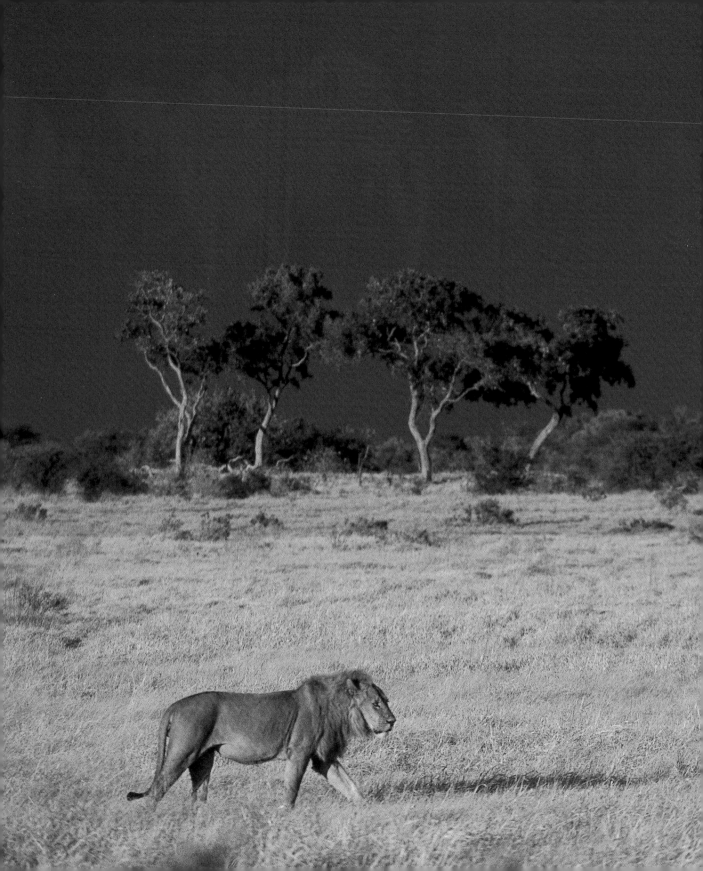

Savuté Dreams

Once Beverly and I settled into life at Sohebele lodge in the Timbavati Game Reserve, I realized that I was ill suited to handle the daily pampering of wealthy guests—but I did get to spend eight hours a day with animals in the bush, particularly lions and leopards. For most of 1978, I watched them silently every day (much to the dissatisfaction of the guests), trying to unravel not only their behavior but what and who they are. Beverly immediately proved herself to be an organizer of note and leaped into running the lodge catering. Every day she managed three seven-course meals, developing recipes for the guests and a passion for cooking, which has clearly brought a great deal of enjoyment into our life together. At the time our combined salary was a princely 450 rand per month ($40 each), which even then was barely breadline.

But we *were* in the bush. And after that first year, we were "head hunted" by Mala Mala, the world-famous five-star lodge and game reserve in the Sabi Sand next to South Africa's Kruger National Park. So from late 1978 to 1981, we worked at Mala Mala and surrounding camps. One experience from that time, lasting only a few moments, is still an intense memory:

JUNE 16, 1979

A local Shangaan [a tribesman from this region of South Africa] wandered into camp today with an ominous looking box. His dogs had gotten away from him and chased a cheetah, finally injuring it so badly that it died. He was sorry. But then a few days later he apparently came across this lot. He opened the box... three of the smallest cheetah cubs we have seen.

What struck me most was not that they were sweet and cuddly, which they were, but that from the moment we pulled each cub out of the box, we were completely trusted. Unfortunately, a few years before this, there was a strange shift in conservation circles, away from what was considered the touchy-feely ways of George Adamson, whose work in Kenya with the release of captive lions was considered unscientific at times. George's notion that these lions were individuals also went against the grain. Now hard-line "hands off" policies prevailed and our cheetahs

There is nothing quite as symbolic of Africa as a lone male lion patrolling his pride's territory.

had to be turned in immediately, no doubt finding their way into some zoo. I believe Beverly and I were deeply affected by this outcome and the memory is lastingly embedded in our thought and, I know now, our actions as well.

The days at Mala Mala were formative. We were learning about life and death in nature at an incredible speed. At some point I embarked on independent scouting or walking excursions. It was perfect for me. I spent three months getting to know the area, walking with a native tracker, a Shangaan about my age named Elfaas Mbongela. From him I learned how to track animals with patience. Often on days when I was convinced that Elfaas was actually tiring of the work with me, I would lose the

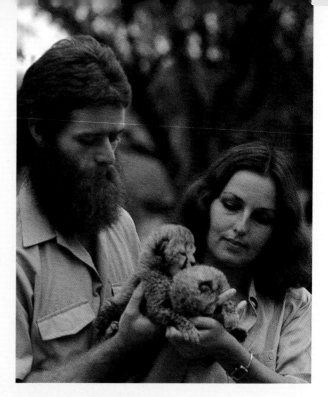

Holding cheetah cubs, only for a few minutes, was a turning point in our lives. Nothing seemed the same after that.

track. But then I'd find myself going back to where Elfaas was; I'd find him silently pointing from one pug mark to the next. We had great adventures together…heart-stopping adventures!

One day while on a walk, we saw a huge snake roll over a rock in the thick brush. Wanting to identify it, I broke into a run, intending to leap onto the rock. Just as I launched myself, the rock stood up…. At that moment, the "rock" was a very angry hippopotamus. The "snake" was a slow-moving roll of neck fat. Elfaas and I were propelled through the forest by our nervousness, laughing our heads off as the lumbering hippo tore up the shrubs in the chase.

Elfaas and I continued our adventures in the bush and eventually decided to build a camp out of mud and reeds, buildings with thatched roofs. My grand scheme was to provide a truly rustic experience. No beds, mud floors, no windows, just holes left in the walls, like the rondavels villagers of Elfaas's youth had built. For me it was three months of being born in the bush. Even today when I swing my head around and peer into the darkness, it is because of something that started back then, some instinct nurtured, an awareness as much taught as inherited. We ate around a fire and drew water from the river, just as it should be. And most nights I slept around the fire, not even in a hut, with a rifle; Elfaas slept with his spear.

MAY 7, 1980

Around the dinner fire, Elfaas looked up into the dark. I had heard it too. A quiet grunt in the dark. We looked at each other. I knew who was coming—and he did. A few minutes later,

the camp was full with the whole pride: cubs playing hide-and-seek on the kitchen table; all pretty
harmless really. A few dented kettles and chewed-up wooden spoons. But suddenly, he was
there, too. Right in camp.

"He" is a huge lion that I called Black Mane, but others called Meanie. Every time
I saw this lion over a period of 18 months, I knew him, and he'd charge on sight
with clear intent. He "hated" humans, although I was beginning to think it was
actually personal.

As we made it into the open Land Rover, he spotted us and changed direction...coming straight at
us in the most hauntingly leisurely manner. I slipped the bolt of the rifle. This time I would shoot if
I had too, even though the paperwork afterward would be as brutal as a mauling. We were backed
up against some trees and I couldn't maneuver much. Just as I realized that, it seems so did he.
He charged from a hundred feet and almost bounced against the side of the truck. I lost sight off
him and couldn't get a shot off. A second charge was even more vicious, the lion roaring this time
and showering us in dust. There were six charges in all. Only once did I have enough of a clear
view to shoot, but then he was so close that I had to lean back against the seat so as not to touch
him with the tip of the rifle. I was waiting for that moment when he might coil to leap. We looked
into each other's eyes. He didn't coil to leap...just walked away from that last charge.

I didn't know what he was thinking, but I knew that with a fraction of an inch pull
on the trigger, I could have killed him. Inside my head I heard *bang!* At that moment
I knew what it would be like to hunt a lion. It didn't do anything for me. In fact,
when I heard tales of "great white hunters," about their fantastic lion hunts, I
thought it a pathetic endeavor. There are few things easier than shooting a lion,
except perhaps shooting an elephant, because most of the time lions are fast asleep,
the easiest of shots. Charges like the ones this lion regularly laid on us are rare indeed.

Sometime later I felt compelled to teach Elfaas something in return for all he
had taught me, so with little else to offer him at the time, I decided to teach him
how to shoot a rifle—which in 1979 in South Africa was seriously forbidden.
"Teach a black man how to shoot? Are you crazy?" We would have to sneak away
to the far end of the reserve, steal or buy ammunition, and give it a try—and hope
that we didn't mistakenly shoot an animal and get sent to jail for poaching. As it
happens, he hated it and never wanted to carry a rifle. A gun gives you a false
sense of safety in the bush, he'd said. I've taken this approach to heart and adopted
it as my own, while he, ironically, came to regrets.

It was in 1980, when I was called up into the army again, into the equivalent
of an active reserve system. When I left, I called Elfaas aside and asked him to take
care of our camp. I didn't want to lose our footing in what was rapidly becoming

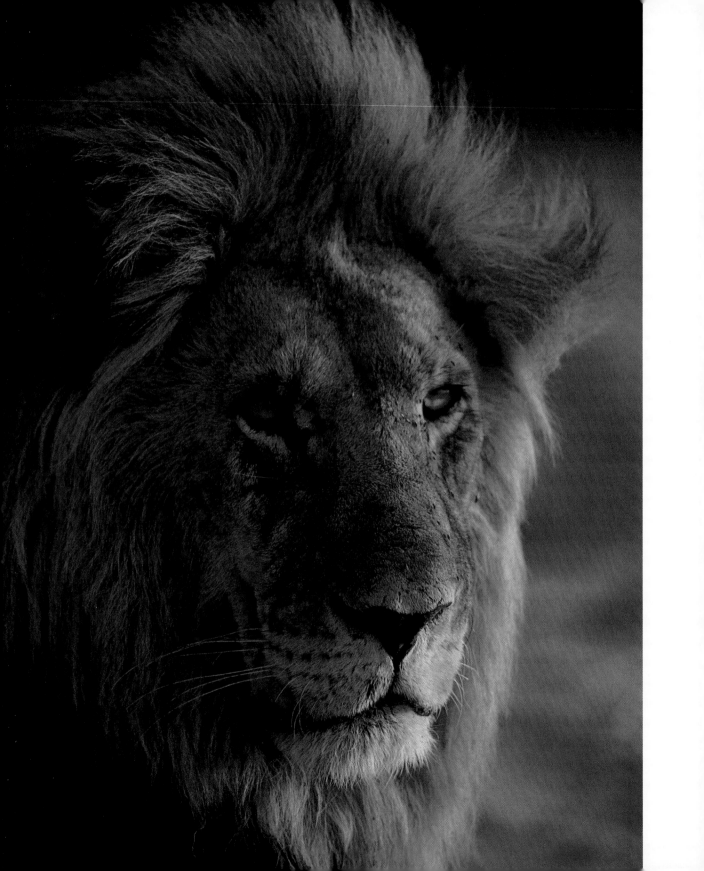

a very unique spot. Tourists loved it and a half-dozen other rangers probably wanted
to take it over. Being there was a true wilderness experience. I wrote the following
as a record of an event told to me by Elfaas.

AUGUST 1980 • *Mala Mala Trails Camp, South Africa*

*Elfaas and his wife Vinah took up residence, and on the first evening while collecting wood, Elfaas
felt a tug on the log they were carrying together. He looked back at Vinah to see why she had
dropped her end and saw a lioness on top of her. The lion had silently attacked her and was busy
mauling her leg. Elfaas swung around and picked up a Coke bottle, smashing it over the lioness's
head. The cat jumped back and growled. Elfaas grabbed Vinah and dragged her toward the hut
only ten feet away. But as he did, the lioness jumped and bit the woman again.*

*Elfaas spotted a lead pipe, swung that at the cat's huge head and connected solidly enough
to send her off again, giving him a chance to get his wife into the hut. Our flimsy reed half-doors
didn't stand up to much as the lioness launched yet another attack through the door. This time as
Elfaas swung the pipe , she moved out of the way, and he smashed the door open himself. Quickly
he dragged Vinah to the far side of the rondavel and plugged the door with his foam mattress.*

*It was quiet as the sun went down. Elfaas tended his wife's wounds as best he could and built a
small fire out of the few sticks he had inside. Before the water could boil to sterilize the bites, the
open window above his head burst into life. The lioness leaped half through, kicking with her back
legs to launch herself all the way into the hut. Elfaas reacted as best he could and punched the face
of the lion over and over, trying to avoid the slashing teeth. Finally she backed out of the space
and the night was silent again. But he knew she would be back.*

*He still had half a mattress so he stuffed that into the window hole she had already found.
That left him with one hole of about three-by-two feet to guard. He looked around and saw his
fire die to a glow. He had only two matches left and no wood inside the hut. As he made a move to
dash for some wood outside, Vinah made a noise and he reconsidered. Frantically he piled up all
his belongings, clothing, linen, anything that would burn, and slowly moved from tending Vinah's
wounds to tending the fire.*

*But Elfaas could hear heavy breathing nearby. The lioness, he realized, had precisely located
Vinah from the outside of the mud wall. Then the wall started to shudder. She started to dig
through in the same way that lion prides dig a warthog out of its burrow. Elfaas doesn't remember
saying a word, but by midnight he had lost his voice so he must have been yelling at the lioness the
whole time. The attack had lasted six and a half hours. The lioness was finally silent, and the shock
of the event was suddenly hitting Elfaas. He started to shiver and his eyes closed heavily, even
though he knew he needed to keep the fire going. Vinah was still bleeding heavily but by now she
was bandaged, though crudely. She was asleep with shock.*

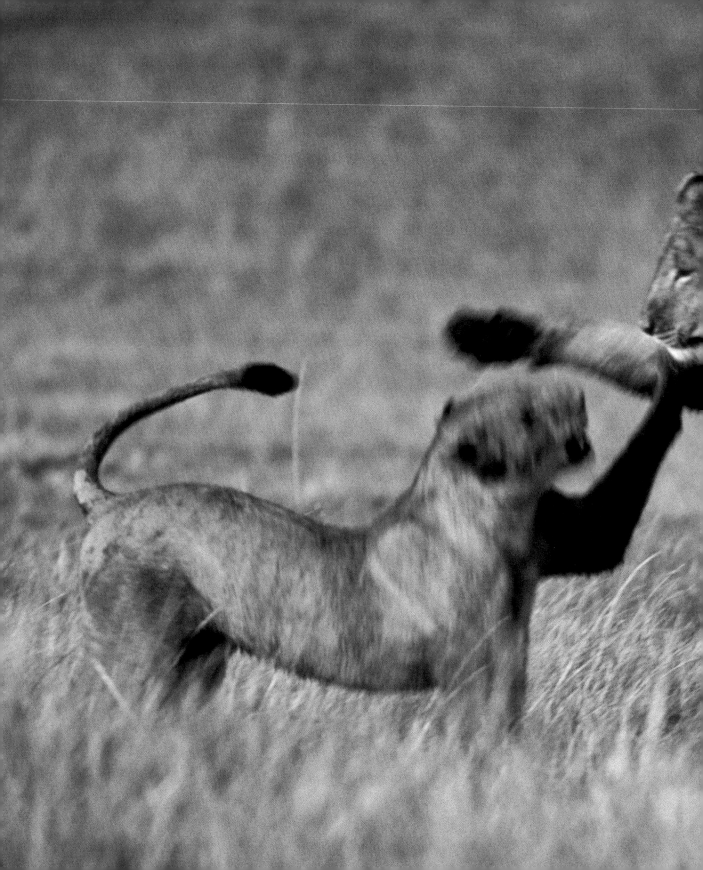

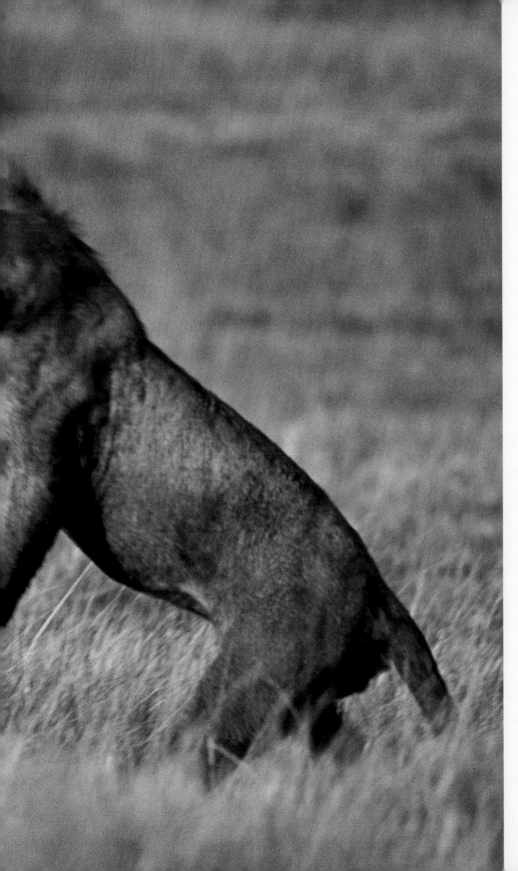

The complex social lives of lions revolve around the pride and the bonds within the pride. Old lions without prides are usually the ones that attack humans.

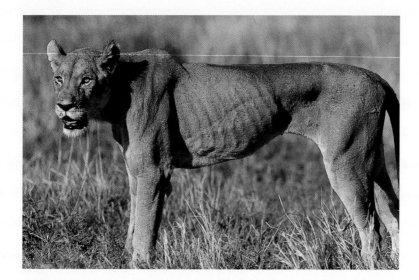

Suddenly the cat was almost on top of them. The last window was now filled with lioness as she clawed away, scrambling to get in. Only her back legs stopped her from landing among Elfaas and Vinah. Elfaas grabbed a bundle of burning clothing and stuffed it into the animal's face. His jacket caught on fire and he ripped it off, also throwing it at her face. This she grabbed with two dangling and flaying paws and scrambled back, perhaps thinking that she had at last caught something. It was silent again for half an hour.

In the meantime, Vinah had produced a cushion that she had just found under her, and Elfaas stuffed that into the window…. In the early hours, the cushion suddenly disappeared with a growl. Throughout the night hours the lioness's face would appear and Elfaas would yell and hurl yet another piece of burning clothing at her until he was down to a blanket and the clothes he had on his back. The blanket had to go, even though Vinah was now shaking violently. As he pulled the blanket away, his panga, [machette] fell out. He had forgotten about this valuable weapon. By now he knew that it wouldn't take long for the hole the lioness was making in the wall to open completely, so he started to chop away at the wall himself. He cut a series of steps into the wall and cut through the grass roof. Then with his belt tied to Vinah, he hoisted her through the roof and struggled to drag her body up to the very pinnacle, where he finally tied her.

Now in the half-light of dawn he could see the lioness watching them and could do nothing but wait for her to leap up as she tried to get to them again. The pitch of the grass roof was just too slippery and she slid off each time. As the sun rose, she limped off and admitted defeat, a battle well fought.

Fifteen miles away and hours after the attack, Beverly opened the door of our hut to find an all but naked Elfaas with Vinah strapped to his back. He was voiceless but composed.

Many months after I had returned from the reserves, we came across some old bones. Inside the bleached rib cage, the stomach contents were still obvious: a cushion and most of Elfaas's old jacket. The lioness's teeth were so broken and calcified

that she must have died hungry. For me it was the end of a puzzle. I had always believed that something had to be seriously wrong to cause a lion to attack like that. It seemed clear that she was starved and desperate.

Word of my interest in lions had gotten out and Rodney Fuhr, a private sponsor of Botswana's Chobe Lion Research Institute, flew down to our camp, looking for research staff. At the time we suggested he talk to our friend Chris McBride, who had become locally famous for his discovery and work with the white lions of Timbavati. Chris was attracting the attention of other scientists as well as hunters because of his unique research methods: He'd play sounds over huge speakers that would attract the lions. The usual scientific method of the day was to use dying animal sounds and hyena calls, but Chris wanted to develop a distinctive Pavlovian

Beverly made this picture of two male lions attacking an interloper at 2 a.m. on a freezing cold night. It just proves that you can never drop your guard if you're a wildlife photographer—or a young male lion in the wrong territory.

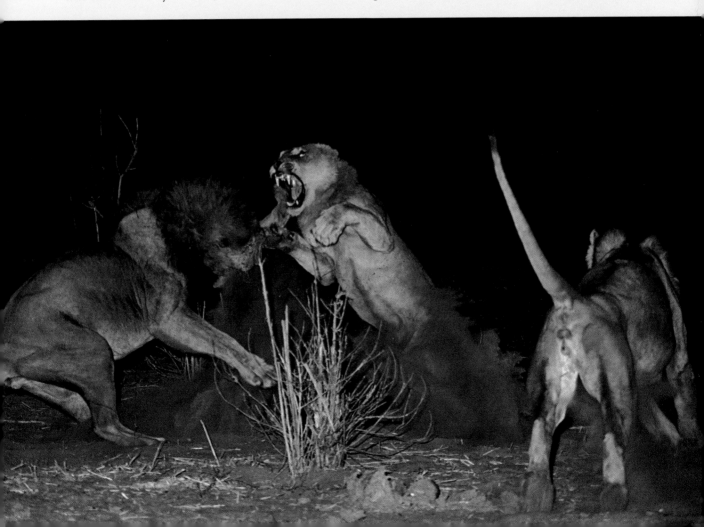

signature and started to habituate them to Beethoven and Mozart. The idea was to attract the lions away from the hunters' boundary fence. On the long dark nights we occasionally spent with him, I must say, Beethoven's Opus 23 became their favorite and mine.

Chris eventually moved to Botswana, but after a few years we were again approached by Rodney. We decided to go up and see Savuté and the research institute, a somewhat overblown name for a handful of smashed vehicles and bleached tents. We soon realized that if we moved there we'd be walking into a hornet's nest. Chris had burned himself out on many very long, cold nights over many cups of hot coffee with the lions. It seemed to be a sign of the life ahead. We also had immediate concerns about the research methods, how they influenced the lions and other animals, and how they offended the tourists in the area. Perhaps that is why

Even though the long, cold nights spent following lions were hard, they were the times we felt most at home.

40

we were being brought in, to fix all that. Whatever concerns I had were softened by the fact that two professors from my old university were coming on board as advisors. Then, soon afterwards, Petri Viljoen, a solid and meticulous researcher, signed up too. Of course, none of this would have been worth the effort had it not been for one thing—Botswana's Savuté Channel region. On our first trip to Botswana and the Okavango Delta, in 1981, we felt we had come home, although we'd never been there before. Even now, whenever we fly back to Botswana from far-flung places, I close my eyes as we cross the border and breathe in the feeling of returning to our true home.

Staying near the lions day and night, we finally got them to take our presence for granted.

We have been here 14 days and in that time have seen, and I mean actually witnessed, 12 lion kills. I have identified 56 lions so far and have seen at least that many that I haven't got ID's on. Herds of elephants glide through the marsh at night in numbers we can only imagine. Sable antelope in herds of over 50. Where we come from sable are rare, in two's and three's only. This is paradise. This is my place.

We signed on immediately. Savuté had worked her magic on us, and indeed had let us into her great dark secret: her night. The night came alive for us—it was a place, not a time of day. Night in Savuté showed us what the real Africa can tell us. We felt energized…like we were standing at the doorway of a great library filled with precious knowledge.

Leaving Mala Mala turned into a great and memorable event. In a touching ceremony, Beverly's staff of nearly 120 danced for us around a fire and wept as if they were losing a mother. They were. I drove out into the bush with Elfaas for the last time. We were heading off to Botswana and he couldn't come with us, nor would I ask him to leave his family. While he and I were driving to nowhere really, just driving, I noticed that with no attempt at concealment a tear rolled down his cheek, down to his lip. I never saw Elfaas again. It is our way.

Went out at 4 p.m. roughly and by 5 had tracks of Maome and Thaka's pride. Went way out into the sandveld, and although we tracked them for three hours, we never saw them. Maome's track is always clear as day, even at night, because of that missing toe of hers.

Gave it up at about 8 p.m. and headed south along the marsh. Beautiful night. Drove the whole night without a shirt on, perfect temperature. At 10:20 found tracks of a strange group of lions. Looked like a mixture of two- and three-year-old subadult males and females at first, but when we tracked them down it appears that they were all adult males. They ran from us so they are new. Hope to see more of them.

Midnight saw us back on the sand ridge, trying to pick up Maome. The Land Cruiser collapsed into a soft spot just a few paces away from the ridge. This thing is too damned heavy. But as we winched against a tree (and we uprooted two because the sand is so soft), who should arrive around the truck but Maome and Thaka and their six other lionesses. All ten of us, us and them struggling around in the thick sand and dark together. After initial inquisitiveness, they started to lope off down the dune while we cursed our luck and the guys who persuaded us to fit double 24-volt batteries into this monstrous truck.

Black rhinos have become dangerously rare.

42

Suddenly Beverly called from the top; and in the spotlight we saw distant glimpses of the lions circling and attempting to bring down a rhino. I worked like a wild thing to get us out in time to get to the action but finally collapsed in a heap, exhausted, as the rhino huffed his way off into the bush. We finally winched free at 4 a.m. and glided down off the dune. I'm never going up there again. What was I thinking?

Watched the dawn from Peter's Pan [so named because Peter O'Toole apparently wished to swim there, and did, even though it is no more than two feet deep] and headed back to camp, only to find Maome sitting innocently in the road near camp.

Today I cut the doors and roof off this truck with a cutting torch.

During the first years at the Chobe camp in Savuté, there were numerous hurdles to deal with, some more practical than others. For one thing, our daily lives had changed dramatically. We were now nocturnal animals and, if needed, we would go 36 to 40 hours without sleep.

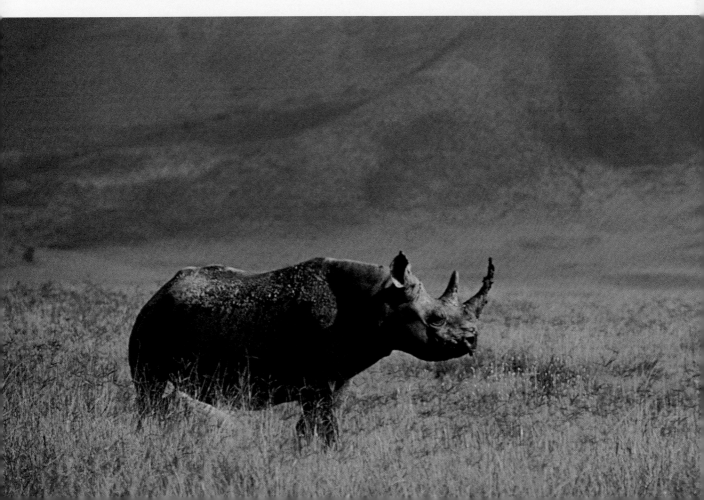

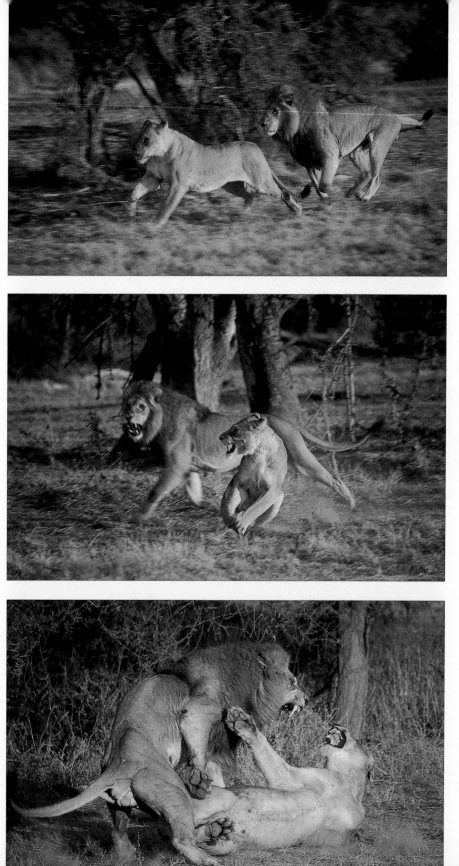

In the dance of courtship played out between a lion and lioness, attraction is actually expressed through aggression.

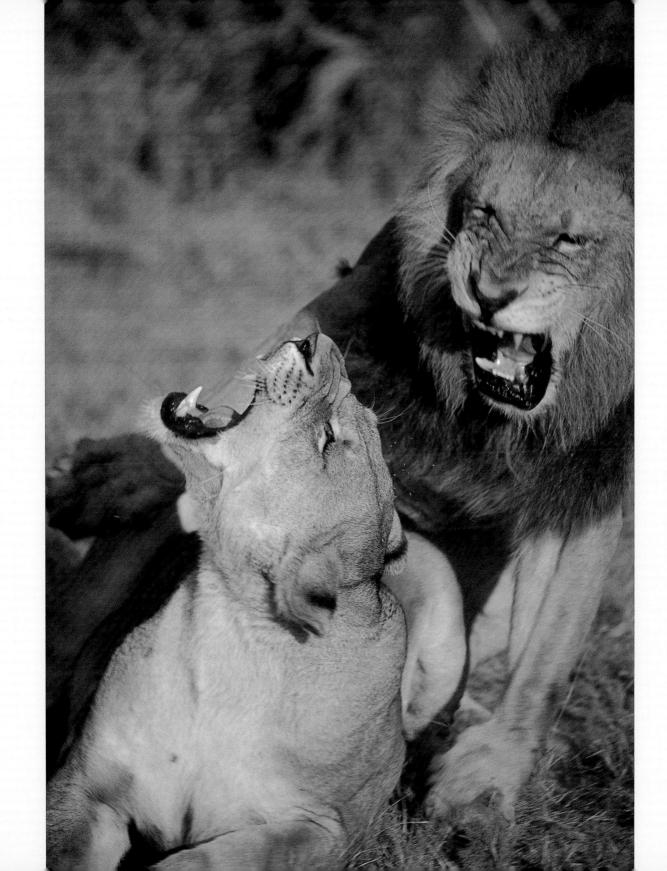

Reading from a pile of the old diaries, I see that during one year in Savuté, we worked every night for 270 nights in a row. Another year we spent 320 days in the bush. It's no wonder that one day going out through immigration at the Maun airport, about 83 miles south of our Savuté camp, when the surly official growled, "Date of birth?" neither of us could remember. We both hastily checked our passports for details. The long night hours with only stolen catnaps were taking their toll on us, just as they had on Chris McBride.

We began our work at Chobe by immediately addressing the problems. We designated no-go zones around or near the tourist camps. The lodges hated seeing lights at night and previous researchers' attitudes were, "So what, we have permits to drive anywhere." Our philosophy was, "We have the whole of this park to work in, let's forfeit the night's data or filming from time to time." Slowly we built up relationships with lodge operators, establishing a rare bridge between research and

The eyes of a hunting lioness are filled with a fire as intense as the fear in the eyes of her prey.

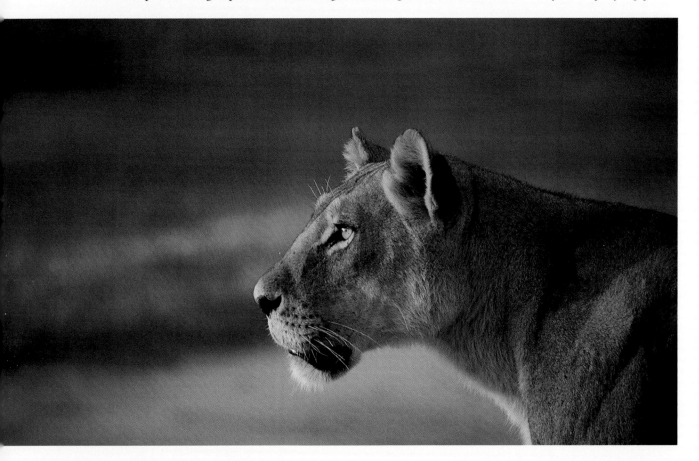

tourism. Gradually true friendships developed, especially with Lloyd and June Wilmot and Harry and Betty Cantle.

This was also a time when, trying to be sensitive and respond to criticisms from safari operators, we developed a set of rules, or ethical standards, which we hadn't needed to think about before: How close can we go without influencing the animal's natural behavior? When can we use lights without influencing either the lions or their prey? How can we minimize our presence around tourists? When is it okay to step in and help? It is this last one that we had to fight most often. In this regard, we followed one dictum: Nature has it's own agenda. We cannot judge. Whenever we humans try to judge, we do it badly. So we should not judge. No interference at all in any natural process…except if man is involved.

This means that if an animal has a snared foot, it deserves our help; if it is terribly maimed because it got away from a lion, so be it. Too often we have seen conservationists play God and put an animal out of its misery after it has just battled for its survival and won by escaping from the jaws of a lion. We have seen conservationists "rescue" lion cubs from an errant mother only to see the cubs killed by some other man-influenced cause, or worse, end up in a zoo. Man's judgment is so often selfishly motivated. People love to "save" cuddly little lion cubs or leopard cubs, seldom an old mottled wildebeest with snot sickness.

We live by these principles even now. It was good discipline to set ethical standards early on for ourselves, because ultimately we are only answerable to ourselves for our actions.

AUGUST 1, 1982

Asked Petri to fly today and track lions from the air, any lions. Found Tsididi's group way down eastern side of the Savuté marsh, so although I had to throw up violently because of this rolling, bumpy flight, we headed off on land immediately. I really have to conquer this flying. Can't be behaving like a barking gecko all the time.

Found Tsididi's pride eventually and watched them chase and catch a jackal. They played with the wounded little jackal until they lost interest and walked off, leaving it in the grass. By midnight they had moved out into the part of the marsh where the holes are really bad…and I drove into a deep one hidden in an innocent-looking grass patch. Sent Beverly flying backward off the roof into the back of the truck, where she hit her head and back so badly that when she came up she looked like she was watching imaginary yellow canaries circling her head, like you see in animated cartoons. I had to laugh, despite the seriousness of the fall.

Worked through until dawn following Tsididi, who was surrounded by a group of hyenas we didn't recognize (of the not-too-shy variety…but also, as we found out when a large unknown

Next pages: The ability to concentrate on just one leg within a sea of drumming hooves is what makes the big cats such successful killers.

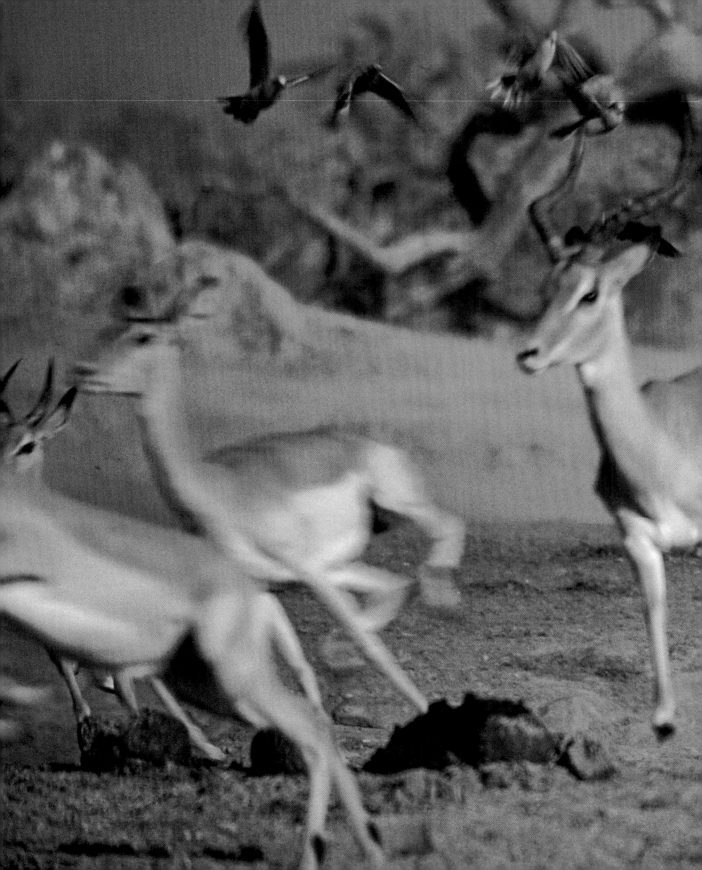

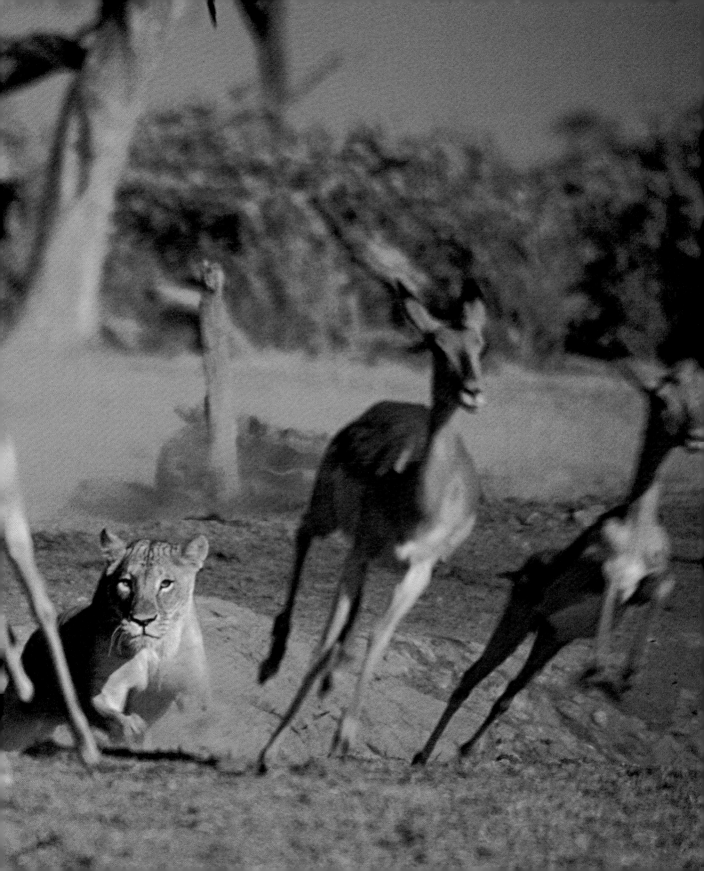

male came by, the not-too-courageous kind either). The new male is fairly used to vehicles (and people out of vehicles, which he was exposed to when we had our second punctured tire of the evening). Managed to get back to camp just in time to repair two tires, shower, and head out again to find Tsididi. Perhaps tonight there will be something magical.

And so it went, night after night, slowly trudging along behind lions, adding little pieces of information to our lion puzzle and indeed the puzzle of daily life in Savuté. We dedicated each moment of every day to this place that so captivated us.

At this time, the Savuté itself was generating some interest. We had set up our camp in the most ideal place in the world, on the banks of the crystal clear waters of the Savuté Channel. Fish leaped for joy right into our frying pans, and all in the land was wonderful. Then something happened. The waters turned to mud, and we lived among some of the most disgusting rotting fish smells you can imagine.

Few places dramatize that moment of fight or flight, life or death, as profoundly as does Savuté.

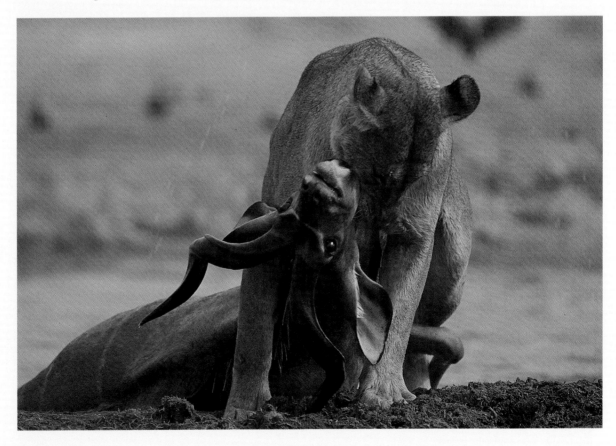

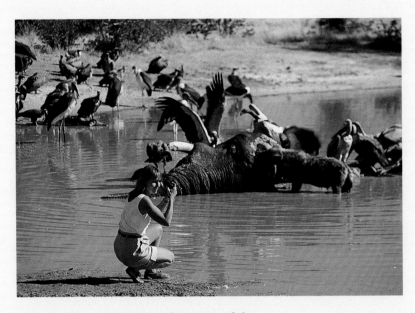

We try to engulf ourselves in each place we study and in the lives of its animals as much as possible. To do this, Beverly shoots her pictures from ground level whenever she can.

It seems as though the Savuté flows sporadically, sometimes breaking out of the Linyanti River, flowing in from the northern border between Botswana and Caprivi, a part of Namibia. At other times the Savuté blocks and the flow of water to the marsh is strangled for decades. At least once water has flowed into the Savuté marsh not from the Linyanti, down the channel, but up from the Khwai River in the southwest. It seems as though this system is always changing, defying our notions of nature's permanence, the idea that rivers and mountains signify stability, at least in our lifetimes. Savuté was undergoing one of her periodic changes right in front of us.

SEPTEMBER 3, 1982

We have cut our own water use to basics. As much as we love the moisture of a shower once a day, the "stuff" that comes out is a thick and brown cocktail of hippo dung/dead fish/elephant urine, almost liquid. When solid lumps of un-identifiable things fall on your head, it's better to hope that its hippo shit. You get used to it, but it's smell is unbelievable…. Problem is you do get used to it. Petri devised Camp Rule Number One: Any newcomers to our camp must first shower—to wash off all that unpleasant "cleanness" they've brought with them.

It was also around this time that we decided what we were seeing needed to be documented. The first roll of film I ever shot shakily documented 120 hippos crowded into one of the last pools in Savuté. Crocodiles slithered over the hippo's backs; hyenas scrambled over torpid crocodiles and hippos to eat on one hippo that had given up the fight for life. The images were so unique that they we eventually included them in our film *Stolen River*. This makes my film training rather short, about 10 minutes.

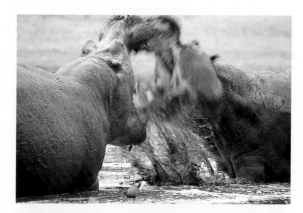

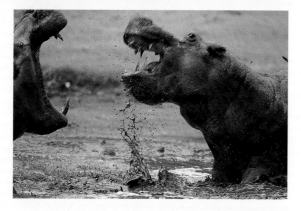

As the Savuté dried up, hippos crowded into its disappearing pools, sometimes fighting battles to the death for water space.

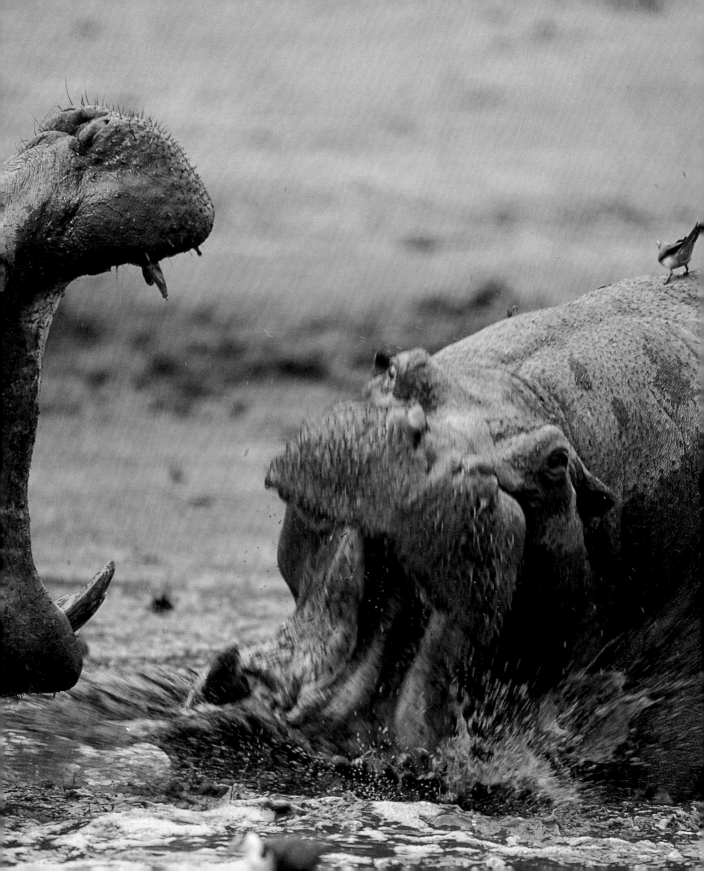

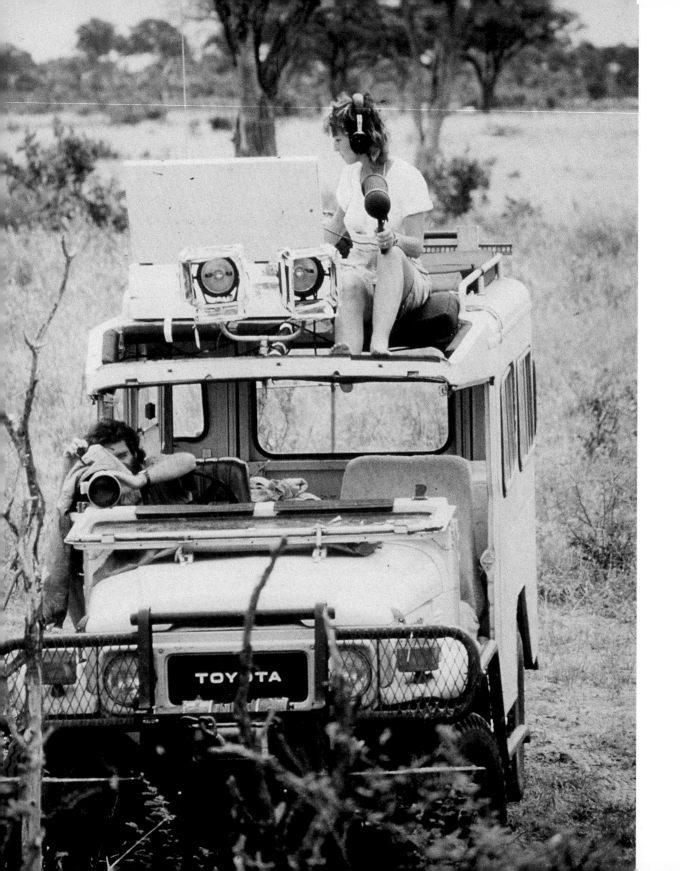

We are often asked what the best film training is, and I don't truly know. All I know is what I did. While I was on a trip to London, Michael Rosenberg of Partridge Films lent me a videotape of a film he thought was good. He was right. I watched *Etoshia* by David and Carol Huges once through, rewound, and then watched it again. Then I turned off the sound and watched it again, and again, then again. When the lights in the building went off, I went home. The next day I watched *Etoshia* again until the lights went off again. The next day the same. Eventually Mike came in and doubled back in surprise. He thought I had returned to Africa days before.

At the end I understood what made a good film. I understood editing, when music worked best, and what I liked about the film. I still do this with films I like: Ridley Scott's *Duelists*, for example, is another which I watch from time to time, slowly unraveling the film, its shots and performances.

Years later I met David Huges in the halls of Partridge Films in London. David had stuck his head into a room where we were cutting *Stolen River*. He watched silently for a long time, then left unseen. Later he said, "So, how's your film working out?"

Our first introduction to some new pride members in Savuté. These two female cubs led the split from their pride as adults, and we followed them for twelve years.

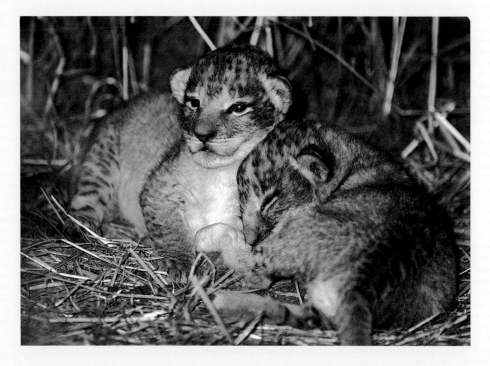

This Toyota Land Cruiser, our third lion-research vehicle, survived the longest. Even though we were acquiring more and more camera gear, each successive vehicle got smaller and lighter and provided us less protection .

"Don't know, but if it fails I'll be getting a job back in the safari industry."

His face brightened and he said, "Oh. Well, let's hope so, I don't need the competition."

Not knowing David's wicked sense of humor at the time, I returned to the editing room with the determination of a wild man, only stopping to think hours later that I had just been paid one of the best compliments of my life. When I next passed David in the hallway, I said "Hey, thanks." He smiled and an hour later he, Beverly, and I were having a beer at the pub next door.

Stolen River was the beginning of another relationship as well, with National Geographic. Over fifteen years or more, and through eight films, two books, and a few magazine articles, we have dealt with the Geographic via the strange gap between continents, mostly by fax (no e-mail yet) to Kasane, the nearest town to our Savuté camp, and by high-frequency radio to our camp or out in the bush.

Even when she's relaxing, a lioness remains watchful.

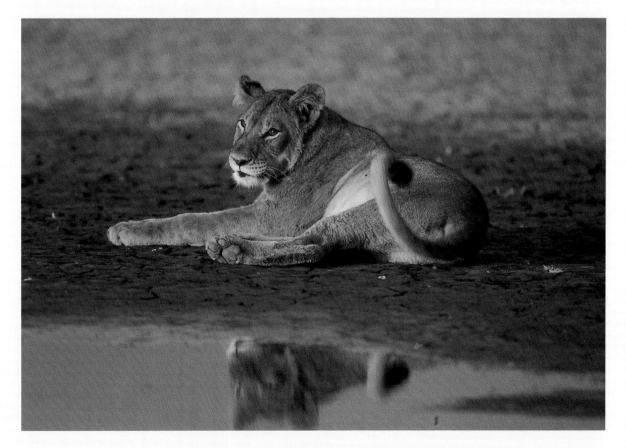

During this time we also filmed part of *The Long Night of the Lion* and produced our own film *Hunters*. Now our major work was filming the drying up of the Savuté Channel. Like some bizarre time warp Savuté changed daily, and we worked both day and night trying to cram in as much of the experience as possible. It was an almost frantic attempt to turn what looked like a great evil at work into something positive. How could this be happening? Nature always moves forward, but not always for the best. Well, in this case it's a screw up. How can we help? What can we do? Questions, questions, theories, principles, ethics being called into question. Every day we struggled, not with the heat and the catfish showers but the moral rights and wrongs of what we were witnessing, and whether we *should* be witness to it at all.

AUGUST 1, 1984

Stark acacias cut the desert sky like tombs as we drive under them in the half-light. The faded body of a tsessebe antelope lies half-covered, (or half-emerged from its grave)....

Last night Keith [my brother] visited, and while Beverly took the wheel, I sat on the roof with the spotlight. Suddenly, some strange tracks on the road.

"Hippo! A live one, maybe the last."

Beverly heard them first. We drove in and pushed through the bush, listened, then moved in again.

Finally we found a spectacle that was the epitome of the harshness of this place now. Hyenas had gathered in numbers, although not too many at first. Some sat silently waiting, watching. Others were systematically and relentlessly eating the head off a struggling young hippo. It was a scene that would have been cut out of a horror movie.

From the tracks we gathered that the mother had been separated and given up hope for her calf when the hyenas arrived. The baby hippo perhaps ran instinctively to the channel, where once again the Savuté plays a cruel trick. With no water to escape into, the calf was ambushed.

In the darkness, with the calls of pain that sounded too much like a human baby's cries, it was easy to get emotionally involved. But it is wrong to indulge these emotions, equally wrong to exploit. To interfere is an ethical sin. Our emotions ran the full range, from revulsion to "How are we supposed to respond to this?" to (when I declined the impulse to interfere) "You're a man with a dark soul, Joubert." But this is Savuté: uncaring, not unfair particularly but certainly impassive to our whimsical passions.

The hyenas ate the hippo over a two-hour period as we sat there, mostly silent, in the dark. The cries still ring in my ears today. It didn't seem to matter much to Beverly right then. She had intended to use the event to record the sound as an exercise yet found out later that it was all but useless because her loud sobs of

emotion could be heard throughout. Finally, perhaps in a need to somehow tame the event, I filmed it all, knowing that no one would ever see it, certainly no one would ever be able to broadcast this footage on network television. Still, the idea that predation is harsh and somehow wrong makes a mockery of our ecosystems, evolving since time and life began on Earth.

Some days we judged Africa, nature; every day we judged ourselves. But with or without our intellectualizing, the Savuté Channel continued to dry, and, slowly, inevitably its drying was bigger by far than we. Elephants eventually came to rescue Savuté by digging up seepage holes, but at these dribbles of water holes, the elephants claimed ownership rights. The channel's entire 70 miles dried up over a period of four years. It left our camp in a dust bowl. The images from that time are etched in my mind, and Beverly's photographs help to preserve the searing memories.

Whether draped across an acacia limb or the back of our truck, leopards always seem to be resting comfortably.

AUGUST 15, 1984

Beverly has been slogging away—with flu—for days, so finally we called a night off to recover. We arrived back in camp around midnight in the freezing cold. By 2:30 we heard a commotion at the water hole (lions and hyenas fighting again) and jumped up. Poor thing not getting any rest tonight. As we got into the truck, I heard something land on the ground nearby. I looked around in my half-sleep but couldn't see anything. We tumbled in and went through our routine. I pulled on a sheepskin mitten, and something just felt wrong. Beverly turned on the light, and we saw that my thumb was sticking out.

"Damn! Someone's eaten my glove thumb."

I felt around for the other mitten and my hand fell into a huge ball of fur. Then we started looking around. A leopard had spent a few hours inside the Land Cruiser, resting comfortably on our new sleeping bags and ripping up my sheepskin mittens. I then started up and noticed that the gear lever, where those mittens repeatedly have contact, was also chewed. An outrage!

A day later Beverly was a little better, and we stayed out the whole night again. On our return, we knew we weren't mistaken about who the mitten thief was; a fresh set of leopard tracks led to our tent and to a small pile of leopard dung on our doorstep. Within this neat delivery was an almost perfectly preserved sheepskin thumb.

AUGUST 1984

Sitting out at Marabou pan mid-marsh today, we were buzzed by a plane. Pilot dropped a note in an empty margarine bucket. Note said: "D&B, need your help. Downed plane due south, two survivors need help. Follow me."

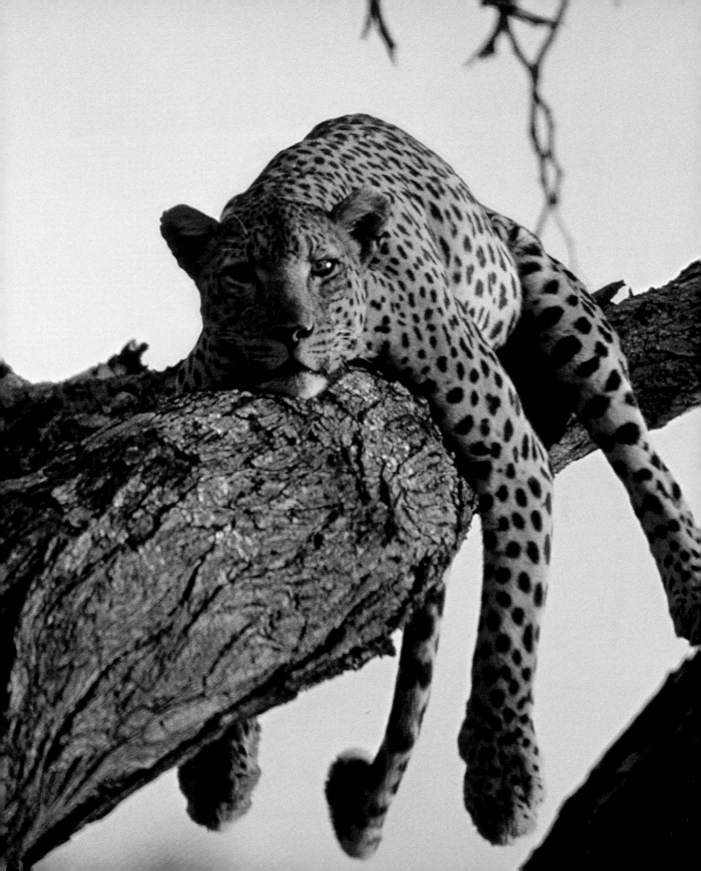

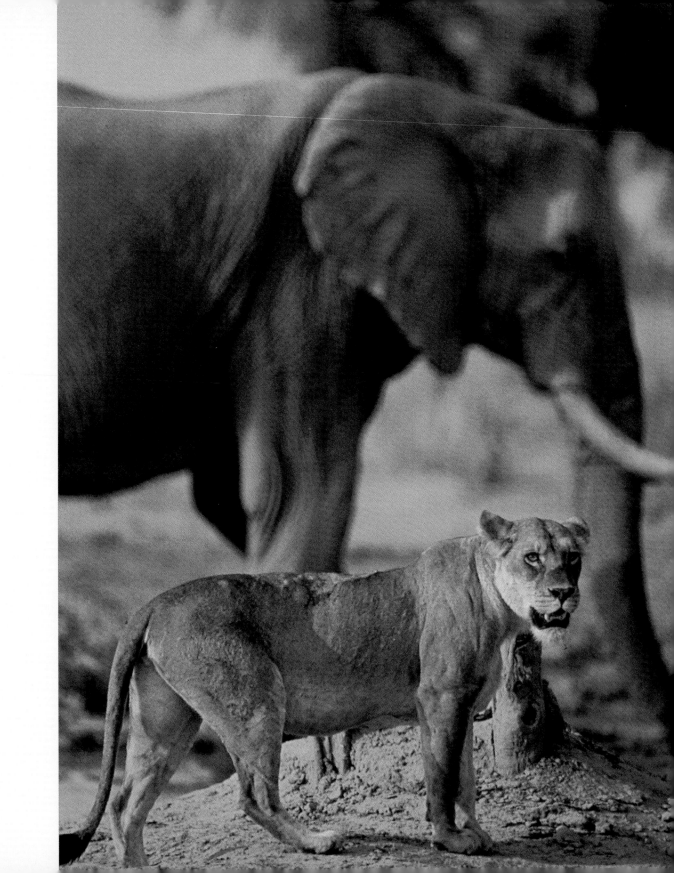

The plane flew off and we followed at breakneck speed, watching as the plane flew from us to them and circled over them like a giant vulture. Knowing that the plane couldn't stay airborne for long, we crashed through the forest as fast as we could before we were left with no clues. Twenty-eight miles into the thick mopane bush we came across them...two old men; the oldest an 84-year-old called Harry. Old Harry greeted us with "Hello, how are you today?" in a good English accent, as if we just met by coincidence in Hyde Park.

They'd survived a plane crash and been in the bush two nights.

OCTOBER 9, 1985

[Beverly's diary entry] Yesterday we had a mishap in camp. Dereck was working on the truck's wiring with the engine cover-up balanced against the roof. Suddenly the wind blew it down... right on his hand/arm. I was inside the tent and heard first the bang, then a long list of curses. I knew that something was very wrong. I ran out to find Dereck collapsed in pain with his wrist caught under the hood, not at the front but where it hinges.

I ran to help and tried to lift the hood, but it was closed, latched closed and bent around his arm. I pulled with all the strength I had and could open it only a fraction of an inch, then had to let it down again. Each time I did this, it crushed his arm in a slightly different place. Then I saw him reach inside the truck door. I know he always keeps two things there, a monster screwdriver and...a hand ax! I yelled at him, "NO, DON'T CUT IT OFF!" thinking that he was going to chop his hand off.

He didn't and had instead gone for the screwdriver. He wedged this into the hood and with all his strength bent the metal back, finally releasing his arm.

A failing or basic character flaw of ours, both of us really, is that we can't not work. With a seriously damaged arm, in an isolated camp in the bush, there was nothing else to do but raid the freezer. There was no ice, just a much prized frozen kudu antelope steak stored by George Calif, a wildlife biologist now sharing our camp. Beverly wrapped the mangled limb with the steak, and we went out to find the lions. Shock eventually lulled me to sleep in the back of the Toyota, with my thickly wrapped arm on my chest. The lions also slept most of the night, but in the early hours there was some growling. At dawn I was shaken awake:

"Are you alive?"

"Think so."

I sat up and followed Beverly's alarmed eyes. There was blood all over me, from chin to stomach. She thought I had been mauled during the night. In fact, the kudu steak had just thawed. It was after this incident that Beverly decided to take charge

The lioness called Motsumi has very distinctive scars on her back and an intense but beautiful face. We came to know the faces and stories of the pride members as if they were old friends.

Next pages: A cub from Maome's pride didn't seem to have a good grip on life at an early age, but she went on to be a full-fledged female pride member, performing great feats.

61

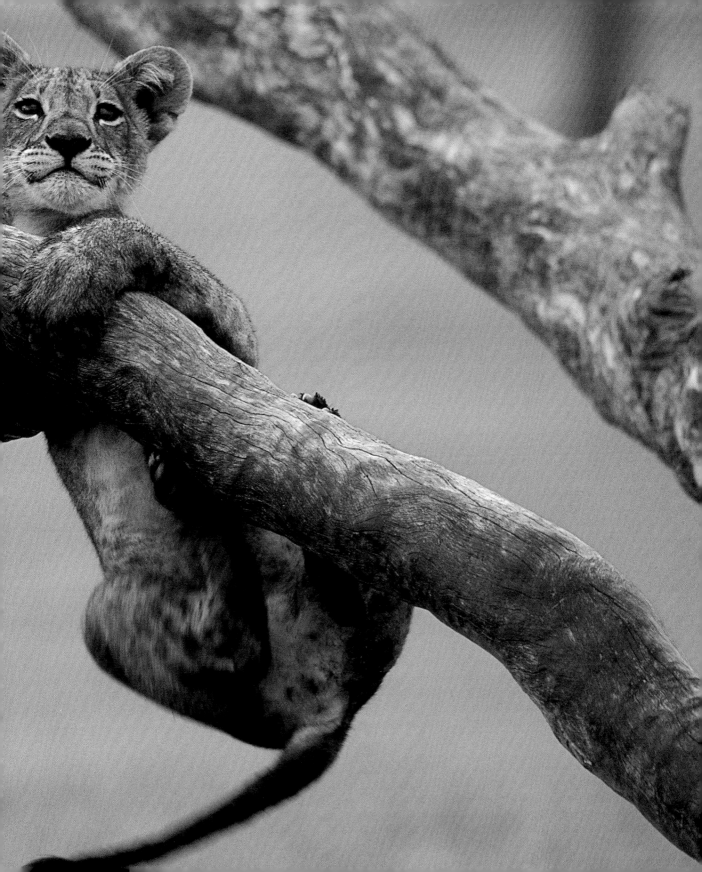

of our health issues. She started an intense study of all things medical and homeo-pathic. It was a study that often saved my own hide as I skipped from malaria to scorpion sting to snake bite.

NOVEMBER 3, 1985

As we followed Tshaba's pride through Mtsebe Island thickets, I forced the truck under a croton bush, forgetting that earlier on today I attached the small tripod to the roof for a higher angle shot. The rubber straps snapped and flicked the tripod forward and down...straight into my face. I felt bone crush and the next thing I knew I was looking at stars (in my head?). It had knocked me out of the door into the grass. My nose was broken and bloody, and the lions were out there with me. Beverly bundled me back into the truck and fixed me up like she always does. Fortunately the lions were not used to seeing people being flung out of the dark at them.

Savuté is still primitive and primal, a place whose spell we are forever in. A place where my own blood seems to flow a little faster. But each day, as we name the lions, learn more about our own survival, and build our comfortable roads, it becomes less primal. Each day there, we saw deeper into Savuté's and our own souls. I found this undated entry on the cover of a journal:

This ghostly sight, like desperate fingers reaching through the darkness,
Cuts deep into my forgotten past.
A past when I was prey to those that flash through the moonlight,
Those whose names we now know.

Far right: A rare but welcome visitor: Boyd Matson, National Geographic EXPLORER's adventurous host, came to learn all he could about lions. He got closer to the big cats than he had intended, I think, but on every occasion deferred all decisions of survival to us. Silly man.

Right: As confident as we were around the lions, there was a certain look we'd get to remind us of our place....

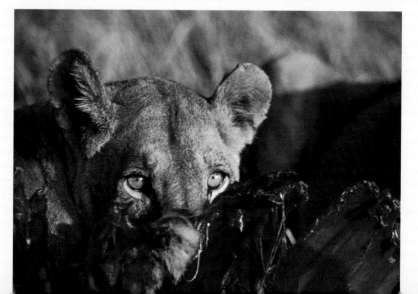

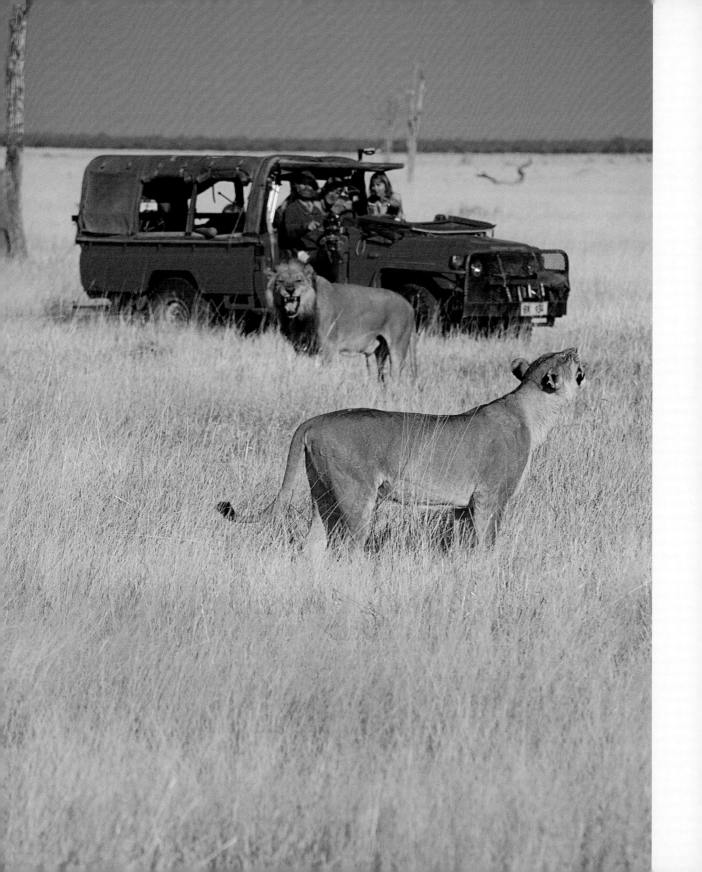

Forgotten Homeland

Memories of the Savuté years always begin with a particular night. We sit under dead acacias on the drying marsh, waiting for the lions to begin their hunt. A young male lion bites the rubber on the spare wheel of the truck; a haunting call that makes us all look up—Beverly, the lions, and me. Suddenly, we are off following along behind the loping lions, heading for what we know will be a confrontation with hyenas.

I often wonder what it was like here a million years ago, when we were less prepared.

OCTOBER 1987

Our lions are dying. It is sad to see Tshaba as a walking bag of bones. Savuté is a dustbowl. Everything with any sense has finally moved north. Tsessebe antelope carcasses lie drying in the wind, uneaten because the lions cannot raise the energy before the wind steals all the meat. It may be time to move on ourselves and take up National Geographic's proposal to do a sequel to Stolen River.

The dust swirled Savuté into a bowl of gray sand. Tsessebe herds dwindled to next to nothing, and their migration had to find a new course. Traditionally, when the channel was flowing, zebra migrations of many thousands—45,000 and more—would find their place in Savuté; a few herds would swim the channel and then go northwest to the Linyanti River. Now, with the channel dry, they all marched north. Hippos, the clever ones at least, left early and shuffled their way across country to the Linyanti and to the source of the withered Savuté, the Zibadianja Lagoon.

And our lions were dying....

Without the endless source of prey, the prides we had known for so long were struggling to feed themselves and yet had to maintain their numbers to ward off marauding hyenas. Lions we had seen born, watched grow to maturity and fade to bones, stayed like ghosts in our minds every time we drove past a tree where one had died.

Beverly has endured more dust storms in Savuté than she deserves.

67

It was time for us to follow the herds migrating to water, too, and leave Savuté for a while. Our time with the Chobe Lion Research Institute was coming to its natural end and *Stolen River* was out, released by National Geographic and Channel Four in the U.K. So in 1988 we followed the herds northwest to Linyanti, the nearest river to the Savuté Channel, and began filming *Journey to the Forgotten River*.

Our Linyanti camp, only four hours' drive north of Savuté, was like a different continent. It was the first camp of our own. Eventually, we even had a tent and a single chair there. The lap of luxury.

MARCH 18, 1988 • *Linyanti River*

So, this is to be our camp. We have the full compliment of furnishings needed. Two knives, two forks, two spoons, two plates, a kettle, a monster-size frying pan, a tent, new Toyota Land Cruiser. (A red one because it would have meant an extra week in town to get a white one.) And all the camera gear we need to make our film. In fact, the cost of the camera gear outweighs the rest of the value of the camp by five to one. Elephant growls are amplified in the forest and leopards cough and saw all night long.

This was the first time we had a camp of our own, set up against a river in cool forests. Few insects could live in the recently dried-out marsh of Savuté, but here, along the Linyanti River, there were insects of every shape and size, the worst, of course, being the mosquitoes, which chewed away at us day and night. But Linyanti was green, beside water, and lush.

When we left Savuté, we were convinced that to get decent footage we needed to be out in the bush 100 percent of the time. Night and day. I was sure that a soft bed would make us reluctant to get up and go out in the cold, damp night. So…we didn't get a bed at all. For the next five years we slept, as many Africans do, on a grass mat less than a quarter of an inch thick. Strangely, it took me those five years to figure out that we weren't sleeping terribly well and were sluggish out of the starting block when something did happen. And things do happen along a dark secretive river like the Linyanti….

One day, while trying to make a fire from rain-soaked wood, we heard a vehicle. Mike Slowgrove, ex-warden, part-time hunter, most-time crocodile catcher, stepped out and joined us for a long overdue chat about life, wilderness, the area, tales from the past and today. He was passing through, having tagged a number of crocodile nesting sites.

We filled the kettle with river water, brewed the tea, and then sat talking. Another cup was needed and another trip to the river. Eventually Mike said, "Do you do that often?"

"What, fill the kettle? Yes."

He nodded, then chuckled in his way, which usually indicates that he knows something we don't. It is a haunting chuckle. "Seen any big crocs around here?"

"No, not in the eight months we've been here."

Mike decided to stay the night and took us out by boat with a spotlight. The water beside our camp lit up—crocodile eyes—and silently melted away as we approached. The biggest one, Mike informed us, was a new male who had apparently replaced one called Nelson. Nelson, who now lives in Mike's croc farm, is 18 feet long even with three feet missing from his tail, and is one of the ugliest beasts known to man. He is gnarled and as lumpy as only an old crocodile can be; and his one good eye stares at you with one very clear intention. Crocodiles like Nelson eat seldom, but they are prepared to creep in, literally, moving closer an inch a day just below the surface of the water, waiting for the right moment. A regular tea-drinking routine like ours would have been perfect for him….

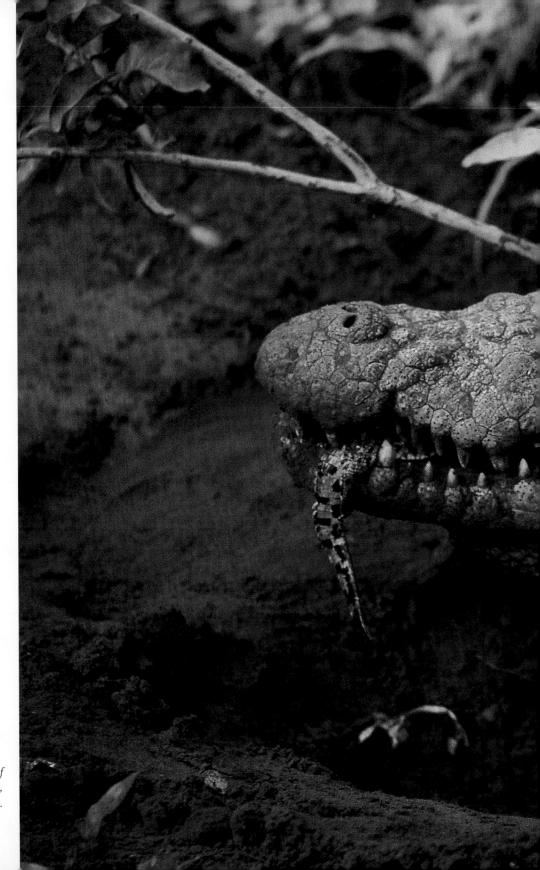

For us, Linyanti was a place of new, small things—shrews, owls, insects, hatching crocodiles.

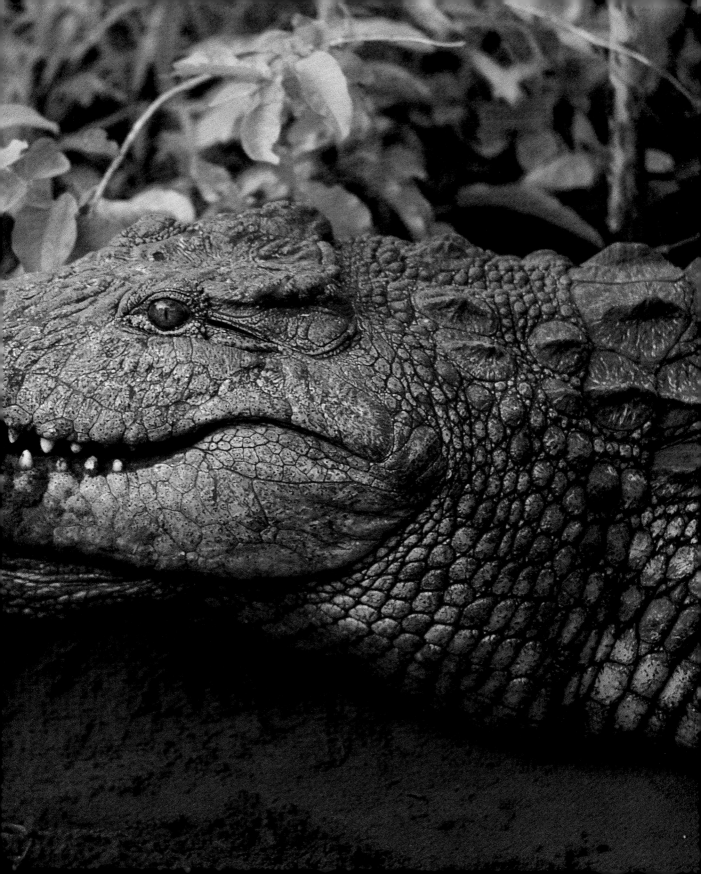

NOVEMBER 3, 1988

It started off like a normal day, but then we saw a warthog and her four tiny piglets crossing the track. A wonderful maternal scene...right.

Just behind her the first jackal loped along as if today was as boring as yesterday. We didn't pay much attention. Up here jackals are largely scavengers.

Suddenly another jackal flashed in and nipped a baby. The pig squealed and collapsed, a jackal at its throat. The mother turned to defend her piglet, and, although she was successful, another jackal charged in behind her and snatched another piglet. This one got lifted up and carried off at high speed. Warthog mom reacted and trotted along after the pig snatcher...leaving the first one.

Both jackals, now racing around behind her as she attended to the dropped piglet, quickly killed the first.

All the time the two untouched babies raced around behind her, trying to keep up.

Beverly started yelling things like, "NO! Come on. Don't be so stupid, they'll kill them all. Don't leave those two out there. Pay attention." So much for not getting involved (which we will have to edit from the sound track later). Finally, it was pigs 2-jackals 2 in what must have been a devastating draw.

Oh, those Linyanti days.

Warthogs are prey to just about any large animal, but we were surprised when two jackals attacked this mother's piglets and risked being gored by her sharp tusks.

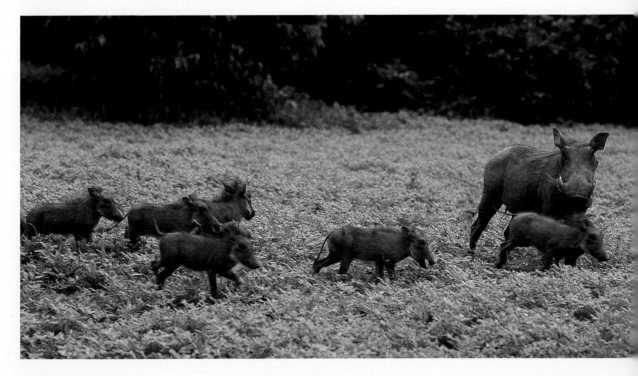

In jackal families hunting and cub raising are cooperative activities.

SAME DAY

Returned to camp to find that we were engaged in our own battle. A huge hole the size of a medium-size animal had been chewed from the corner of our tent. We approached cautiously.

Peering inside we could see that the place was a mess. I unzipped the tent and heard them... porcupines rattling their quills threateningly. In the dark, we maneuvered these pests past the ripped clothing, over the broken food supplies (they had eaten their way through glass jars), and out. At one stage I used a broomstick to guide an adult past me and he attacked the stick, stabbing four quills into the wood so fast it was a blur.

After some time, we got rid of them, and they scurried off into the dark. We started to pack our clothes neatly back into the corner. Beverly swept out the broken glass, and we finally sat down to collect ourselves. It had been a long day.

Suddenly Beverly looked toward the corner. The clothes were moving. A whole pile of clothing was slowly walking toward the entrance. I uncovered the culprit, a young porcupine who had decided the best response to the earlier action was to hide. We had simply added to his camouflage.

Around this time we broke down and decided to use an inflatable air bed that Beverly's mother had sent up to us from Johannesburg, undoubtedly in response to what must have been an overly descriptive letter of our living conditions. It was not until a night after the porcupine debacle that we discovered one of the worst combinations of physical matter on Earth: an air bed and a porcupine. We awoke the next morning cold and aching, lying on a limp piece of plastic.

Camera gear mounts up, if you let it. The steadicam I'm strapped with here was an experiment at first, but as we moved to more and more subjective filmmaking, we used it to take viewers deeper into the animal world.

Right: Frogs here range from the tiny reed frogs that sing beautifully at the moon, to warty beasts with teeth that make even a jackal wary.

While living at Linyanti, we started exploring what remained of the Savuté Channel beyond the Chobe National Park boundary. Once again we were both captivated by the beauty and wonder of the area. I have always had as much resistance to laying claim to a place as I have to claiming possession of "our lions" or "our warthog." Beverly and I believe that we are nomads or scouts. But in the Linyanti River region, I had my first pangs of wanting to make a place mine. It wasn't so much that I wanted to own the land. It's just that, as I've already said of the region, we felt like we were home.

We spent as much time as possible camped there, living out of our truck, drinking from the stream, surviving month after month without other human contact, miles away from anyone who cared (or who didn't). Everyday we explored the wilderness, finding hidden water holes, filming as we went along. But exploring was more important to us than the filming.

NOVEMBER 12, 1988

Massive flocks of quelea birds swirl in the millions, their wings flick up clouds of dust as they dance and turn in clouds, all moving with immaculate precision within millimeters of one another. Crocodiles lie in wait, leaping into the air to snatch mouthfuls of these tiny birds every few minutes.

We found a pool that probably only had crocodiles smaller than me in it. I stripped down and slithered into the muddy water with tripod and camera to get a crocodiles's eye-view of the quelea as they swirled in to drink.

The lens was just above the water, and I waited there silently. An hour or two passed; besides a baking head, I was cooler than I have been in weeks. I waited longer. The birds started to get used to me. Then I felt something slither over my foot. It went away so I didn't bother.

As the birds came in to drink that same "something" took a mighty bite of my nipple. I stood up fast—birds flew. And once again Beverly cracked up laughing. I was standing there, disgruntled, buck naked and not quite waist-deep—with a bullfrog hanging from my left nipple.

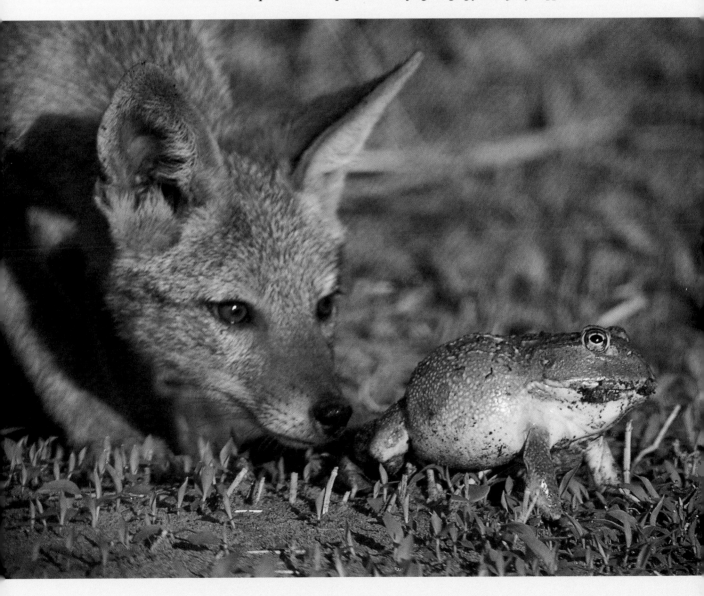

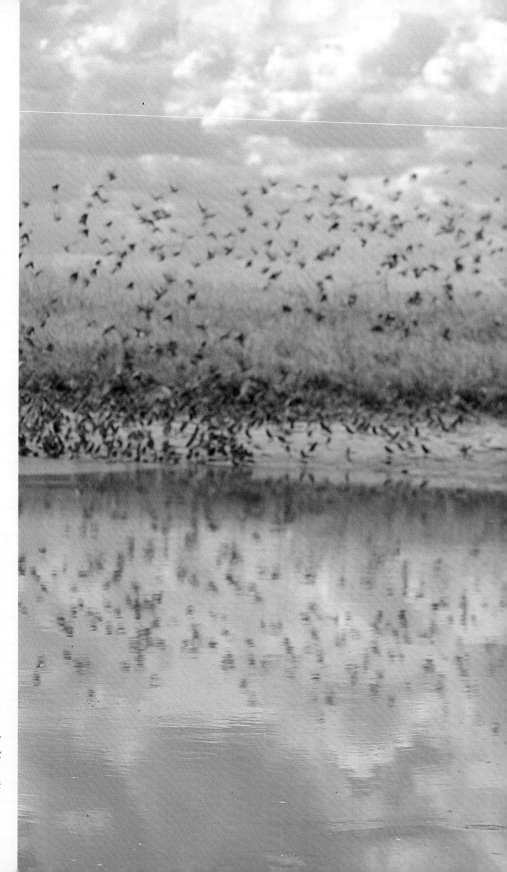

If you want to get the shot, there really is no substitute for getting down and dirty. It can take long, hot, miserable hours to get that special five seconds on film.

76

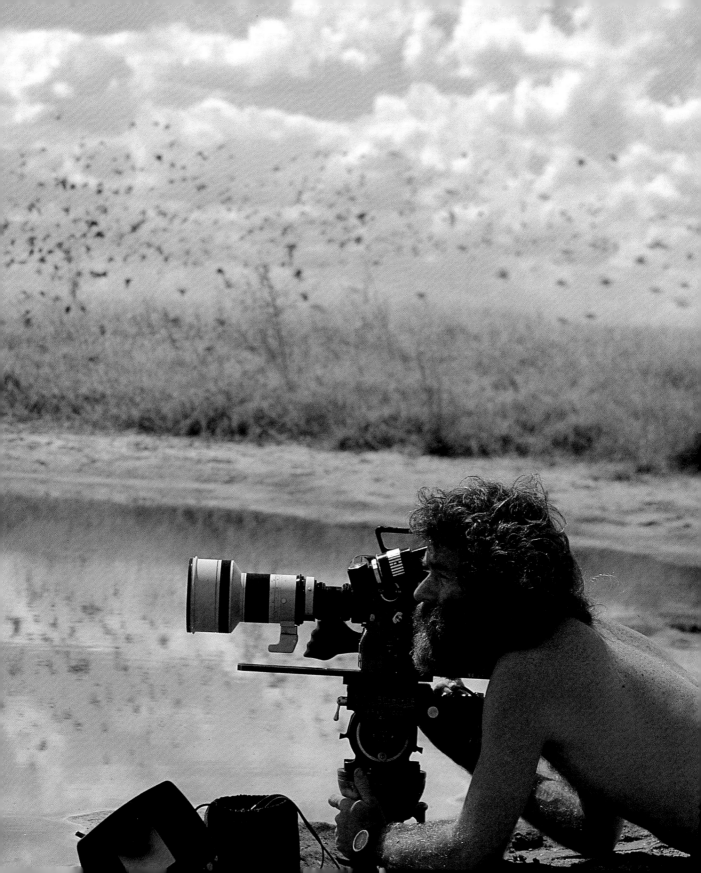

MARCH 30, 1989

Crocodiles are one thing, but the leaches are really a pain to deal with. They attach themselves and suck your blood, but the worst is that they inject some kind of anticoagulant, so when you do pull or burn them off, you keep bleeding.

Even though it is March, the black mosquitoes are around us in swarms all day.

Beverly seems to have developed an affinity to snakes. Not that she particularly likes them, but they like her. She is getting good at spotting them.

APRIL 1

I filmed a painted reed frog in the rain today. Two seconds of pure bliss. Rolling the camera again…. Then the one-inch-long frog leaped out of frame and the day's activity was over. Mosquitoes chased us home, well…a combination of mosquitoes, flat light, and general disillusionment.

APRIL 9

Still nothing today. Well, not exactly nothing, but by comparison to working with lions at Savuté, where we were filming five or six rolls a day sometimes, it feels like nothing. Had to drive two hours to a hunter's camp to drop off a tent, then straight back. On the way, saw and filmed the most amazing sight. Hunters out on a barge lighting fires in the swamp. They must have burned a few thousand acres of reeds, including birds' nests, frogs, reptiles…even mammals. I would hate to have been in that myself. The natural oils virtually explode into flame. We know there are leopards in those reeds…or used to be. Phew, I thought these guys were a little more environmentally friendly than this.

This was our first insight into what the hunters were doing. It was strange to watch men, some we knew personally, behave with such blatant disregard and ignorance. We logged the scene in our minds to think about later and kept plugging away at our film, which was slowing down to a crawl.

APRIL 13

Still nothing. Beverly saw a huge snake curled up on the refrigerator. Filmed a shrew (really desperate now), but, seeing as the little thing found us, we thought he deserved a part.

While we were asleep during last night's drizzle, I woke and said to Beverly that I had something slithering over my foot. Given the number of snakes we've been seeing, I fully expected to see a black mamba wrapped around my foot. She slowly peeled away the bedding and started to laugh. There in the warmest hollow underneath my foot was the tiniest little ball of fluff: a shrew curled

up for warmth. We placed him (her?) in a sheepskin boot (after doing a shot or two of it sleeping), where he is less likely to get squashed. We'll see if he is still a guest in the morning.

He was, and Shrew stayed with us, living in and on the tent for weeks.

Linyanti in the wet season was a combination of unpleasant wet and heart-warming intimacy as we lived with all the smaller creatures of the bush. We had up until now glossed over this smaller world as we focused on lion research and filming. Now it would have been hard not to notice. Our tent was a micro-ecosystem. The shrew moved in permanently, but so had a variegated bush snake, a harmless green spotted snake about three feet long. She managed to find a rolled-up window flap, and spent most of the day with a few inches of her head poked out surveying

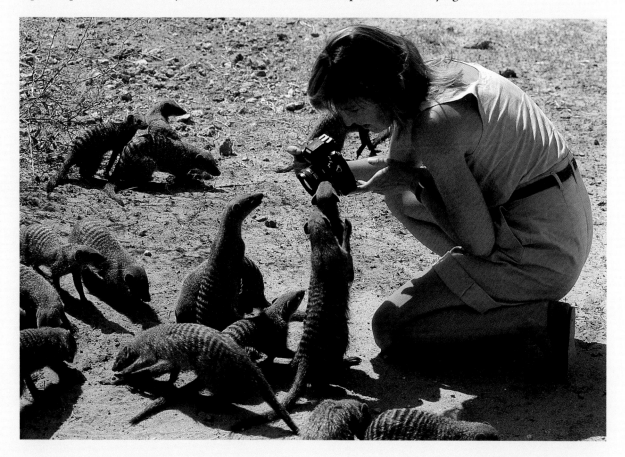

Usually shy, banded mongooses have become used to people along the Chobe River.

79

the world. When it got very damp and cold, it was the one window flap we left open so as not to disturb her. In the front-left support poles, a small gathering of painted reed frogs lived side by side, the largest being about an inch long. On the left side of the tent, along an inside seam, a mud wasp decided to build a nest. Once the first foundation was laid, the wasp could find the exact spot without hesitation. There were times when we went out for a walk and Beverly would stop and say: "Oh, damn. I forgot to leave an opening for the wasp to get in and out," and we would return to the tent.

That season we had an outbreak of multimammate mice, the only truly unwelcome guests. Sleep would be disturbed by the gnawing sounds of mice eating through the gauze tent windows. Every morning, the daily rituals included sewing these holes closed. The feeling of mice running across one's face is disturbing enough at night, but then to wake up at dawn and find one's shorts eaten is angering. Another resident clothing-eater was the door mouse, a fluffy version of the others, with big eyes and as such much harder to evict. It lived pretty much in our clothes, and the associated holes became a part of our dress code.

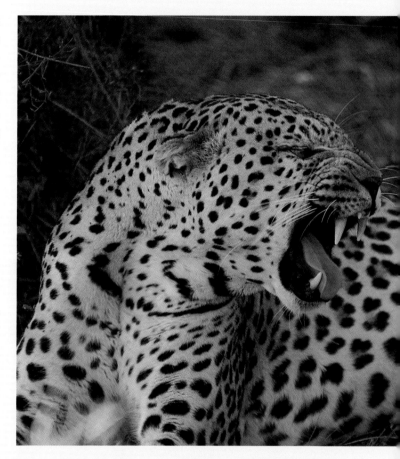

At Linyanti we listened to this old male leopard sawing calls as he circled our camp at night. Then he'd splash into the water to swim to an island in the swamp.

MAY 14

Beverly was about to walk into the tent this morning, when the tree frog let out the most gutteral of calls. She stopped and looked up...the tree frog, inches away from her face in the jaws of a cobra.

She has this intuitive thing with snakes at the moment. Yesterday at the hand basin, she stopped and said to me: "There's a snake here somewhere. I can feel it." She was calm; we started to look around. Up above her head, out of her visual range, was the bush snake (gone out for a slither I would imagine, to stretch the stomach muscles).

Among all this, there was a big old leopard that never allowed us to get away with sloppy kitchen habits; any pot left around the fire smelling vaguely like chicken or meat disappeared at night. It seemed as if our connections with the animals of the area were as naturally intergrated as those that support their interdependent system for survival in the bush. Linyanti supported a complex ecosystem of animals and plant life: baboons, eating in the trees, drop foliage for the bushbuck to eat from the forest floor; growing elephant herds, in search of water, travel to Linyanti, year after year, pushing down forests as they go, eating the vegetation. Feeding on huge mouthfuls of reeds, the elephants drop debris into the river, which floats down-stream, creating silt build-up; floods develop and finally watercourses are changed. These are normal shifts in Linyanti; elephants and other inhabitants are simply the agents of change.

At one point we headed off to a river that flows into the Linyanti, the Chobe, on Botswana's border with Namibia in the north. We borrowed a houseboat aptly named the *African Queen,* only because of its periodic desire to sink to the bottom of the Chobe River and general propensity to behave as unreliably as Humphrey Bogart's little ship. Why my brother, the owner, was so enamored with this junk heap I didn't know, but he was gracious enough to loan it to us, and we set off to film crocodiles and live like Robinson Crusoe (before his shipwreck).

Awoke to buffalo crossing the river. Tried to film but the waves make the boat roll too much. Tried to get close to elephant herd crossing but got stuck on a sandbank. While I gunned the motor, Beverly had to get out onto the sandbank and push. She was successful eventually, and the boat took off at great speed, leaving Beverly standing in the middle of the river alone, with a look of complete surprise and abandonment on her face.

It was a pretty good life for a while, I must admit. Our filming permit allowed us to stay on the boat anywhere, and we tucked ourselves away from everyone. It was like living on the original *African Queen,* exploring the great African rivers. Then our time in paradise ran out.

Headed toward Serondella. Tried to film the rare Chobe bushbuck and baboons. Only managed 20 feet of film on them because the boat is terribly unstable. Stability isn't helped by the fact that the steering is broken and we now steer with a vice grip locked onto the steering shaft.
Midday disaster.
Turning the corner toward the Watercart inlet where we last spotted the big crocodile basking in the sun, here the vice-grip steering slipped off. With the engines at full throttle to make the tricky turn between

Next pages: Young baboons are a blur of energy as they play and fight, establishing their status in the troop.

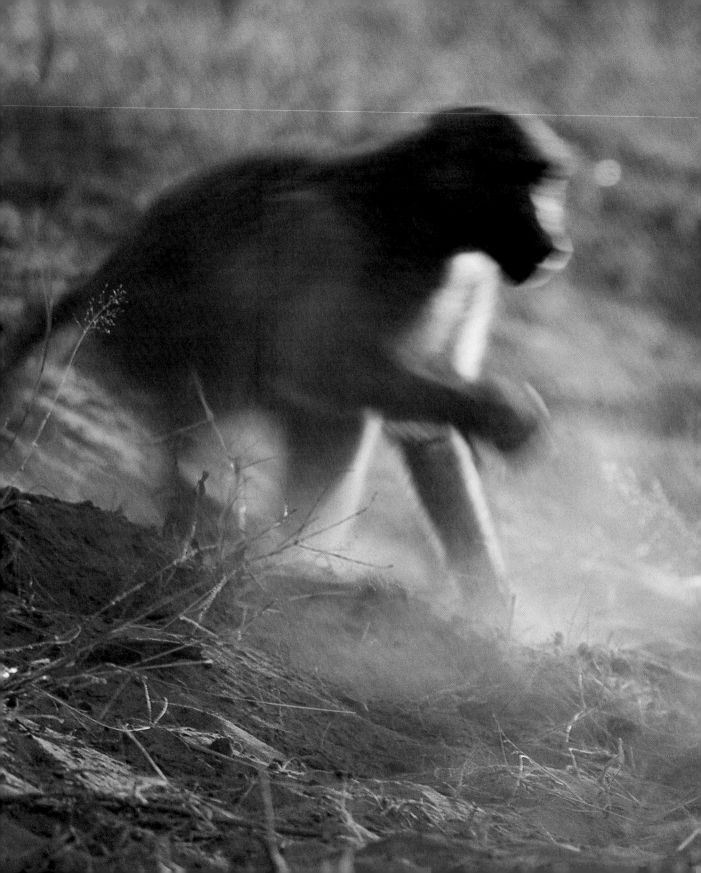

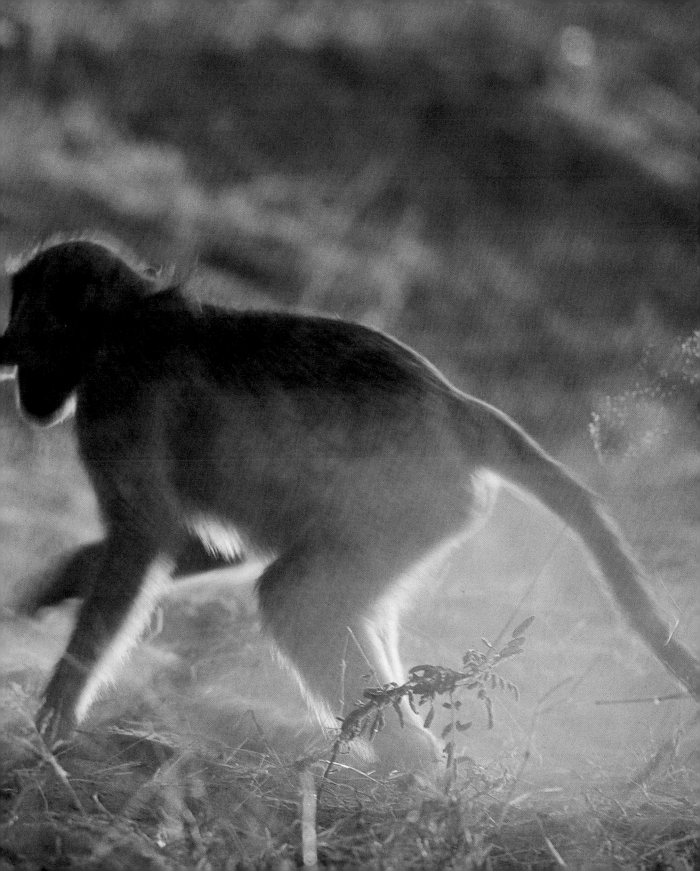

mud banks, we had no control of the careering vessel. Too late I saw (from the top deck); thick dark fingers of a submerged acacia tree. The broken branches struck home; we staggered across the deck and the African Queen came to a dead stop.

We made sure we were both okay, then I dived underneath to check damage. It was extensive. Two holes the size of my forearms right in the softest part of the hull. Beverly had to swim our camera gear, precariously balanced on a punctured rubber raft, to a tiny sand island. At last we limped onto the boat-launching ramp in town, and I rammed the Queen as far up the ramp as I could, sending the holes out of the water, so at least the damned thing wouldn't sink. Is this the worst day of our lives?

One should never ask. That night, physically and mentally worn out, we both collapsed at 7:30 and slept to dawn. At least, we thought, we hadn't sunk the *Queen*…

Arrived to start repair work on the Queen at 6:00 to find the boat five feet underwater. Overnight she had sunk. When I ramped the holes out of the water, I must have put the boat at such an angle, the two stop valves at the back of the boat went under. It started a slow filling that eventually weighed the boat back into the water. Now we really are stumped.

Dived inside the boat for our belongings that hadn't floated away into Zimbabwe. Saw amazing fish life…in the lounge.

Over the week we have worked from dawn to dusk trying to repair this rotten old boat. Every place I try to weld falls apart. Went for a shower and left the boat on two high-lift jacks and blocks that took us most of today to insert. When I came back someone had stolen my jacket. I parked the Land Cruiser on the ramp…WITHOUT the handbrake on. It ran down and rammed the boat, sending it off the blocks and into the water, where the holes started their usual gurgling sounds.

Ten days later the *Queen* was afloat, and although I had malaria, we were basically back in action—and sworn off ever using the *Queen* again. Some years later she decided to visit her submarine realm again, but this time there was no one as stupid as Beverly and me to salvage her. The *African Queen* is now a breeding ground for the local tilapia fish.

Around this small-things-of-Africa time, we started watching a few pied kingfisher nests burrowed into the sandbank near camp. As you can no doubt see, we were pretty desperate to film…anything. The big game we had come for were, so far, rather camera shy. We later found out that it was because of excessive hunting in the area.

MARCH 1989 • *Linyanti*

Filmed the kingfishers a great deal over the last few days. But today when we looked out, the nests were all quiet. It seemed strange. We waited an hour with cameras ready, then approached the nest. Large soldier ants had raided the nests and attacked the eggs. Eggs were broken and lying everywhere, and farther down the bank we found a few half-eaten chicks.

Then we found a survivor. He must have been a slightly larger chick, but now he lay panting in the sun. The broken-off heads of soldier ants were embedded into his leg joints. Must have been remnants of the struggle he fought against the painful bites, by pecking away at the ants' bodies. When soldiers lock their jaws into you, they don't release.

Our dilemma was just about to begin: Is there any way we could have influenced this, our presence, our filming? The nest was a battle zone, with one survivor. Could we live by our own rule of noninterference under these circumstances? What if our filming here had somehow attracted the ants? Maybe we dropped a crumb?

"Could never have been that close to affect it."

"But isn't there a theory that simply by observing, one creates an influence?"

"Theory of observational influence. Doesn't apply."

As Beverly and I debated these things, the baboons screeched above us. "We have to leave it to its own chances of survival." This was clearly not greeted with much enthusiasm.

"Not much chance of that now; the baboons have been watching us."

And then there was Kodak....
We were the kingfisher's companions
for a while, before he returned
to his natural life in the wild.

With some irony, we named the black-and-white bird Kodak, and clearly lapsed on our nonintervention approach. To many it may seem a trivial time-wasting effort to agonize over whether to save one small bird. But it is a short step between that and denying everything we believe in; a short step to stopping hyenas from attacking lions, lions from attacking elephants, from interfering in every aspect of nature that makes us uncomfortable. We feel strongly that it is folly for man to believe in his divine right to govern nature. We cannot be in control of everything we see around us, although what makes man Man in this time is that he thinks he can. It will change....

We did decide to raise the bird. But we would not tame him, not contain him; we would wait for him to find his freedom, and we would not film Kodak until he was wild again.

At first the pied kingfisher was too weak to even raise his head. Beverly, ever ready with a formula or two as a remedy for our own health problems in the bush, concocted something for the bird. It seemed to work.

APRIL 1989

Beverly spent the morning dipping a mosquito net into the water to catch tiny minnow fish for Kodak. She was so successful that we fried up enough for a snack ourselves.

Kodak won't eat [wrote Beverly] unless I shove the fish right down his throat, a scary task because I don't know if I'm hurting him or not. Both exhausted by the end of the day. By 5 a.m. Kodak needed company, so walked out of his box and snuggled up in my armpit for warmth and slept.

During this time we had expanded our possessions to include a second tent and an editing table, which meant we could edit out in the field, progressing our filmmaking range enormously. Now we could virtually drive out and do one very specific shot—for example, of a fish eagle flying right to left along the water—and know that we had our sequence complete.

I would spend rainy days editing and doing Quixote-like battles with the underpowered generator we had bought to run the edit table. This usually involved servicing, cleaning, and starting the generator, a very

Beverly devised a bush-style "trims bin" by sticking selected pieces of film against our sometimes full air bed. It worked well for a while, until porcupine holes deflated the bed and the film ended up on the floor.

silent little thing; then running down to the edit tent, starting the table, and getting in a few edits before the strain of the table started to affect the generator. The effect of which sent the table into a weird mode; the film either whistled through at twice normal speed or dragged at half-speed. Nothing was predictable and I could not grasp any pace from looking at the cut. Instead I had to hold up strips of film and gauge the length of the shot physically.

The temperature inside the new edit tent reached unbelievable levels. The tape that glued the film together melted off, leaving long strands of cut film flopping around on the tent floor once again uncut. Beverly came in a few times a day. She'd douse me, and we would run the cut film. We'd discuss the edit and decide where to go next.

Long hours of cutting and recutting Forgotten River, Eternal Enemies, *and* Patterns in the Grass *were spent in our 'edit tent.'*

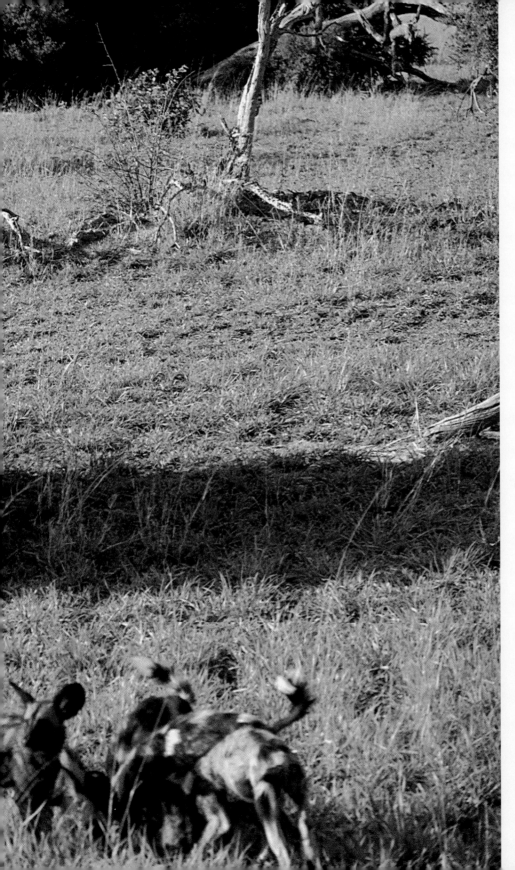

Rare wild dogs move through
Savuté and Linyanti hunting
down their prey as they go.
Skilled predators, they usually
kill eighty percent of the
animals they attack.

MAY 6, 1989

Woke to a racket outside. Kodak is back and needs food. Later in the day, as Beverly was fishing for Kodak's food, he decided to take his first dive. It was a near disaster. He splashed down and was immediately waterlogged. The take off was difficult. He landed in the grass just in time to hide from the fish eagle that swooped down to catch him. The fish eagle only just missed him, and Beverly went to the rescue once again. He spent the rest of the day decidedly unhappy, shivering and very quiet.

MAY 8, 1989

Kodak went out early for a test flight and perched near the old fish eagle's branch. At 8 a.m. adult male pied kingfisher came flying by, and in an almost comedic double-take put on his airbrakes as he passed Kodak. Kodak reacted by giving a call not used since he was a baby. The male flew back and circled, fast, then disappeared.

A few minutes later two kingfishers flew in from the same direction, a male and a female, and perched in the reeds opposite camp, chirping up a storm. Kodak did the baby thing again, and the others responded. Then he took off right at them, and the three chirped incredibly excitedly, and all three flew back to the other nests together. We think Kodak has been adopted.

From then on Kodak visited regularly; at first for a few hours, later alone. Beverly had fish on hand. He would feed and fly off. When he dived in and caught his own fish, we knew our time with Kodak had come close to its natural end.

A good natural end.

A few months later the sun started to shine again, the water started to dry, insects started to call, and our little menagerie melted away again to their own private lives.

JULY 1, 1989

Very quiet day, so we drove down the floodplain looking for elephants swimming across the Linyanti. Found a small herd of three females at a pool in the reeds. Knowing these elephants, I motioned to Beverly with my fingers: "Three only. No good for us."

As she got back in the truck, the springs on her side made a small metallic noise. (Must fix that.) Suddenly a huge female came out of the reeds, head up, charging straight at us. Weird thing, though, she was totally silent. I started the truck, knowing that the engine noise is usually enough to stop a charge without disturbing the animals too much. No reaction. She kept running forward. I let out the clutch and drove forward, hoping that this aggressive move would stop her. No reaction.

By now she was within a few paces and running hard. I put the gears in neutral and released the brakes...to soften the blow of the impact, and heard Beverly say softly, "Oh no, here we go again."

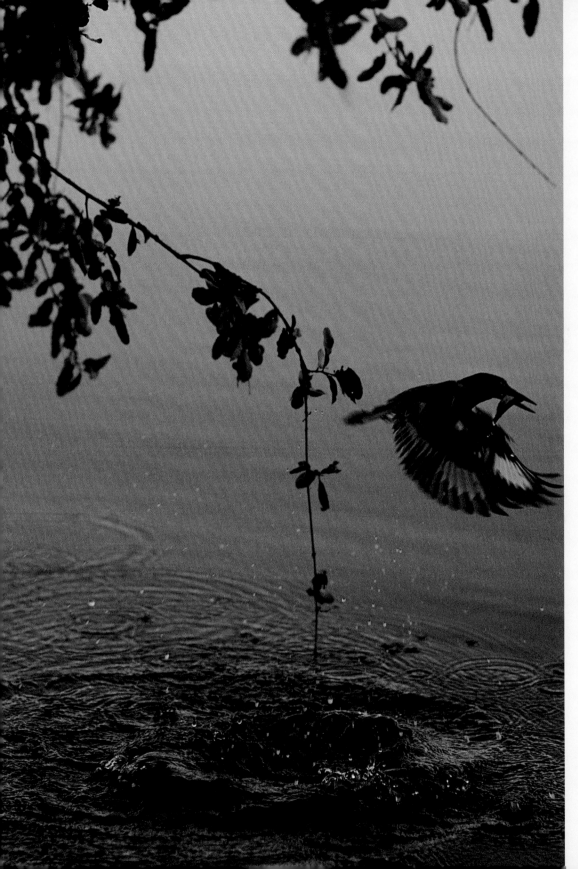

Kodak came back to visit often and fished around camp for a while before gradually getting wilder and wilder.

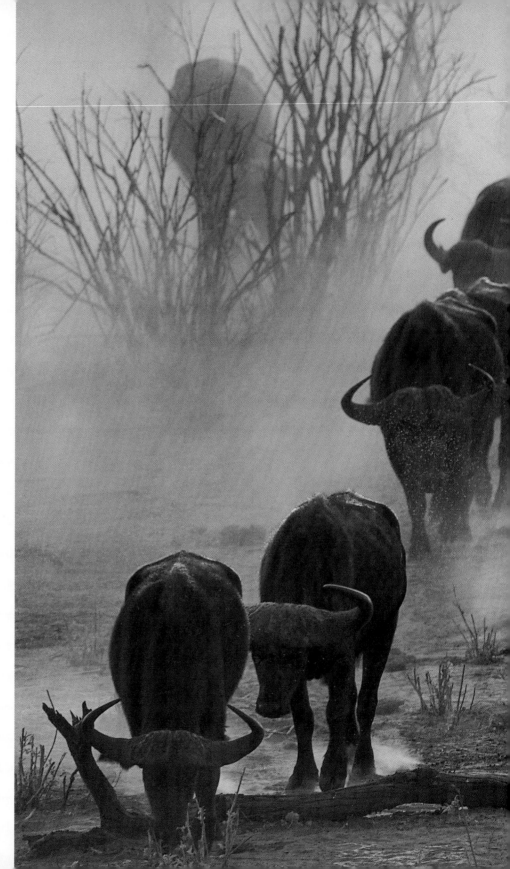

Lions seem to prefer buffalo over any other prey. When a large buffalo herd wanders into Savuté, the lions hunt them almost exclusively.

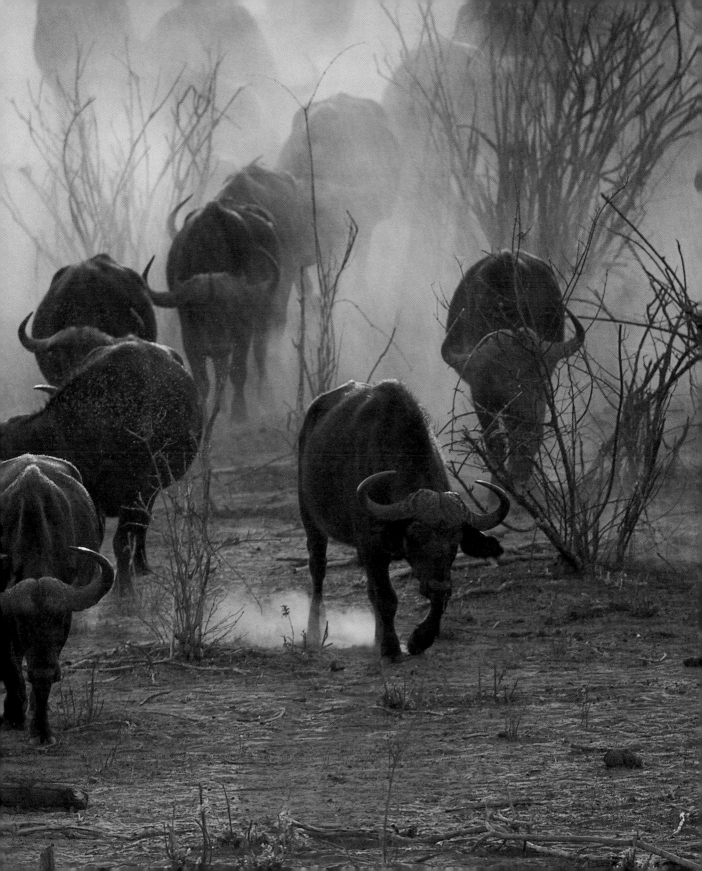

*She hit us hard, harder than any elephant has hit us before, and then she put her head down
and pushed us backward at about 5 or 10 miles per hour. It was violent. It was then that
I realized that she could easily turn us over if we hit the elephant dig holes behind us on the track.
Still in neutral, I jammed on my brakes to give her resistance. Suddenly she whipped her head
back, her tusks ripped up the solid bush bar, and it snapped. A large chunk of ivory came flying
through the front, and the attack was over. As she walked off, we saw her injury for the first time.
It was a large cyst that we suspect is an old spear or bullet wound.*

Out here you never know who came before you....

The migration of animals between the Linyanti and Savuté was a journey of life;
it was a path to survival for thousands of Africa's diminishing animals. This trail
and the journey's end was a refuge and saving grace for them. As *Journey to the
Forgotten River* reached its final stages of editing and scripting, we knew that nature's
changing ways and the animals' determined survival was clearly the primary message in our film.

Journey to the Forgotten River was a long hard film, but just as our previous film,
Stolen River, had led us naturally into its genesis, so it too pointed us in the direction
of our next film. We had spent a great deal of time living with and observing
the animals that moved back and forth between the Savuté and Linyanti Rivers and
became fascinated with the migration of the zebras. Our nomadic existence was
once again carrying us further along an extraordinary life, deeper into our convictions and work.

*From the first steps forward,
there is a subtle difference
between a mock charge and a
serious one. Then again, some-
times an elephant changes its
mind in mid-charge. We've
survived three different attacks.*

94

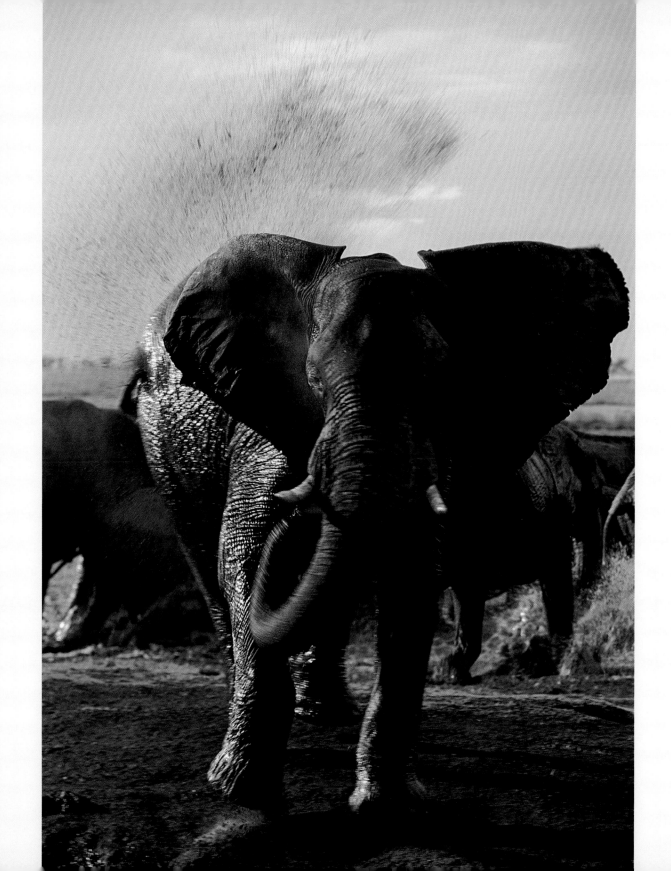

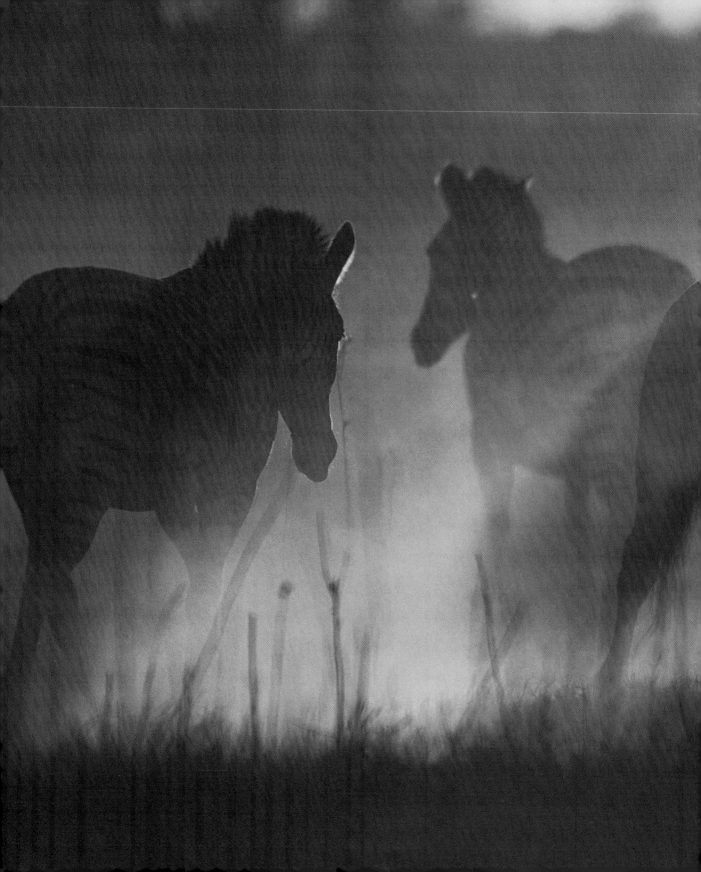

CHAPTER FOUR

Following the Winds

Tonight was an eerie experiment. We chose not to know where the lions were going. We simply kept moving with the zebra herd after dark.

Suddenly, their behavior changed. Now totally used to us, the zebra slipped into formation silently. The herd stallions quietly took charge of their harems, walking off to one side while the females and foals kept strictly to single file. We drove with them, settling into their rhythm, moving almost as silently.

It was a moment of complete calm, an almost dreamlike state in which we felt like we were floating above the ground somewhere.... When it was over, I longed for it to return. We followed the zebras wherever they went. Slowly we got to know individual zebras: "Hey, there's that male with the mismatched third rump stripe." Seems impossible, I know, but we did in fact begin identifying specific zebras within the herd. Our list eventually rose to include 112 individuals. We became like them, knowing calls, seeing familiar faces or, in this case, rumps.

Gradually the tension mounted as we marched through the long buffalo grass on the southeast plain. We knew that this was a prime lion spot...and so did the zebras. We could tell. There was not a snort, not a whinny. Foals were glued to their mothers, and bachelor males started falling back to defensive positions. We walked on for over an hour like this. Although it was cool, drips of sweat rolled down my face. Now we know what it must be like to be prey rather than predator.

Is there a lesson here? We know stuff is going to happen to us sometimes; it's hard to avoid. All we can do is stay sharp and trust that our reactions will help us survive. The zebras have nothing else to rely on...nor perhaps do we.

We followed zebras day and night for months.

On one day as we peacefully watched the zebras, we heard alarming sounds over the ridge....

Very nervous herd of buffalo, so we sat quietly and filmed with a long lens. Suddenly they stampeded out of the dust, and we saw a hunting vehicle charging among them, guns blazing. Buffalo dropped all around, and, before we could comprehend this, the vehicle was off in a cloud of dust. Before us lay a mess of wounded and dead buffalo.

We slowly drove down and saw a big old bull struggling to stand up, shot through both front legs. Completely outraged by this, we turned to chase the hunters, only to find them returning.... Had the following conversation:

"What are you doing?"

"Hunting."

"Well, do you know that you have left a few wounded animals here?"

"Yes."

"So why? Why don't you go and finish them off at least?"

"Oh. What for, they will die. Do you know how much ammunition costs?"

When I asked to see their permits, not something I can legally do, they drove off.

This was the second experience that signaled to us all was not well in the hunting world of Botswana, between human predators and their prey.

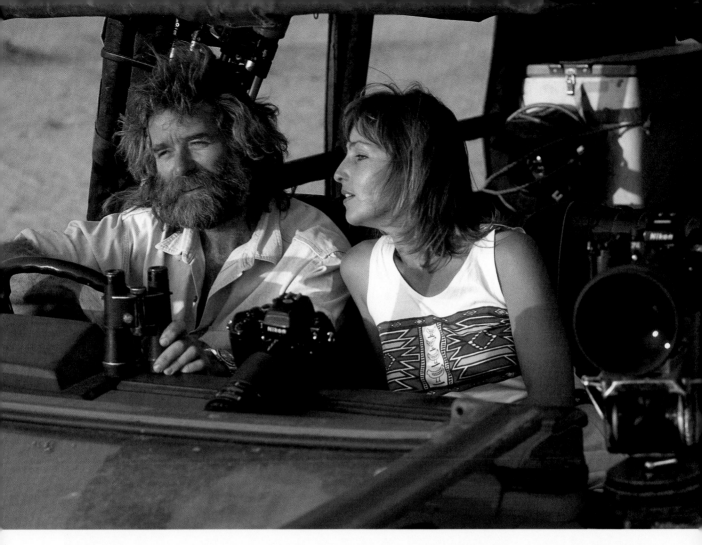

Just before this period, we had written to National Geographic with some ideas for our next project. I had submitted three proposals to choose from—but all of them came back approved. Now we really had a load of work ahead.

The first film, *Zebras: Patterns in the Grass,* about zebras and their migration across northern Botswana, was taking us into another nomadic phase of our life. We simply drove with the migration day after day, filming their behavior, from sleeping to fighting. At that time Linyanti was our camp in name only: we lived mostly out of the Toyota Land Cruiser, driving behind zebra herds and formulating strong ideas about the way we see and use animals in Africa. Although we officially held our Linyanti camp from 1988 until 1992, we set up a small (temporary) fly camp in 1990 at a second location in Savuté, nearby Lloyd's Camp. It was a single tent, sometimes used during the day. But our official address from 1989 until 1992 could just as well have been BK 934, the red Land Cruiser's license plate.

The red Land Cruiser was our only real home for the better part of six years.

Left: Sometimes all you need is a bigger lens!

*We learned that zebras live in
tightly bonded societies.*

Drove through the night with zebras moving and found ourselves emerging from thick bush into familiar territory...Savuté. We had successfully followed the herd's precise route between Linyanti and Savuté. The Sand Ridge crossing was easy, as it had rained almost the whole night and past four days. All our clothes are now either damp or soaked, and it gets cold at night. But the worst thing is driving through the scrub, because wet branches, unseen in the dark, slap our faces, spraying cold water everywhere and leaving stinging welts across our cheeks.

Arrived in Savuté itself by midday, and we used the chance to climb up the mountain at Peter's Pan.... View of 5,000 zebras all massed together is spectacular. Spent the day trying to thaw out, but the afternoon drizzle set in again. Needed fuel so decided to check in at Lloyd's Camp in the north to see if our fuel drop had arrived. It had, and with the best hospitality always in abundance at Lloyd's, we were offered a hot shower and a good meal. Actually...slept in a tent. On a bed. First in.... [I obviously flipped back in the diary to find out and either fell asleep or heard something outside. It was never filled in].

Refueled and refreshed, we were ready for the Savuté leg of the migration. It is a difficult time for zebras because of the high lion and hyena densities, still high despite the dried channel. It seems as though the predators wait for the zebra troops like kids expecting the circus to come to town. Thin, scraggly lions turn fat and sleek as the migration passes their way.

The start of the migration is sparked by the first rains. By the time the zebras reach Savuté, the grass is a mixture of browns, yellows, and green. By the time they leave, fat lions roll on brilliant green grass, often too well fed to care about the warthogs that run within feet of them. This is the time when Savuté transforms itself from a desert to a lush savanna.

The zebras are here for the grass, those new protein-rich shoots that start turning colors after just six weeks; and they defend their resource against the masses of others that want to eat the same shoots. On arrival at Savuté, zebras start to foal, almost as one. Within days there are foals everywhere. Eating their protected share.

On another level, this seems stupid. With all the predators coming to the area to feed on the plants, the zebras choose this time to give birth? But the flood of foals saturates the area; and lions can only eat what they can fit in daily. Chances are some foals just won't fit in. Time is on the zebras' side because after a few weeks their foals are less vulnerable, faster, and have a better chance of survival. If, like us, they foaled randomly along the way, each foal would be picked off as it was born.

Getting close means taking risks. Here, the risk of being mistaken for a small female zebra by either a zebra stallion or a lion would not have been good.

And there were other classic defenses that we observed, as when the lions surprised us all.

JANUARY 12, 1991 • *Savuté marsh*

11:34, moonset.

12:15, lions exploded all around us. It was chaos. Zebras scatter at first, but almost immediately they form up into a bunch again and look for leadership. We focus for once on what's going on with the zebras, not worrying about the lions (quite a discipline I must say). A lead mare set the direction, and the herd melted into one again, not into distinct kinship groups. They ran in a circle, avoiding lions that were strung out in ambush. Still the lead female made all the choices.

Then we saw the pattern within the pattern.... Five males, bachelors, lead males...I couldn't tell, but all were males, and they closed in, in a classic V-formation, kicking out at the lions. We had to watch all this through binoculars or an image intensifier so as not to interfere with either the lions or the zebras. Eventually they outpaced the lions, and we were left in a cloud of dust, with dazed and confused lions.

When I wrote the script for *Patterns in the Grass,* I had a fragment of a sentence from my favorite Greek mythologizer, Homer, in my head. I wrote: *"...and the field was littered with the vaunts of the vanquished,"* which was transformed for the final script: *"The haunting calls echo across the grassland like a lament for the fallen."* Both phrasings reflect just how Savuté turns into a battlefield every night. Lions appear from nowhere for the migration; zebra herds are chased from one lion territory into the jaws of the next pride, falling to hyenas along the way.

All facets of everyday migratory living benefit from timesaving approaches. Our daily routine, if there was one, worked like this:

Dawn would find us still working, because there was just so much happening to the herds at night. (One night we saw twins born.) By 10 or 11 in the morning, the heat and humidity were up and it was difficult to work. Zebras started to settle, sometimes lying down flat or resting with the weight off individual legs, heads down, ears flat. Once we had filmed this often enough, we could use the midday to get some rest and eat as well. We'd drive off to the nearest shade, and with the speed and efficiency of a team of mechanics at a Grand Prix race, we'd get to work.

I collected wood and made a fire. Using tire levers in an often precarious balancing act, I'd create a tripod in the flames and suspend a tin of water to be boiled

Lions can pop up in the grass anytime.

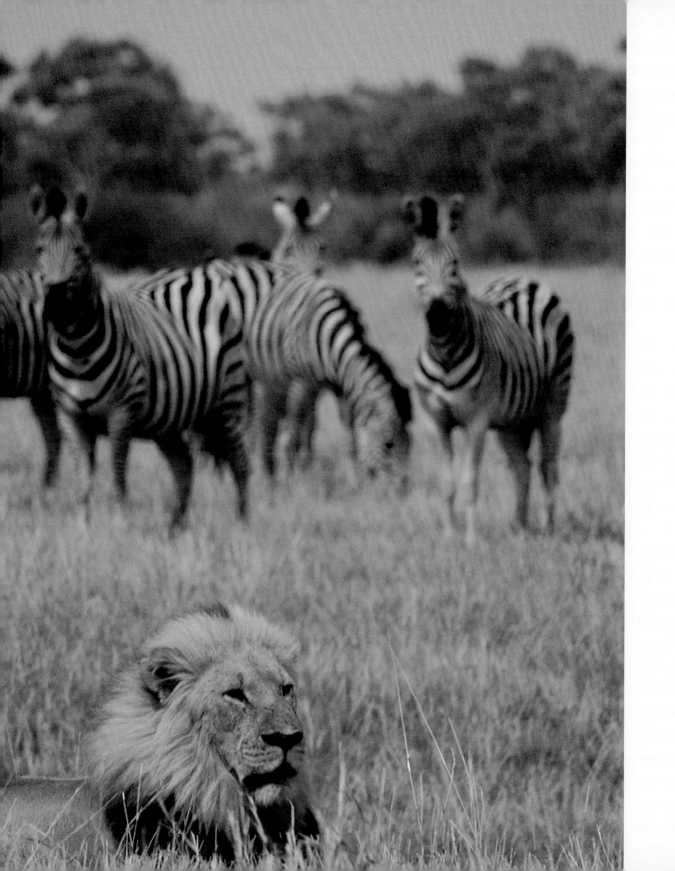

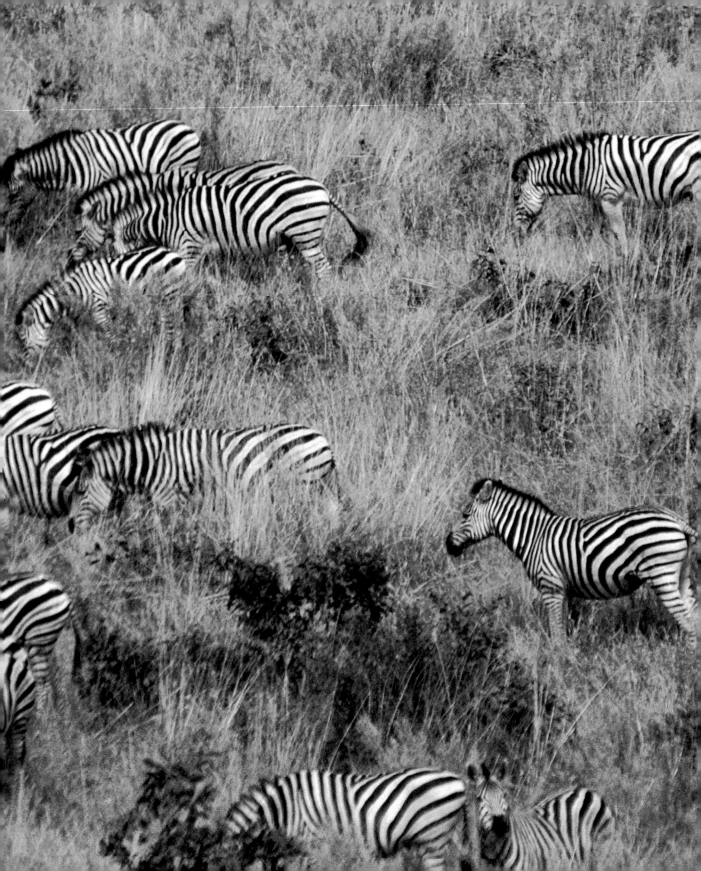

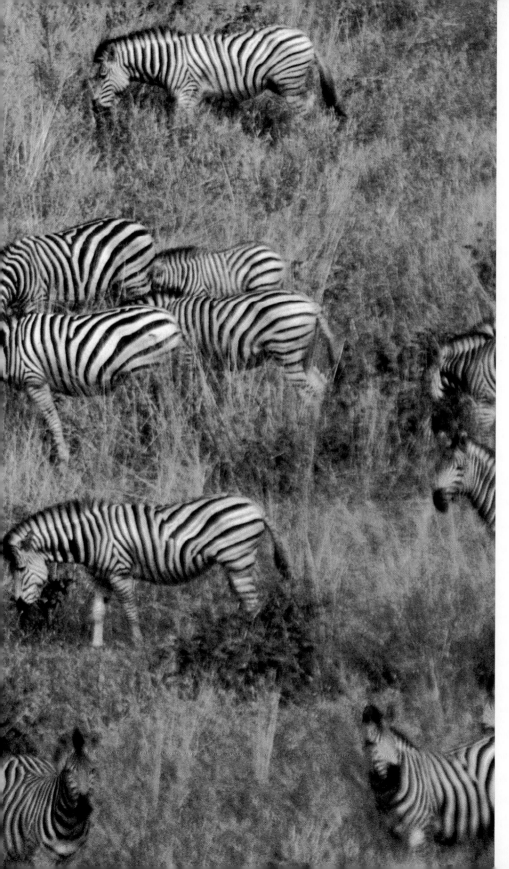

The zebra population has fallen
dramatically in the last ten years.

for tea and for filling hot-water flasks for the night work. Beverly set about preparing food for two meals—midday meal and evening meal. The first we ate as it came off the fire; the second was packed in a flask that kept it warm enough to be eaten eight hours later, or else it was wrapped in foil. The whole operation had to take less than 30 minutes because we usually had another priority. By then the small solar-water bag had heated the 10-liter shower enough to hang it on a suitable tree. We'd take turns soaping down and rinsing off. Frugality was the word for using this precious water. We could both shower full, twice…from 10 liters of water.

There were even times when we didn't have to stop for our midday ritual. I had cut a small plate of tin and molded it to the shape of the exhaust manifold, the pipes that leave the engine block. Using a tiny piece of wire attached to one of the spark-plug leads or any handy contour, we were ready to cook. The foil-wrapped food was placed on the engine exhaust manifold tray, and without losing the lions or zebras or even turning the engine off, we'd start cooking our meal. Driving along, with the engine heat steady (unless we were in thick sand or mud), the meal would cook well. Mainly it was vegetarian fare, but here's one example from a day when we got fresh supplies.

LEMON CHICKEN

Cut chicken in pieces
2 tsp of grated lemon peel
1 tsp black pepper
2 cloves of crushed garlic
¼ cup lemon juice
1 tsp of mustard powder
1 tsp paprika
1 tsp grated fresh ginger
1 tsp thyme
Salt to taste

Place chicken pieces into foil. Mix the spices in the lemon juice and add to the chicken. Fold foil into boat shape and close so juices can't escape; place foil on manifold of truck. Cook slowly for 1½ hours, driving at regular speeds (1½ hours equates to roughly 24 miles at average searching speed). Check the moisture, you might have to add a little water to keep the chicken moist.

And herein lies the secret. Don't let the juices escape. As it happens we often did.... Ours was the best smelling Land Cruiser in the region, possibly in the world. The jackals were constantly raising their heads and noses at the car, sniffing deeply.

Of equal importance for our daily routine was sleep. And for that we did need to stop. At those times, we'd try to steal at least two hours of sleep, with luck more. The fire was covered over completely, any sign of our showering completely hidden, and within the hour we were under shade (hidden from tourists, hopefully) and bedded down. Some days while we slept, our little portable generator charged the batteries we'd use for light at night. It took us a little while to discover that as they were charging, they were letting off a gas that knocked us out cold for hours. We'd wake feeling groggy, not unusual for a daytime nap, but with headaches we couldn't explain.

The long nights gave us new insights into hyena life. One night we watched as members of a pack victimized an orphaned cub.

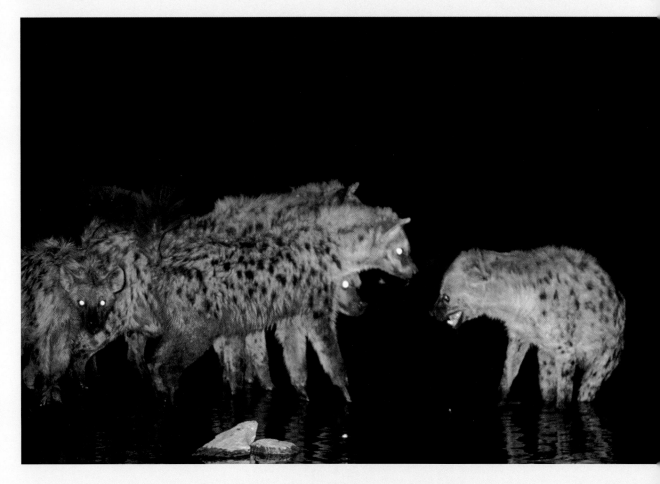

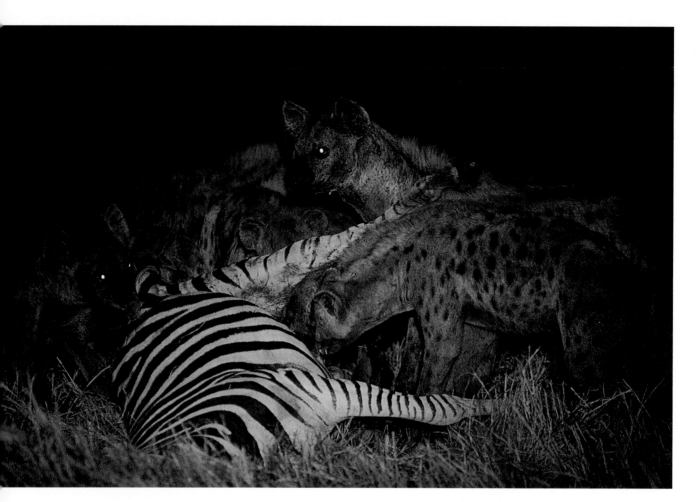

Hyenas feast at a zebra kill.

At night, if we ended up lost or without anything to film, we'd try to steal some more sleep and had yet another ritual: Before crawling into sleeping bags, we'd check the front of the truck for loose ends. As we don't have doors, hyenas can easily poke their heads in, and often do. We don't mind that, but we get grumpy when we hear them making off with our shoes, jackets, or pieces of film gear. Shoes have to go on the roof or dashboard. Light meters get locked away, and jackets serve as sleeping cushions

One cold night Beverly hung her jacket inside next to her head and awoke as it disappeared through the window. She leaped out and managed to grab hold of a sleeve as a young hyena started to run off. Surprised to see this nocturnal apparition chasing after him, the hyena abandoned the jacket and loped off.

APRIL, 12, 1991

Some luck last night. The zebras we were with started to run, but not a panicked run, a loping run. Behind them one hyena was testing the herd. We watched and filmed a little, but probably thought as much about it all as the zebras did. No big deal. But suddenly there were five hyenas and the pace increased. We started to follow, and because I didn't quite know where we were on the marsh, I set the odometer. Nineteen miles later, and with the addition of ten more hyenas, five zebras had been brought down. Hyenas kill zebra, wildebeest, young hippo, and even adult buffalo. Those cute little bearlike cubs quickly turn into killing machines.

APRIL 30, 1991

Damp night, mid-marsh with Maome's pride as they hunted zebra. Migration all but left the Savuté by now, heading north. They made several attempts at killing zebra but these zebra are way too wise now, the foals too fleet-footed. Lions turned to the next prey item, a herd of wildebeest, almost innocent from months of lack of lion attention.

7:30: They attacked a herd in the distance. We could only see one lioness attempt and succeed in bringing down an adult wildebeest. In the confusion we took some time to realize that not all of the pride were present. Then we heard the growls off in the dark. We followed and found another kill and the rest of the pride feeding. Suddenly the night was alive with the calls of hyenas. Hyena eyes bobbed and danced menacingly in every direction, too many for us to count, but an estimate of 40 seems realistic.

Another commotion in the grass.

A hyena had suddenly discovered a dead wildebeest that the lions had abandoned in the confusion of abundance. A gift from the gods. But back at the two lion kills, the hyenas were massing, drumming themselves up into a frenzy.... I've never seen hyenas as aggressive as this. A lion ran in and charged them, changing the dynamics in favor of the lions at this kill, but leaving the second kill vulnerable. The hyenas switched without hesitation to swamp the lions at that kill. Lions scattered everywhere as hyenas viciously bit escaping lions.

Finally, the hyenas coordinated an attack on the main body of lions, a direct confrontation at full speed and aggression. But something changed on the battlefield. The lions seemed to recognize this and abandoned both kills to the hyenas. Strangely, but perhaps because of the intensity of the night-long battle, when the lions left the carcasses, the hyenas paid almost no attention to the prize. They continued to chase after the lions, isolating and attacking them viciously, chasing lions up trees, biting legs and rumps as they went crashing through the branches. Only when they couldn't attack even one last lion did the hyenas return to the kills to eat.

111

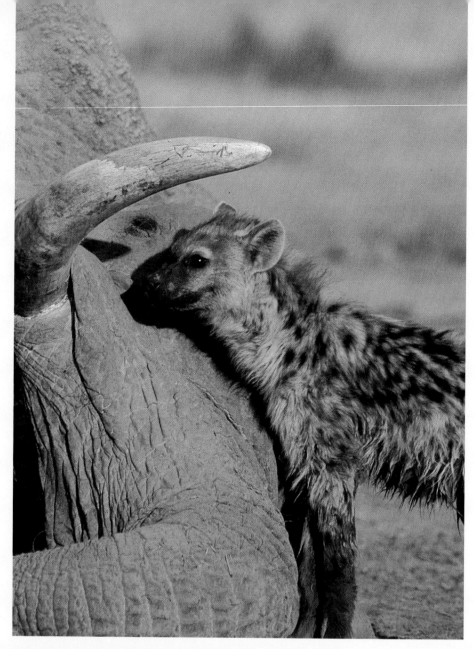

This back and forth went on for hours, the battles becoming more violent as the size of the meat diminished. We found ourselves racing our vehicle back and forth from one kill to the other as the filmable action switched. As we sat there, the night slowed down again when the last of the hyenas gobbled down chunks of meat. Dominant female hyenas ate their fill and left the scraps to the lower-ranking clan members. It was this evening that the title for our next film came to us: *Eternal Enemies: Lions and Hyenas.*

Hyenas and lions are locked in an eternal battle. These are two species that go out of their way to attack one another. The great controversy at the time was if they harbored this antagonism whether food was being fought over or not, as on one night when it seemed that the male lions had simply gone out *looking* for hyenas....

MAY 7, 1992

The two males from Maome's pride set out one night, straight for the hyena dens. At first we thought it was a casually chosen direction, but they seemed determined. Within half an hour, the males had not changed course. They were not running forward as they would if there was a kill, and they were not looking around as if they were simply searching. Instead had this steady and determined pace. They only stopped to mark a bush or tree.

When they arrived in the general area of the hyena dens, they became more alert, looking around, eyes darting from side to side. A sleepy hyena stood up and lowered its head. One of the lion males immediately broke into a charge, chasing the adult male hyena for at least 400 meters. The peace of the night at the dens was shattered as the hyena yelped and other heads lifted from the grass.

Suddenly hyenas were running everywhere and the two lions were lost for choice. Both ran at fleeing individuals and switched to closer, slower hyenas and back again. It was wildly chaotic.

The lions harassed the hyenas for just over an hour, and when it was over the two male lions regrouped, breathing heavily, and walked off again, back from the way we had come. As they gently rubbed heads in acknowledgment, the two lions' bodies shone in the moonlight. One had taken a sliding tumble and had a wet grass stain along the shoulder.

What was that all about?

Well, it was all about eternal enemies.

The film became a big success for us. *Eternal Enemies* won all kinds of awards, from Emmys to the Grand Teton Award at Jackson Hole, Wyoming, in September 1993. Since then we've heard conversations about it in bars and restaurants from Washington to L.A. In New York a bartender knew the film; a singer and drummer in Jackson Hole had all the names of the lions in a small book he kept in his pocket. Kevin Costner, when we were introduced at a party, retold the story of *Eternal Enemies* (perfectly, virtually frame by frame, except he translated the name of one lion as He Who Comes Like Thunder instead of He Who Greets With Fire) to a large circle of friends and admirers. And I've been greeted with: Oh, you did *Eternal Enemies?* Wow, you know I named my dog (cat, even son) after one of the lions in that film. Ntchwaidumela.

A hyena can survive almost anywhere, from the most isolated woodland to the forest of ele-phant legs that crowd a congested water hole. To me, the hyena symbolizes the survivor.

114

The story of *Eternal Enemies* struck a chord in many people's hearts, perhaps because we all see a little of our own struggles in it. We see the eternal struggle between good and evil, light and dark, and we see these forces doing battle *within* us as well as on the streets around us.

MAY 1993

It seems that we may be the only species which has so many opportunities to choose between good and evil, and the only one who chooses so badly.

In 1992, we were offered a site on the Zibadianja Lagoon, a further three-hours drive southwest along the Linyanti River. When we had first moved to Linyanti, we worked in a dense forest; lush, thick reeds everywhere. When the channel dried and we saw the zebra herds on their annual migrations, we decided to follow the winds, the rains, the herds. We moved back and forth between Linyanti and Savuté doing *Eternal Enemies.* This nomadic existence, living out of a vehicle, exposed us to the intensity and feel of being a predator. It also saturated us with death. Some days to escape that we sought refuge among the elephants.

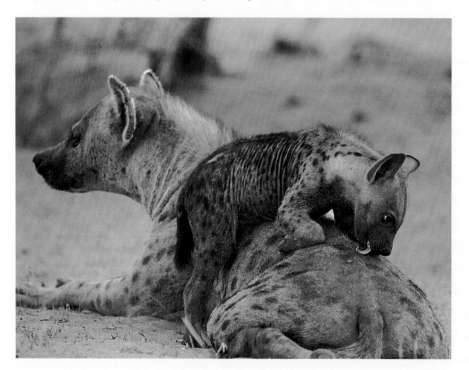

In the unique hierarchy of hyena society, cubs inherit their mother's rank.

Our film work with elephants had begun in 1991 and in a sense grew out of the antithesis of our work with the lions and hyenas. Elephants are meditative, thought provoking, noble, and gentle. They helped to bring balance into our lives. As we looked around at the overhunted wilderness and thought about our battles with hunters and poachers, and the new tourist camps growing like mushrooms after first rains, we began to wonder…. Could we ever find true wilderness again…anyplace in the world? We made some enlightening discoveries.

APRIL 22, 1993

Mike [Slogrove, part-time hunter] has a client with an interesting story, an Italian who is off to Russia after this safari to hunt snow leopards. Our mouths dropped open. Do they still hunt snow leopards? Getting all the info we can about this.

JUNE 15, 1993 • *Kopet Dag Mountains, 12,000 feet, Turkmenistan, (once part of southeastern Russia)*

Asked Vladimir today if he could translate a question to Turkmenistani guides: "We have been up here walking in these mountains for two weeks without a track or any hair; no kills, no fresh scat, in short no sign of a leopard. While it is very nice, can they tell us how they know there are snow leopard here?"

A string of conversation went back and forth, English to Russian, Russian to English: "Says plenty leopard here."

Hmm…. "What do they look like?" Off went the message, then back.

"Cat, like lion but smaller; spots, color like gold."

Gold was *not* the right answer. We were a thousand miles away from the nearest snow leopard. The leopards we were tracking were Asian azur leopards. We had found a real wilderness all right, but we were after snow leopards. So we moved immediately to the next newly independent ex-Soviet state and continued our search. Finally, unsuccessful, exhausted from climbing at high altitude, and a little frustrated by the lack of honesty of all our guides and advisors, we left Russia. Everyone was most polite and friendly, hospitable to a fault, but in their eagerness to be helpful and have us come to work there, they had brushed over the fact that there were no snow leopards. Our Russian adventures didn't end there, though. A little later we stumbled into another project. While we were searching for snow leopards, our Russian cook told us that in the far east of Siberia, he had come across the most remote and wonderful of wildernesses. All we knew of Siberia was that it

was the place that Stalin sent people to die. But our cook had described great
forests, and tigers. So we returned to Siberia the next year.

MARCH 9, 1994 • *Siberia*

*March is supposed to be the worst time to travel here. No wonder we picked it. Siberia beyond the
towns is indeed wonderful (thank you, Vladimir), just getting out to the forests is difficult. We just
completed the journey of a lifetime. We thought the trip from Zibadianja to Kasane was bad. Here
we didn't get stuck, but it still took us 40 hours of straight driving. We were so frozen in the back
of the Russian-made truck that even sitting inside -40° sleeping bags we shivered. Ice forms on the
inside of the windows. It is -27° out here. And we're from Botswana. Help.*

*Stores are empty. One day we found a store with four oranges and two boiled eggs in it, and
our interpreter was so excited, we thought she had won the lottery. Strangely, I love these people.
They are hard as nails, make do on nothing, and still have time for humor. (If you can break
through the language barrier.)*

*A red ball of fire rises every morning from a deep blue sea north of Japan, over a snow-covered
beach where tiger tracks dot a line from the forest to the sea.*

It is a magical place this Siberia. Magical.

*Beverly, unfortunately, doesn't share my passion this time. I think we could do this film.
I've always liked tigers and the Siberian tigers are the biggest in the world. There are less than 200
left, and a film could help save them. That's what we do. Admittedly, it is a bit cold, the food is
bad, when we can get it, and in 12 days we haven't seen one tiger, but if it's easy it's not worth
doing, right? Beverly's case is that to do the kind of films we do, an* Eternal Enemies *with tigers
will take a hundred years.*

She also has a premonition that we will die in this place. Both are inarguable points.

*One thing that bothers both of us is that the Russian professor involved in the captive program
is serious about breeding two siblings, an incestuous relationship that cannot be supported scientif-
ically. It's not something we want to be part of. It also involves captive tigers, and we can't see
that fire in those eyes dim behind a fence.*

Regretfully we have to decline.

We did eventually see tigers in the snow.

MARCH 12, 1994 • *Siberia*

*We went out to find a wounded tiger.... We stepped out into thigh-deep snow and started to walk.
After about an hour I spotted a shape, and we all froze. It was the tiger. As I filmed briefly, those
amber eyes locked with mine. It was just a moment, but perhaps that is why I am so captivated by
this place. If it was just wilderness we seek, this is as wild as it gets. If it is passion, there is none*

*Outfitted to avoid being eaten
by a Siberian tiger, I stepped out
into the snow a long, long way
from Botswana.*

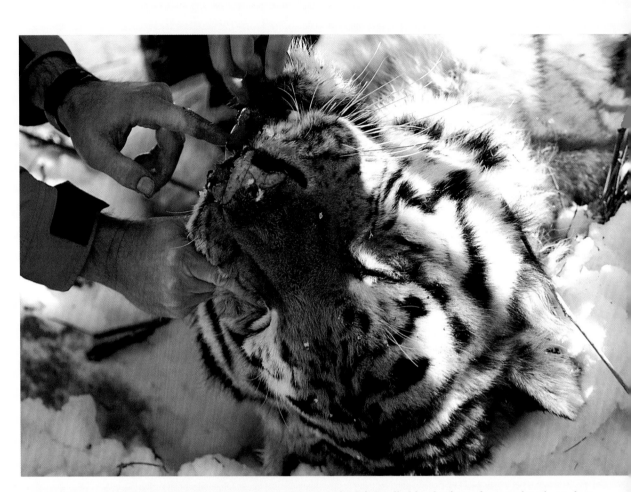

like the look in those burning eyes, a passion for life kindled by the fear of survival perhaps, but a passion for life that will be defended to the last. He leaped up and bounded off into the snow. We followed and didn't catch up for another three hours. At one point sweat had soaked all our clothes and had reached the outer side of our down jackets; my knees wanted to explode from lifting each leg over and over out of three feet of crusted snow.

"Can we dart this animal, treat its wounds?" I asked, then watched the volley of conversation bounce around. Both shoulders were severely wounded. Was I detecting a question of who could do this? (The interpreter was left at the vehicles hours away. I was flying solo here.)

"I will, I can get up close. I can dart and treat it if you like," I volunteered.

I was pushed into white camouflage, either because I was to be the only fool to get close enough or to protect the National Geographic person from getting eaten. It was unclear, but the banter and change of tactic gave me hope.

More confusion, eventually we pushed on, me totally in the dark it seems now, because I thought my proposal had met with general agreement.

Then there was a charge from the tiger and a shot. The first Siberian tiger we saw was dead. A trigger-happy soldier, our escort, was quicker off the mark than expected; the tiger more aggressive than imagined. My long, exhausted "Noooo" came too late.

I later found out that none of the gun bags carried dart guns, and the original intention was probably to shoot the tiger. So much is lost in the translation...add one Siberian tiger to the list.

I mourned that one striped cat as if it was family, even though we have seen scores of lions die, and even though its injuries were definitely too severe for me to fix. It was the shattering of a great hope. We had traveled so far to see and help the Siberian tigers, we had finally succeeded in finding one, and, as we reached out, this fragile jewel slipped from our grasp and shattered at our feet.

Beverly had been right: To do the film we would do on Siberian tigers would take too long—for us and the tigers. They needed a voice right away. She was also nearly right on the second count, about dying in Siberia. Within days I fell ill. In their keenness to get us to work there, the people of Tourney had ignored a quarantine and welcomed us in. The Siberian flu sent my white-blood-cell count so low I couldn't walk to the plane to leave, and Beverly had to negotiate with unwilling Russian officials to let us out of Vladivostok and equally unenthusiastic Japanese officials to let us into Japan. Much of the trip back to Africa was a blur for me; the last clear thing I was conscious of in Russia was a large woman with a mustache saying to Beverly, "You may not leave Russia," and Beverly's counter, "You don't understand, we are going on this plane." We did. We suggested to Geographic that Mark Stouffer, a friend and fellow filmmaker, take on the job. His style was better suited to the shoot. He had done a film in Alaska, so the cold wouldn't phase him; and despite the issues we struggled with, we believed that a film on the plight of the tigers was important.

Mark did take on the project, produced a good film, and spent two seasons in Siberia. We still haven't apologized to him for that.

CHAPTER FIVE

Lost in Paradise

For most travelers on a pilgrimage, the steps taken on the journey are more important than the eventual arrival. Often, once you do arrive, you realize that you've been there a long time already. Beverly and I now felt certain that Africa was our true spiritual homeland. On our return to Africa from Siberia, we continued to seek balance in our lives.

Over the years, between our work with zebras, lions, and hyenas (and our Russia trips), elephants gained an increasing presence in our lives. Elephants are gentle animals that appear to avoid stressful encounters and tend to avoid strangers. Bonds are clear, and greetings seem to be accompanied by affection and kindness. Their lives seem filled with dignity, gentle bearing, and time. Time just to be elephants. We were beginning to spend more time around the elephants—and more time on our next film, *Reflections on Elephants*—when we set up camp in the Zibadianja Lagoon region back in 1992.

MARCH 9, 1992

Zibadianja works perfectly for us. It is remote, it has water, and on any day in almost any direction, you can see some animal. It is like Ngorongoro Crater [Tanzania]. Elephants use our little island every night; lions come by every second day, at least; zebra, letchwe, hippos, cheetah, sable antelope, impala, and loads of other animals are a daily occurrence right in front of camp. Paradise!

At Zibadianja, the habitat *was* like paradise. Often when Beverly and I would wake up and drive out into the surrounding game-filled floodplain, or into the magic-hour light as it caressed the land, I'd feel the breath catch in my throat. I couldn't stop myself from uttering from time to time, "Wow, this place is like—" and Beverly would cut in, "like paradise?..." Amid this paradise, lost in paradise began to take on new meaning. It was here we discovered that there is only one species that slaughters for sport....

Left: Armed and ready for contact, soldiers of the BDF (Botswana Defense Force) hunt down poachers.

Next pages: Letchwe crash through the shallow waters of a Zibadianja swampland also favored by poachers, who can virtually disappear in the miles of marshes .

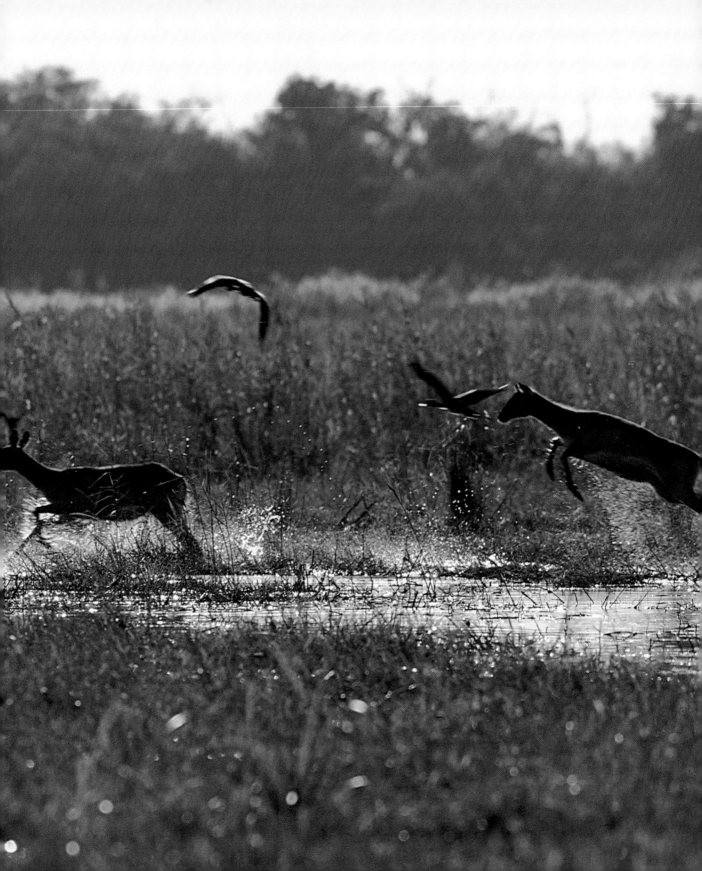

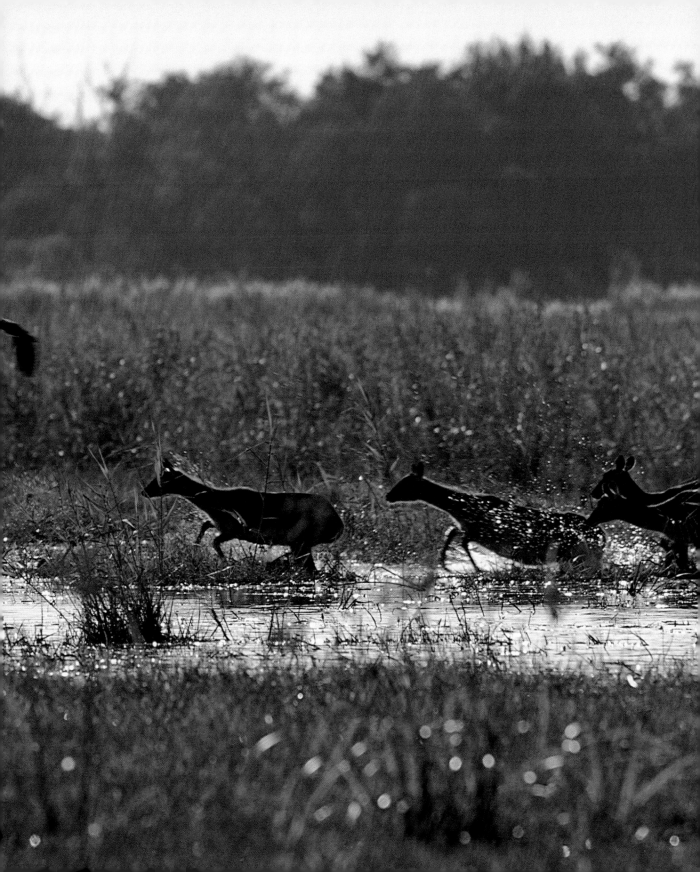

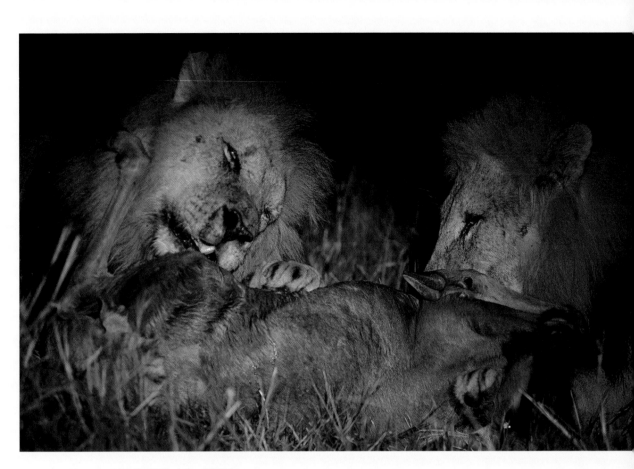

MARCH 15, 1992

Tonight we heard lions and followed. Calls led us into the reeds, at night impossible to gauge their depth. Pushed on and found ourselves getting closer to the lions but deeper into the towering reeds. Suddenly we collapsed into a stream that was completely hidden. Front wheels were completely buried and at least three feet off the bottom of the hole. Nothing to winch onto here, so we pulled off both spare wheels and dug them into the hole to give grip. As we were busy, Beverly heard a rustle in the reeds. The young males from the camp pride popped their heads out about a foot from the side of the truck. One took off as he saw us, but the others were intensely interested in our noisy labors so we had to retreat to the vehicle for a few minutes, let him sniff around our tires, then carry on once he stepped away. Noise often attracts lions.

The three young males started to frequent our camp, and we got to know them really well. They started to use the single solar panel in our camp as a meeting place, turning their tails and spraying it as a marker. We didn't mind, it kept the dust down! Often when we heard the males coming in from different directions, we waited at the solar panel for them to appear: Nine times out of ten we weren't disappointed.

One day, as we sat on the floodplain not far from our camp, we watched one of the males come over the ridge. He was making an eerie call, one I hadn't heard in a long time. Sadly, our thoughts were confirmed. We learned that his two brothers had been shot that week. Within a few days the lone male was in our camp and our hearts nearly broke as he walked up to the solar panel and smelled for any fresh sign of his brothers' markings. He turned and looked at us as if we were hiding them. He again called mournfully and turned to spray the panel. It was the last time we saw him.

The next day we ran into some hunters. We stopped on the track to let them pass, but the American hunter couldn't contain himself: "Howdy. Ya seen the big cat I got? Real bute. Caught him sleeping." We looked at the mess of blood and blond mane in the back of the pick-up and declined the offer to take a closer look.

These male lions in the Zibadianja pride had the closest bond we'd seen in years.

Old friend John Benn arrived one day to see how we had settled in.

"Where are your staff?"

"John, we don't do that old white colonial, servant–master stuff. You should know that."

He looked at us and said, "Ra de Tau, it may be time for you to start contributing to our community, time for you to be Ra of another kind."

He was using my Setswana name, sometimes used in admiration, sometimes not, depending on where you stood. Ra, meaning "father," de Tau meaning "of the lions." Largely it meant the "one who takes care of the lions." John was suggesting that we cared more for lions than we did for people: "A lot of people in our villages don't have work, you know."

It was clearly time for us to hire staff, whether we needed them or not, whether we felt comfortable with that or not. Once again we agonized over it. Is it right, will it steal our freedom and the feeling of wilderness? Is it too domesticated?… We shouldn't have worried so.

MAY 20, 1992

Nyepi was recommended by Ryland Wallace, who supplies the hunters around here. We have taken it upon ourselves to understand what the local community thinks. If Nyepi is representative of that community, they **hate** *wildlife.*

The lions came to camp on his third night. I asked Beverly if she thought Nyepi would like to go out and see the lions.

"I'm sure he would love that."

I went to his tent and said in my best Setswana, "Nyepi, do you want to come with me to see the lions?"

The reply came back immediately. "No."

I thought I hadn't said it understandably: "No? I'm offering to take you out to see the lions."

The reply: "No. I don't want to see the lions. I can hear them. That's enough."

Nyepi, this is special."

"Yes-thank-you-goodnight."

"Nyepi, get in the car."

We went out, and I noticed that the old man was completely terrified. I tried to make him feel comfortable by driving around the lions so they were on my side. He gripped the dashboard so hard I thought he would dent it. And these were *sleeping* lions.

Finally a male looked up at us and yawned. It was enough to start old Nyepi shaking. I could feel it through the steering wheel.

"Can we go back now, sir?"

I looked at him and said, "Okay, Nyepi. On one condition. You never call me 'sir' again."

SEPTEMBER 1992 • *Zibadianja*

It's getting to the point where we realize that by working with these lions we are doing them a disservice. We find totally wild, scared lions and calm them down by our presence, sometimes spending 24-hour stretches with them until they accept humans. Then, not only do we make it easier for the hunters to shoot them, but, as we found out today, Nyepi is telling hunters exactly where to find them. I fear that we have failed to impart our feelings about wildlife to Nyepi.

Nyepi was leaving messages for hunters about where we were finding the lions. Hunters were simply collecting the latest information and going off in the direction of our last lion sighting. It was disturbing to discover Nyepi's ambiguous loyalty. Only later did we find out that years before a leopard had fallen through the roof of his house, and he had spent the night and next day huddled in a corner. No wonder he wasn't happy living as we did. Old Nyepi soon told us he wanted to retire. We felt like we had failed him in some way. Later after talking with our hunter friends, many of whom we had known for ten years or more, they promised to avoid the male lions that were obviously from around our camp.

SEPTEMBER 15, 1992

Pretty much at our wits end about these lions. Today Darryl came into camp. We gave him and his

128

The excessive hunting of lions here took its toll. Deaths of males destabilized the region, and we started coming across more and more dead. Most were killed by new males or passing nomads.

American clients some tea. As we had tea, Darryl and the client saw lion tracks around our fire and started tracking them RIGHT THROUGH OUR CAMP! Is there no shame? They raced off in the direction of the tracks in a cloud of dust. A few minutes later I heard a grunt behind camp as one of the males woke up within a few feet of the tent. He slowly walked out of camp and across the road and off across the open area behind us. I knew what would happen if the hunters saw these tracks, so with a few branches tied to my feet I walked out behind him. He looked back at me and headed for the forest. This is ridiculous, probably not even legal, certainly pretty crazy. Our noninterference policy just went out the window. No more lion work.

JULY 1992 • *Selinda area, Zibadianja*

We returned to hear that in our absence one of "our friends" brutally shot one of the males, at night...right in front of our camp. He drove the lions into a reed bed and blasted away at any move-ment or noise in the reeds, not knowing (one hopes) that the females have cubs in that exact spot.

We at last fulfilled our dream to remove all lion collars from the Savuté lions. But old Maome started waking up before I was out of the way.

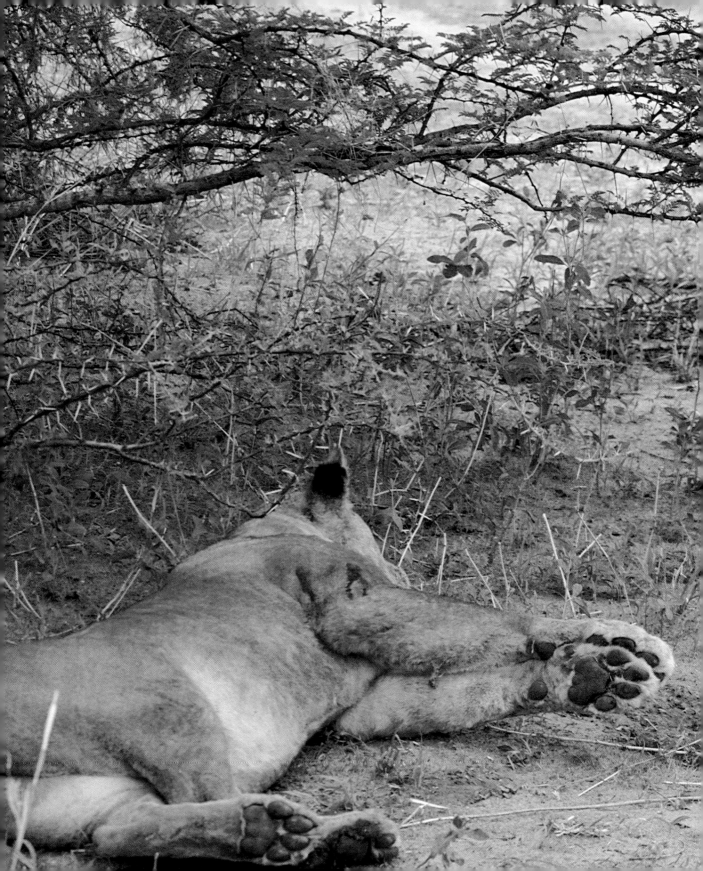

A week later we watched as one of the pride lionesses walked away with the carcass of one of her cubs in her mouth. She wouldn't let us near, but we could tell that the cub had been dead about a week.

> *If this continues, I fear Botswana will be left without animals...and ethics. The gene pool is obviously being depleted and these hunters are pushing the system too hard. They know it. An incident like the lion hunt last week is indicative. He (the hunter) has apologized, in a way, but why is it so difficult for hunters to be ethical?... Something has to be done.*

During this time we got the offer to buy back all the film we had originally shot for the Chobe Lion Research Institute. We had accumulated lion footage over six hard years (1981-1987) and knew there would be little we'd have to add. We were back in the lion business!

In Savuté the lion research had all but stopped; as with many places where scientists do their research, when the funding ends and the PhDs are awarded, many collared animals remain. The collaring of lions is a controversial research method at best, but in a tourist area like Savuté, it really ruins the atmosphere of the experience. It is an ongoing argument between researchers and tour operators, both with their own self interest; of course, both valid in their own way. But to see this wild predator stalking through the grass with a collar on does something to my soul. It hurts at a level where something inside me wants life to be forever free and wild, untamed and untouched. Beverly and I often talked about what effect the collars had on individuals. Were they like weird growths to the lions, or did the collars feel like small dark manes, perhaps elevating their status? We were determined to remove all the old collars at our own cost.

Three male lions together, masters of the night.

When we got back to Savuté, we found Maome under a thorn bush. Maome had been burdened long enough. With the help of Mark Van de Walle, we made up a mixture right for a lioness of about 320 pounds and darted her. Darted lions often look at the ground or other lions as the source of the attack. Maome eerily looked right at us, then slowly fell under the drug's spell.

But Maome was a big girl, and she never fully went under. We had all been peripherally involved in darting over the years, and a half-doped lion is never a safe thing to be around; but Maome was so accepting of us even when awake, I decided to risk it.

Within a few minutes, with Beverly and Mark watching out for the other lions nearby, the old lioness was free of her growth. As I crept away she growled at me semilucidly. I wonder if her life changed. I know ours did.

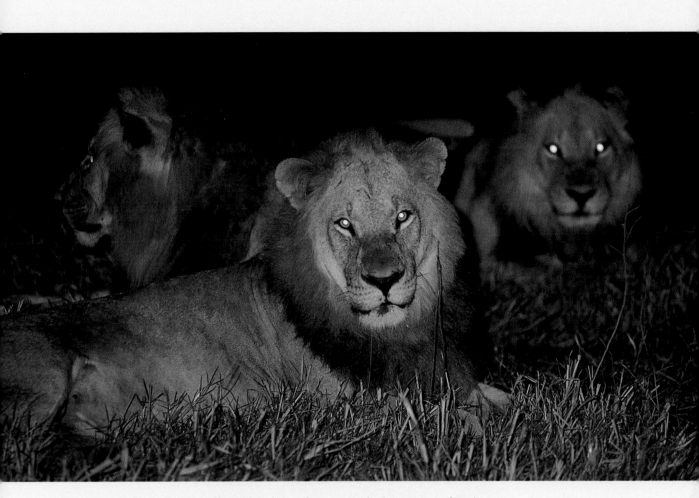

When we finally pulled together old and new footage, we had our *Lions of Darkness*. It told the story of three male lions—Tsididi, Tona, and Nyatsi—who came into Savuté in the early 1980s and ruled the entire area. These lions dominated the three largest prides of females and left behind an unknown number of cubs in the system. Known by the tourists and operators as the "Beach Boys" (for a reason we never understood—two had dark manes), these lions were the most magnificent we've known. They worked together like a real team, were often affectionate—rolling over on each other in tender greeting gestures—in ways that we have not seen in male lions before or since. They were clearly related and so attuned to one another that even when separated, their ears knew where the others were.... You could tell.

AN EARLY 1983 JOURNAL ENTRY READS:

Astounding lion sighting tonight. Sitting with Tona, the most blond male of the three. He was alone but turned his head slightly north listening as a distant roar echoed through the night.

He had a casual face—eyes half-closed, ears relaxed—then lazily roared a reply. As he finished, he shifted position and looked out east, ears up and attentive, waiting. After a minute or two the third male decided to let us all know his position. As the call started, Tona relaxed again. It seemed as though he knew exactly where the third male was, and, when it was confirmed, he could relax.

After a while we too could hear them and knew the individual lion's calls. As they got older, their voices changed, but their calls were still distinctive, even to us.

Returning to Savuté almost nine years later, we searched for Tona, but he was nowhere to be found. We searched beyond the park and asked hunters. One story we were told was very disturbing: a hunter tossed a pebble at one of the males to wake him…just to shoot him! Other hunters gleefully admitted to us that they had shot one of the Beach Boys. In fact more hunters claimed to have shot a Beach Boy than there were Beach Boys (five claims and only three lions)! One was shot within feet of the national park boundary as he ran for protection across the track. Finally, only Nyatsi remained; Tona and his brother were dead.

Hunters and poachers light massive fires each year to flush out animals, burn the tall grass that hides game, and generally make it easier to kill wildlife.

134

Nyatsi came back to the old territory, calling the familiar short roar of his. He walked Savuté from top to bottom, smelling markings and rubbing his regular marking bushes.

Every ten minutes he stopped and looked off into the distance and called. Through the night his calls grew softer, more cublike. We sat at the sand ridge and listened to the male grunting into the night, powerless to do anything. Even if we darted Nyatsi, he would eventually go in search of his brothers and find his way into the hunting concession. It was a sad farewell.

Sometime after *Lions of Darkness* was finished, we presented our film to Botswana's President—Sir Ketumile-Masire. He watched intently and then asked Beverly where the three males were now. She was too polite to respond, so I stepped in and said they had been systematically, but quite legally, shot. A few months later, lion hunting was restricted, limited to just a few a year. It has taken hunters six years of lobbying to try to overthrow this decision, and each year they gain more strength. Now they have hired private researchers to come up with results that say there are more lions in Botswana than you could shake a stick at, which would increase hunting of lions again. In the game of conservation, small victories are often offset by waves of old thinking dragging the process backward again.

With this turn we were aiming for a head-on collision with the hunting industry in Botswana. It was not a battle we were unprepared for. We had lived in the hunting areas and watched as our hunter "friends" blatantly shot undersized animals from vehicles, within the parks, on illegal baits, with the use of fire or diesel, without licenses or ethics. It was a slow, sad rot of our confidence in the hunters. At first we tried to separate the good from the bad but found our efforts disappointing. Something had to break…. It was nearly us.

At first hunters tried to talk us out of our position. Then, when they couldn't meet the challenge to control themselves, and we asked for government control, they threatened us. They had clients write to the National Geographic Society, hoping to have the Society reign us in. When that didn't work, they had a "bird hunt" near our camp, firing over 200 shots above and into our camp. By now we had invested in a small aircraft, mainly to search for elephants and good elephant spots. One day we went over to the plane and saw strange tire tracks at the plane. We make a habit of identifying everyone's tire treads, a basic survival technique. Hunters had been there. I checked the plane extra carefully that day…and found cut brake pipes and fuel drained from the plane. But I had learned from the best…Lloyd Wilmot! A couple of cans of car fuel saw me to Kasane safely. The landing at Maun airport was interesting, but we were back up and running within hours.

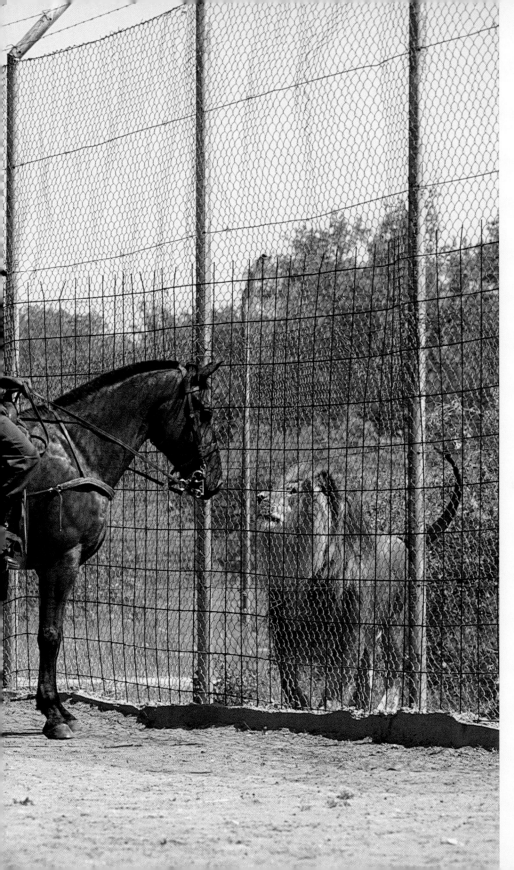

The BDF horse patrols diligently train their mounts to accept the scent of lions, so the horses won't get spooked in the wild.

Years later I walked into a bar to get a sandwich before flying back to camp. It was between hunting seasons. A hunter came up to me and offered me a drink and said, "You know I don't do all that illegal stuff anymore. A few fires maybe but not the big stuff."

"Oh?" I said suspiciously.

"Yeah, you know I never know when Dereck and Beverly Joubert will be behind some bush filming me, I better be clean."

I touched him on the shoulder and said, "If that's your best reason to be clean, I'm sorry for us all."

Since then a law was passed that hunters must have a government game scout on every hunt. One of the problems with writing all this down, though, is that it seems like we crusaded and did it all ourselves. But we were part of a new wave of eyes watching what was happening to the wildlife—and a new wave of change that had already begun in Botswana.

MAY 13, 1991 • *Chobe National Park*

It was already a hot day when we started at 7 a.m. driving north along the western boundary of the park. Gavin Blaire from Lloyd's Camp drove in ahead of us for a while. The grass seeds were fierce, and within an hour we had to stop to clean out the radiators before they got completely blocked and had to be pulled out. As we stopped, Gavin closed his door and I swung around.

"What was that?"

"My door."

"No, out there."

Beverly was looking east as well and confirmed that she had heard something. Then we all heard it—another gunshot, then another. Although we were standing right on the boundary between the protected land of the Chobe National Park and the hunting concession, we were in a moral gray zone. If a hunter had wounded an animal just inside the concession, it was law that he had to follow up and kill the animal; yet if he shot it within the park, he was clearly illegal. But there was also something else wrong with this today....

Beverly rigged up her sound equipment to listen for voices, vehicles, any sign of who had fired those three shots within the park.

"Let's go in.... What have you got by way of something to defend yourself?" Gavin shook his head. I took my hand ax, slipped it into my belt, and started to walk with the parting instruction to Beverly that if we were not back in half an hour to go...get help...don't stop for anything if we're not out exactly on time.

138

We walked in for 20 minutes as silently as I have ever walked in the bush. We came across tracks and followed, but as the bush got thicker the hair on the back of my neck started to stand on end. It was just too damned quiet. If hunters or any shooter had shot and missed, there would have been talking. If it was a kill, there would have been movement, skinning, talking. A wounded animal would have bellowed, and the hunters would be running after it noisily. No, something was wrong here. I looked over at Gavin and could see the tension in his face. (I remember now how different the bush is when you know there is another person out there, another armed person whose intentions you don't know.) Finally we both climbed trees and scanned ahead. Nothing, just a sea of silent bush. I looked at my watch and pointed to Gavin, thinking of Beverly waiting back at the trucks. I marked the tree and silently we crept back to the boundary.

We started up and, after marking the road and taking a compass bearing, raced for the Savuté Channel. An hour later (record time), we skidded into Lloyd's Camp, pulled him out of a hole he was digging, and hustled him into a plane. Gavin commandeered a second plane. We took off, found our marker, and flew the compass heading. Within sight of the road we found it: a dead black rhino. I couldn't believe it. Didn't even know we had any black rhino left in Botswana....

We radioed General Ian Khama, the commander of the Botswana Defense Force, and within a few hours we had a platoon of 8 men and another of 32 standing by.

As we flew around, cursing...we searched for the poachers. Within a few miles we came across a dead elephant, then another and two more. We also found where the poachers had been living within the park.

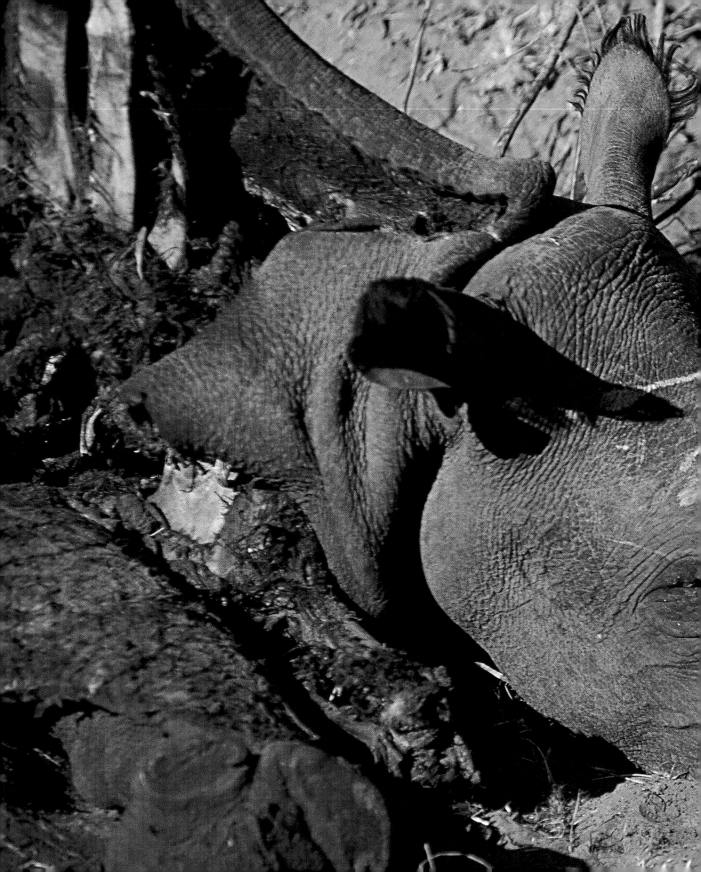

Within minutes they had taken their prize, the horn of probably the last black rhino in Botswana, shot within a half a mile of us one crisp May morning.

On the ground we lead the soldiers to the rhino. It was an efficient operation: ears off, an L-shaped cut in the abdomen to extract the pancreas, horn gone, all valuable on the black market. Rhino horns were then valued at $5,000 a piece.

As I looked around at the tracks, I leaned against a tree and surveyed the carcass. I chose a boscia tree for my vantage point. Suddenly, I went cold. My hand was resting on the small notch I had put there a few hours before. Poachers had probably been aiming well-used AK-47s in our direction.

It was only later that we discovered the secret to the poachers stealth and silence, why we had so much difficulty finding them. Poachers would cut off the soles from the bottoms of elephant's feet, string them, and wear them wrapped around their own feet like sandals as they tracked and poached the animals. We seldom saw a human footprint.

We now knew that the notorious poaching in East African countries was on our doorstep, and it was going on under our noses. General Khama took to the task admirably. He suggested to President Ketumile-Masire that his soldiers could do double-duty in training under real bush conditions while at the same time performing antipoaching patrols. He would then motivate the troops to *want* to combat poachers. Suddenly the military, the B.D.F., were on our side, and up to 800 men at a time were engaged on the right side of conservation. Poachers were hunted down and arrested.

It was also the start of a new way of life for us. Ian arrived in camp one day and suggested that we do a film on poaching and the antipoaching effort. This was a good film idea, but we wondered, could it be done fairly? Could it be done without seeming like patriotic propaganda, and, on the other hand, could we look at this from the poachers' point of view as well?

Elephant skulls, the deadly debris of poachers, started littering the bush before we realized what was happening.

AUGUST 1993 • *Tuli*

Out on patrol last night we were about to go into ambush at 5 p.m. when suddenly a soldier looked back at me and signaled a sign I haven't seen in 15 years. It was military for "five enemy approaching." I turned and tossed a pebble onto the nearest soldier and repeated the signal, but looking at Beverly I couldn't communicate exactly what was happening. She looked at me quizzically. I had to motion her to sit low. With the Nagra sound recorder on her lap that was difficult, and I watched her double over as much as possible.

The poachers walked right past us in a relaxed fashion in broad daylight.... Suddenly one stopped and crouched down, shading his eyes against the light...looking right at Beverly.

Once the force of the military was thrown at the poaching problem, choppers would arrive from the sky and pick us up, then take us off for an hour or a week...we'd never know in advance. Eventually, we got a message from the poachers saying they thought we were leading the soldiers to them, and they would be coming for us.

She was busted. Almost not believing his eyes, he stepped forward and then must have made out the shape of a soldier. On the word "Halt," he headed for the hills.

A few minutes later he and his companions were tied up on the ground.

JUNE 13, 1994 • *Zibadianja*

A quiet morning turned into a scramble as the now familiar sounds of a distant BDF helicopter chopped away above. By now the staff know what this means. Kelikele ran for the kitchen tent and without prompting stuffed a day's supplies into a knapsack. Galebose [another staff member] came to us, looking for ways to help with camera gear. The gear we use for filming wildlife was much too heavy and elaborate, so Beverly and I stripped the cameras and sound elements to bare minimum. Two extra rolls of film, camera body, extra magazine, one lens, no filters, no support for lens or camera, jacket filled with water bottles, knife, still camera with zoom lens and wide angle, 10 rolls of film, sound tapes, Nagra sound recorder, toothbrush each.

Galebose ran the backpack of gear, minus camera, out of camp and came back for the food bag from Kelikele. By the time the chopper landed, we were ready to throw gear on board and fly. Looking back at our waving dustblown and rather excited staff (no one knew if this would be for an hour or ten days), I thought, 'What is it about helicopters?' Every time I take off, looking out of the open door, dust blowing...I feel drugged, a player in a world I once wanted desperately to forget, yet never could.

Once inside we were usually given military coveralls and a briefing by the officer in charge, usually a captain that we by now knew well.

Within a few hours we were in the poachers' camp, a camp so well used that they were living next to an igloo-size mountain of stripped meat. At this camp the "shoot to kill" as opposed to "shoot on sight" policy was tested. In Zimbabwe and some other heavily poached regions, the antipoaching units shoot on sight anyone who is seen in the area. In one region of Zimbabwe, they even used helicopters to fly along the Zambezi and randomly blast gunfire into the riverine bush. In Botswana, the softer approach is to call for the poacher to "Halt…. Put down your guns." Then if they are not armed and still try to escape, soldiers give chase and capture without gunfire. At this camp, however, one poacher put down his rifle as another raised his and tried to get off a shot in the direction of the hidden soldier's voice. He was shot and the action erupted, with two other poachers diving for guns again.

Although disgusted by the damage these men had caused to our wildlife, we looked into their faces, now slowly losing body oils in the sun. Who were they before? What brought them to do what is obviously an illegal and high-risk job? Did they have families?… And yet something has to be done. It is harsh justice. I am left with the highest admiration for these soldiers. Not only are we all safe, but they moved in like cats, then gave the poachers every chance to surrender peacefully.

We filmed what we needed to. At some point I noticed that Beverly was photographing everything but the dead men. It is hard but it is our job now…. "Just doesn't seem right yet," she said, "not until their souls leave."

Their souls did eventually leave and so did their bodies, in our helicopter with Beverly and I sitting next to them—me with my foot, as respectfully as possible, against one to prevent him from falling on us.

What has this struggle for nature become? When one man kills another to save a leopard, a sitatunga, and an elephant?

Arrests mounted up.

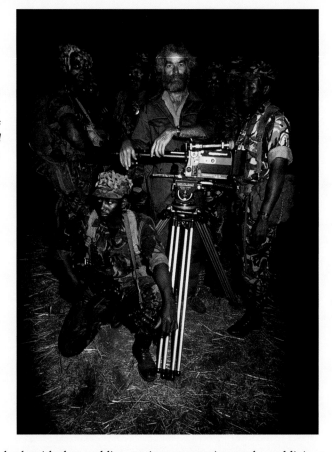

Our lives changed once again.
Wearing military fatigues,
we became mercenaries
working to show the world
what was happening.

We spent weeks in the bush with these soldiers, eating army ration packs and living the life of only slightly privileged army officers. We walked the whole night without light and had to be totally still in ambush positions. This meant that after 5 p.m. in the afternoon, we were not able to move or stop to urinate until 7 or 8 o'clock in the morning, which meant we would stop drinking water sometime after mid-afternoon. The strain on our kidneys was extreme with this low-water diet. To help a little with the dehydration and to cool off in the August heat, we had the luxury of our first bush bath. The army does it in style: a team of soldiers arrived at our tent one day and offloaded a cut-off 44-gallon drum, which, if one is careful of the cut edges and the placement of body parts, makes a very good bathtub.

In one month, we were able to catch 27 poachers. Our black rhinos were extinct, though; and we didn't know what damage there was to the white rhino. The only real way to find out was to search for them and maybe even remove them from the wild altogether. A major operation was mounted to relocate the remaining white rhinos to a sanctuary set up in Serowe (the Khama Rhino Sanctuary). After four years, poaching rings were broken up and poaching dropped off significantly.

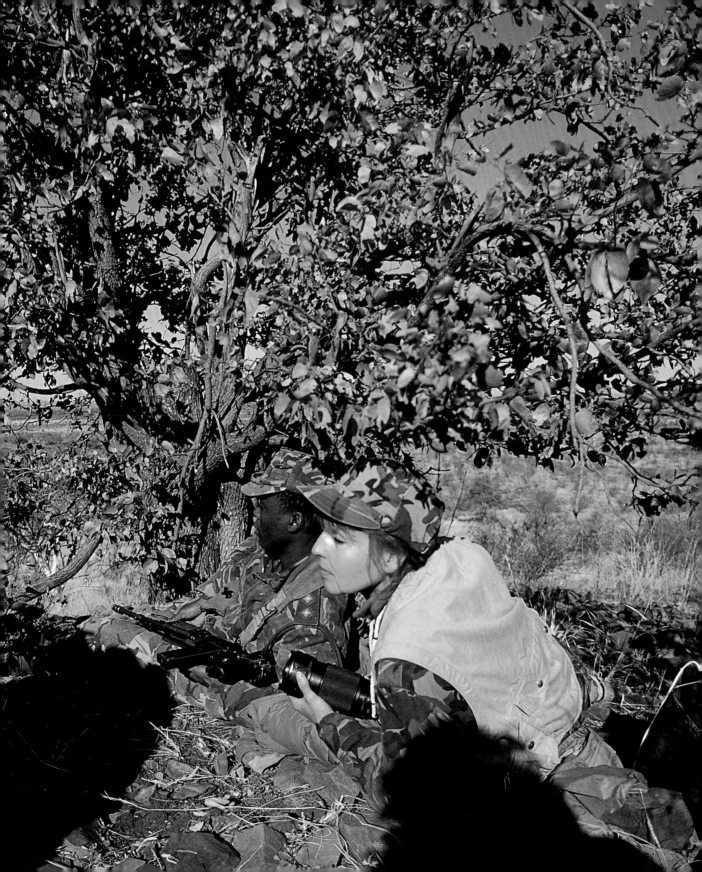

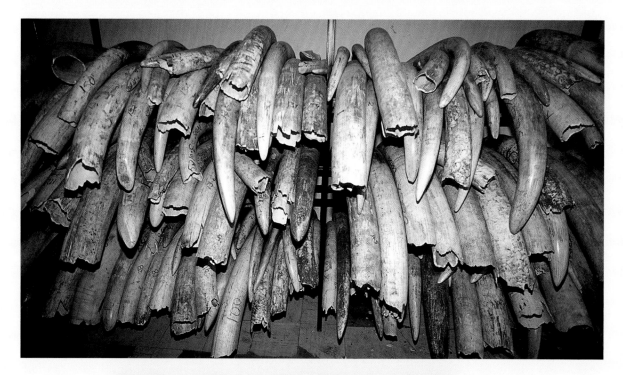

Above: A secret cache of 11 tons of ivory confiscated in Botswana.

Left: Stilled feet of a man who was once a poacher.

Following a stint at the Geographic in Washington, D.C., in 1994 to edit the film, we presented *Wildlife Warriors* to President Masire and a gathering of ministers and policymakers in Botswana. The effect was astounding. One and all came up to us and said how much they had learned about their soldiers. The antipoaching effort was financed indefinitely, only partly because of the film, mostly because it was the right thing to do. The result is a country with almost no poaching... and soldiers who know what it is like to work in the bush. It has also created a military force that cares on an individual level for wildlife and the national heritage. It is the beginning.

The images of these atrocities are indelible. Animal flesh and stomach linings, lion hides and teeth, elephant meat and tusks—piled high, an abattoir mid-forest. We've seen animals languish and struggle to survive, for the rest of their lives, with the wounds they have received from both hunters and poachers. One elephant we filmed had his trunk nearly shredded by a snare. He could hardly provide himself with enough water during dry season and became more and more dehydrated. The precious liquid spilled from the puncture wounds as he raised his water-filled trunk to his mouth. In Tuli, similarly snared elephants have lost their trunks and other herd members care for them by passing branches of food, an indication of the capacities and awareness of elephants. It is also an indication that sometimes despite human encroachments, animals will survive.

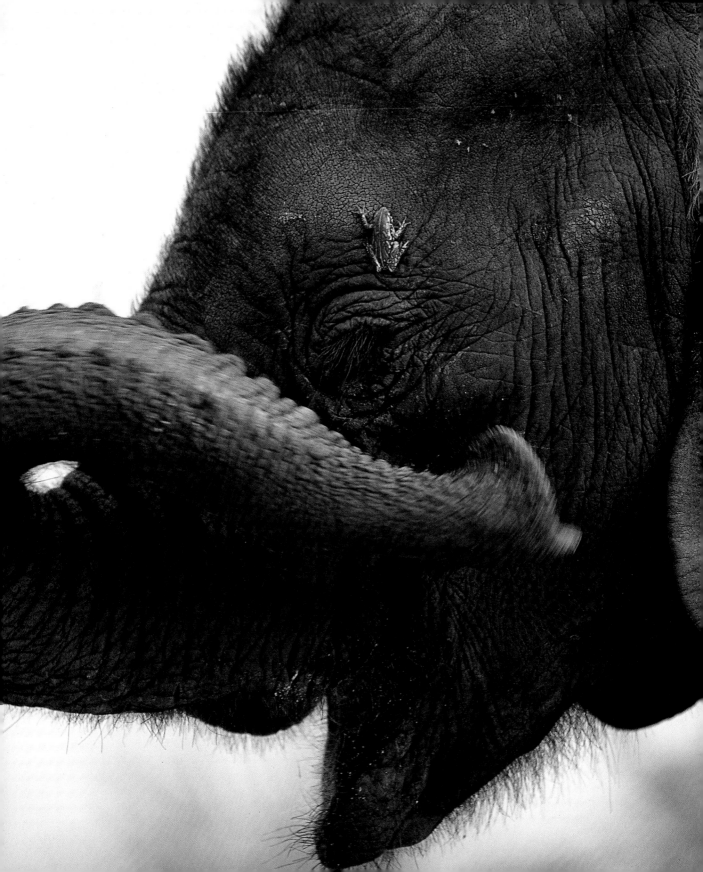

CHAPTER SIX

The Tales Elephants Tell...

We stayed in Zibadianja from 1992 until we officially dropped the camp in early 2000. From there and from our fly camp in Savuté, we produced, filmed, and wrote *Reflections on Elephants, Lions of Darkness, Wildlife Warriors,* and wrote our first book with National Geographic, *Hunting with the Moon.* It was a productive place. It was also during this time that our lives turned off one path and onto another...on second thought, this was simply the same path, but it wound through totally unfamiliar territory, telling a story in an entirely new way. And, oddly, it was a story that began a long time ago, conceived in our heads back in Savuté in 1986 when we were attacked by an elephant protecting her newborn. *Whispers: An Elephant's Tale* tells a story from a little elephant's point of view, a story that has been nourished over all the years of our living and working with elephants. The accumulation of our experiences with them has provided us with many insights into just how complex their personalities are.

MAY 3, 1986 • *Savuté*

While writing the diary today at the water hole, a huge trunk snaked its way into the truck and stole my pencil.

At the same time, Beverly's peace was interrupted when an elephant head came up behind her and reached for her water bottle. She snatched it away, and the trunk slithered through the roof hatch. When he couldn't get to the water, he seemed content simply to rest his head on the back of our truck. Problem was, all of Beverly's camera equipment was also up there, under his head.

Now **no one,** *and I mean* **no one** *messes with Beverly's camera gear! She jumped up and confronted the bull with little effect, so she slapped him on the trunk. Startled, the old bull backed off. Problem was that Beverly hadn't anticipated that an elephant's trunk is slightly harder than a brick wall. Her hand and wrist ached for days...but she saved her cameras and taught that old bull a lesson.... Well, maybe not.*

"Is there a frog on my face?"

151

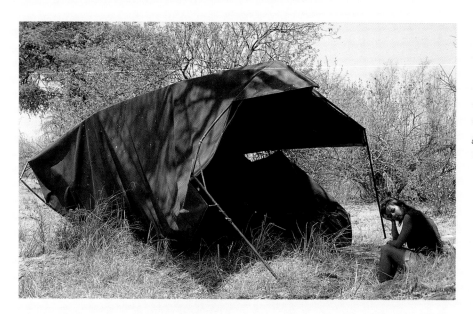

When an elephant ambled through our tent, we lost every-thing and spent the next year in a grass hut until we could afford a new tent. It was a good year.

The old bull was in fact one that tourists were starting to call "Baby Huey." They enjoyed the fact that he would calmly approach and even take offered fruit. This old bull became very tame around people, in and out of camps and around passing tourists. But park officials started to get worried about "an incident."

> *This morning we arrived back in camp to a tent that was...well, best described as not there. As we drove up, a bull elephant sauntered off into the bush, pretty much over the crumpled mess of can- vas that was once our tent. Beverly gave a gasp. She had been sprouting some fresh organic sprouts that required half a glass of water to keep going. The elephant had probably smelled the water and tried to get to it, bundling the tent into a twisted ball in the process. We don't have another tent, so I guess we have been told that we don't need one.*

Officials arrived that day while we were trying to extract our spare lenses and bits and pieces from the ex-tent. The scene caused great excitement.

"Was it Baby Huey?"

I looked through the window at the underused .458 elephant gun and the gleaming eye of the young game scout.

"No, it wasn't. This one had a lump near the tail." (It had.)

With obvious disappointment they drove off, leaving us to our problems.

Over the next few days we built a grass and reed shelter, reminiscent of the old camp where Elfaas Mbongela and his wife were attacked by the lioness. We lived in this shelter (and our car) for a little over a year. The grass roof kept us dry most of the time, although because it was open on one side, the free flow of wildlife and bat urine was a bigger problem than rain most of the time. It mostly kept other animals out, too, besides the genet cat, a civet, baboons, vervet monkeys, leopards,

and, one day, a hyena that climbed into our film fridge and escaped with rolls of precious undeveloped negatives.

One very tired night, we lay in our hut listening to a hyena crunching a very expensive light meter in the dark after our efforts to stop him from raiding our truck had failed.

APRIL 19, 1989 • *Savuté*

Today we went past the Savuté public camp and saw Huey sneak up on a party of tourists. We were on the opposite side of the channel and couldn't warn them that this invigorating close communion with nature was going to go bad.

Huey scattered the group with a happy flick of his trunk and scoffed all of their breakfast, which by tourist standards looked lavish, but to Huey was a disgrace. He expressed as much and marched up to a trailer. The door was closed, but Huey seems to have mastered horizontal doors. He peeled the lid off this strange can and started to go though the backpacks. Someone had been holding out and Huey sashayed off with the backpack flung over his right shoulder.

His days were numbered. No matter how much we tried to protect him, from then on we knew the day would come when he would take apart the wrong Toyota Land Cruiser, a popular vehicle for safari and government use alike.

That day came. Baby Huey, innocent of any crime but that of developing too close a relationship with man, was shot one overcast afternoon by a hunter.

SEPTEMBER 10, 1992 • *Chobe River*

Today we came about as close to an elephant as anyone ever has. It was around sunset and the breeding herds were coming down to drink. One small group chose a little mud wallow near the road to Kasane, and all piled in for a good mud bath. We filmed a little but the light was bad.

Suddenly a government vehicle drove up behind us, saw the elephants, and panicked. Many of these civil servants are terrified of the bush.... When the driver saw the elephants, he screamed and floored it, leaving skid marks, us, and a herd of panicking elephants in his dust. As the dust cleared and the white car disappeared, we noticed that the herd was still unsettled. A huge female came charging right at us. When we didn't respond, she hit the front of the truck, but the bush bar prevented any real damage. Instead of backing off and risking the start-up of the Land Cruiser causing more disturbance in the herd, we stayed there silently.

She hit us again, more gently this time, more like a warning not to get any closer. By now females were screaming and backing into each other. Another scattered dust over us. What was going on, we wondered. Then we saw. No bigger than a large warthog, a baby had been trampled

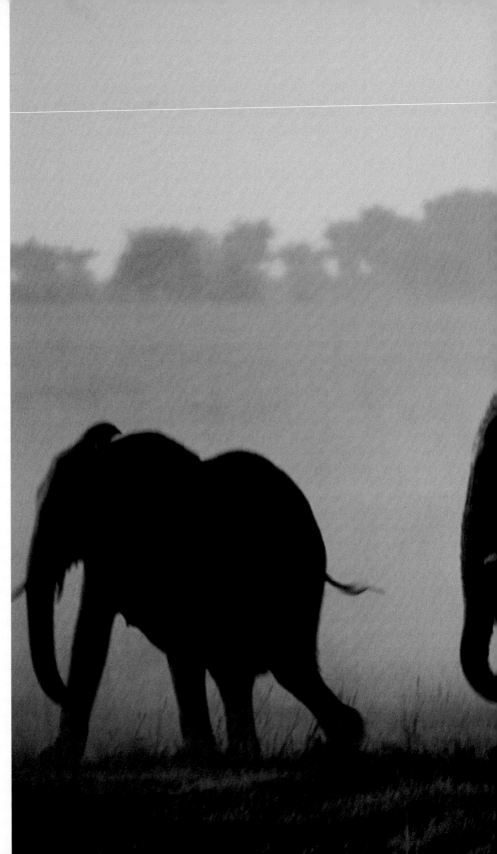

There is something ageless
about seeing a herd of elephants
gliding silently along an
ancestral path toward the river.
Something right.

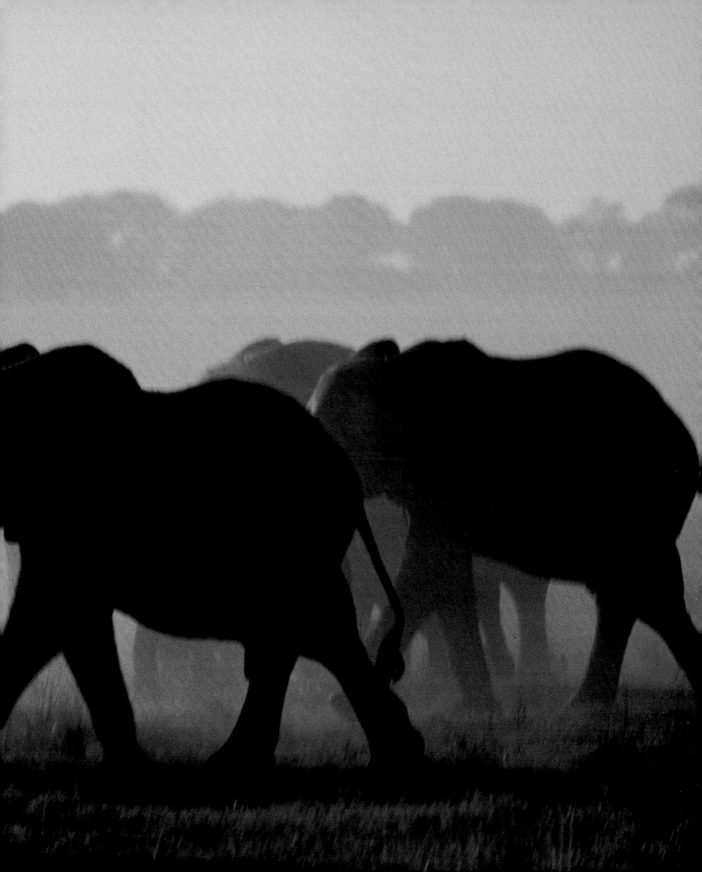

into the mud. He struggled to breathe, completely stuck and losing the battle. Again the lead females charged us, but this time didn't touch the vehicle.

At last light they seemed stumped, and, after digging a little, which only seemed to make matters worse, they started to calm down and, to our surprise, leave the water hole. As they left, each one passed within a few feet of us to head off into the forest up the bank. It was obviously a herd decision to leave the calf. I think the mother was not the matriarch.

We waited in the fading light, trying to decide what to do. This was definitely a human interference and qualified for our help, but how?

Decision made, I waded into the mud and tried to push the calf out. Don't know what gave me the idea that I could do what the mothers couldn't, but I tried anyway. Of course the baby bellowed as I got in, and I could see the terror in its eye. For all he knew I was a hyena or some other predator coming in to feast on him. The bellow of terror brought a similar response from the bushes above us. The mother burst out of the trees in a full charge, which sent me scrambling through thick mud for the far side, just like a scene from "The Far Side."

Not far away from this mud wallow is the luxurious safari camp called the Chobe Game Lodge, famous for its honeymoon guests Richard Burton and Liz Taylor (second time around, I think). Beverly and I stomped into the reception area, dripping mud onto elegant tiles, and had soon talked Jonothan Gibson (owner of the place), Mike Myers, and Dave McCormack into helping us.

Back at the hole, Jonothan, Mike, and I dug away at the mud surrounding the calf's legs, managing to thread the winch cable under his tail and backside. Careful not to cut him in half, we rolled up a blanket to protect him against the wire. Beverly was in charge of the winch, which is a really delicate job because of its power. If the cable pulled too tight, too fast, we could really injure the calf; too slow and it could come off, whip around, and take off our heads. Each time we made a move to release him, he bellowed and…. Mom came out of the forest again, angry as hell and ready to defend her calf. This is where Dave came in. In a second vehicle, he blocked the female from attacking us. There were a few harrowing moments when she slipped past Dave and waded into the mud with us, swinging her trunk wildly as we scrambled to escape. At one point I had to dive under the truck to avoid getting trampled on, and Mike had a close shave, too.

Finally she lost heart and went off again, and our work paid off. As Beverly winched gently, we guided the cable and pushed the calf free. Sadly, when we wanted the mother to take over, she was nowhere to be found. And the calf seemed to realize that we were not about to feast on his little body. In fact he was quite happy to stay as close as possible to us. Not good.

I waded into the mud to save the elephant calf after my usual agonizing debate about when to intervene and when to let fate determine who should survive.

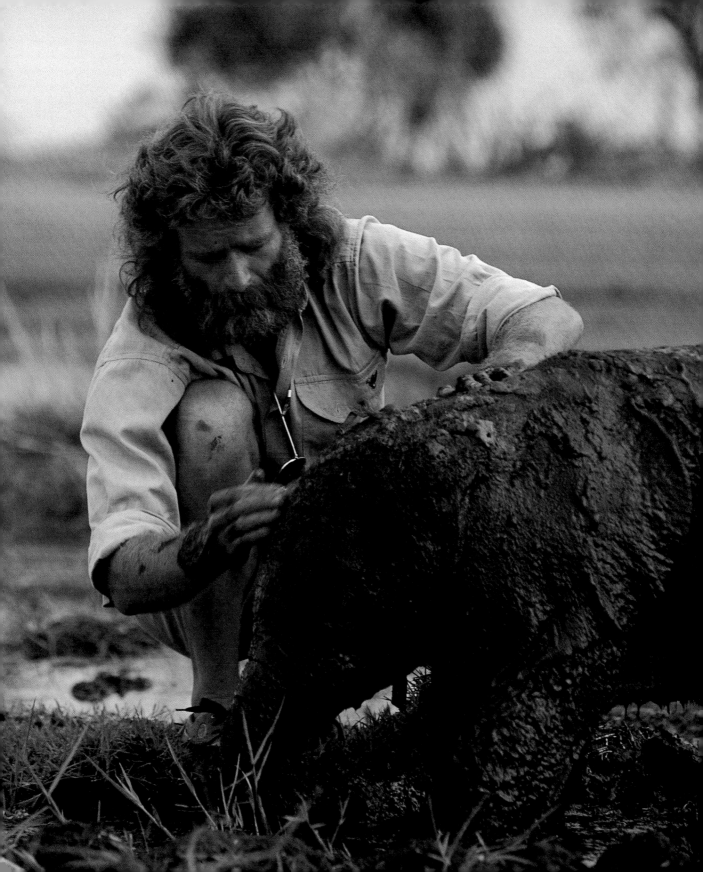

Beverly came up with the idea to aim a flashlight into each eye successively and steer him away from the mud. But there was another problem beginning to develop, as the helpers touched and grew fonder of the calf by the minute. Such moments require swift action. I twisted the little one's tail and was rewarded with the desired effect. A solid bellow echoed into the night and immediately the mother broke out of the forest again. This time, though, we were too exhausted to run again.

Then the most amazing thing happened. The mother came toward us slowly and calmly, reaching out with her trunk to sniff at us and the calf. We pushed the calf forward and backed away. She gently held her calf and ignored us as we relaxed and went about our business of collecting shovels, winch, and bits and pieces she had made us abandon during the past hour. At times we were walking within three feet of her and her calf as he suckled and she picked at the grass.

Adoption is rare in elephant society, but we filmed one in 1993. It wasn't without a touch of sibling rivalry.

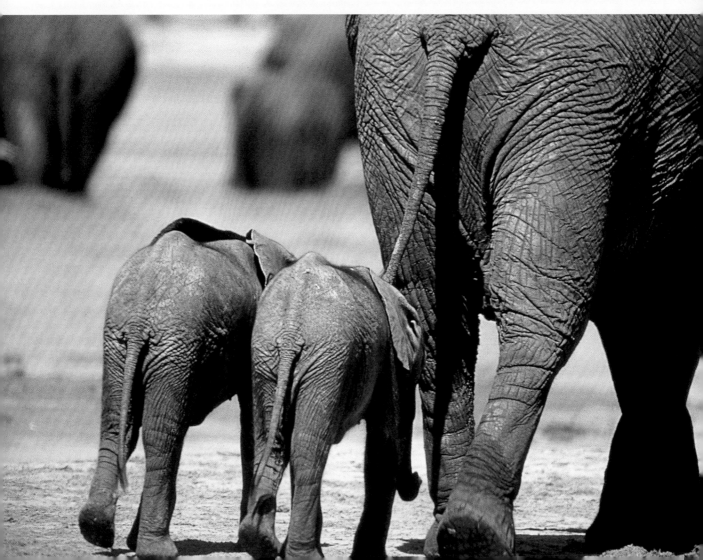

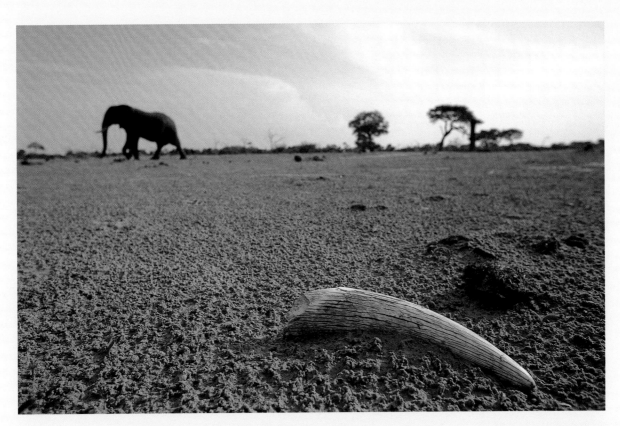

It was a rewarding experience, an experience that made us feel that there was some recognition of what we had done. Not surprising, perhaps. We have observed elephant awareness in other contexts as well.

We often settle in for long, continuous watches of dead elephants. I had always wanted to document the complete decomposition process of a large carcass, because it is a location for successions of dispersal agents, from lions to maggots. Many of these scenes are a little disturbing to the uninitiated; and eating food within a few feet of a seriously rotting, maggot-crawling, stinking elephant carcass can be a challenge in the beginning. Stepping out into the piles of wet hyena feces is never pleasant, and the days of sleepless nights as hyenas cackle and howl away eventually gets to you. But it is worth it, or has been for us. This is the place that interactions happen, and many incidents are simply sidebars around the main event: Elephants seem to have a comprehension of the past and of self. The investigation of bones and burial rituals hint at the acknowledgment of death, and death embodies memories of the past.

The most stunning scene is always the gentle investigations by elephants of their dead, so often conducted tolerantly over the heads of the scavengers, though usually after chasing the opportunists away.

Elephants are cursed with teeth that humans covet—or used to until the 1989 CITES convention basically killed the legal trade in ivory and stopped the slaughter.

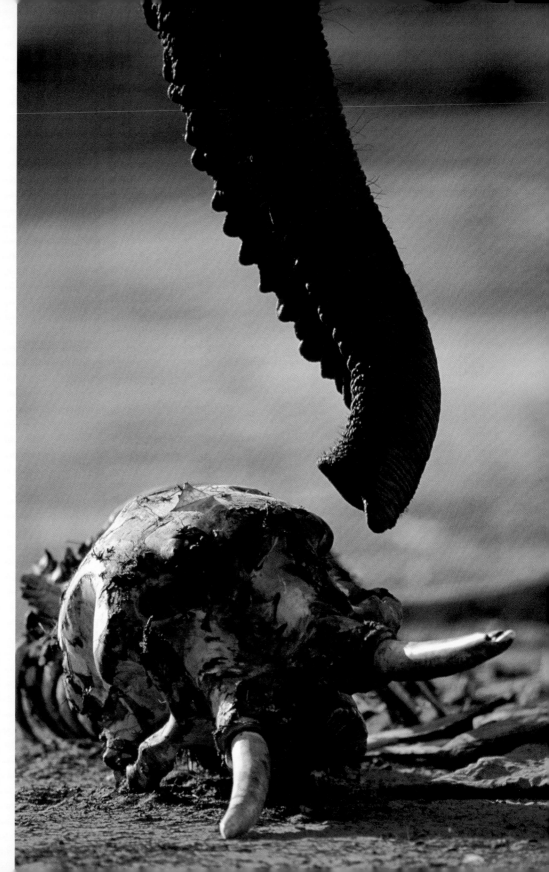

Elephants spend an extraordinary amount of time investigating their own dead.

Next pages: Thousands of doves flutter around the last of the drying waters, hotly contested by the bull elephants of Savuté.

AUGUST 2, 1990

Gentle trunks sniff slowly over the remains, dribbling moisture in an almost hypnotically sensitive dance. I can watch this for hours, and they seem to be able to do it for hours. A parade of elephant bulls comes to the carcass to touch and fondle but mainly to smell. What are they thinking now? What are they learning about their own mortality? The stench gets worse and the water hole is completely fouled by the rotting flesh and hyena crap, but moments like this seem to freeze time and all inconvenience.

AUGUST 12, 1993

Traveling back from the far eastern pans, we came across an old elephant carcass. The tusks were still in place but slipped out easily. We debated what to do with the ivory, clearly no one would ever find it here, and, if we turned it in, it would ultimately fuel the ivory trade, which we don't believe in. We decided to collect the ivory and hand it in to the Savuté game scouts when we got there.

Savuté was over a day's drive west, so when dark came and we tired, we pulled over and rolled out our sleeping bags, as usual, then collapsed in the back.

Around two in the morning, we woke to a bump against the vehicle. Beverly looked at the moon and saw nothing but black. Must be overcast, she thought. But she was looking right into the side of an elephant, so close she could touch it. I looked up and saw another on my side. When I clapped my hands, they moved off a few feet and settled down. We went back to sleep with three old bulls standing around, which is always fine with us, almost comforting actually. But half an hour later they were pushing us around again, this time rocking the vehicle back and forth. I got out of my sleeping bag and chased them off, properly this time.

Back to bed; half an hour later and we were rocking and rolling again. By now we were both getting grumpy.

"What's got into you old guys?" Beverly said. Then we saw his trunk dart into the open door. He was smelling the tusks we picked up yesterday. We humans are slow learners, but when precious sleep is under threat we eventually get it. I threw the tusks out of the car and went back to bed. The rest of the night was quiet.

When we woke up, we tracked the clear footprints and drag marks of the three bulls. The elephants were nowhere to be found; but about 100 meters away, one of the tusks was discarded near a tree. There were scuff marks on the tree, and some fresh moisture and bark pieces on the tusk. Trying to fit the marks, we decided one of the bulls had tried to wedge the tusk into the fork of the tree and broke it.

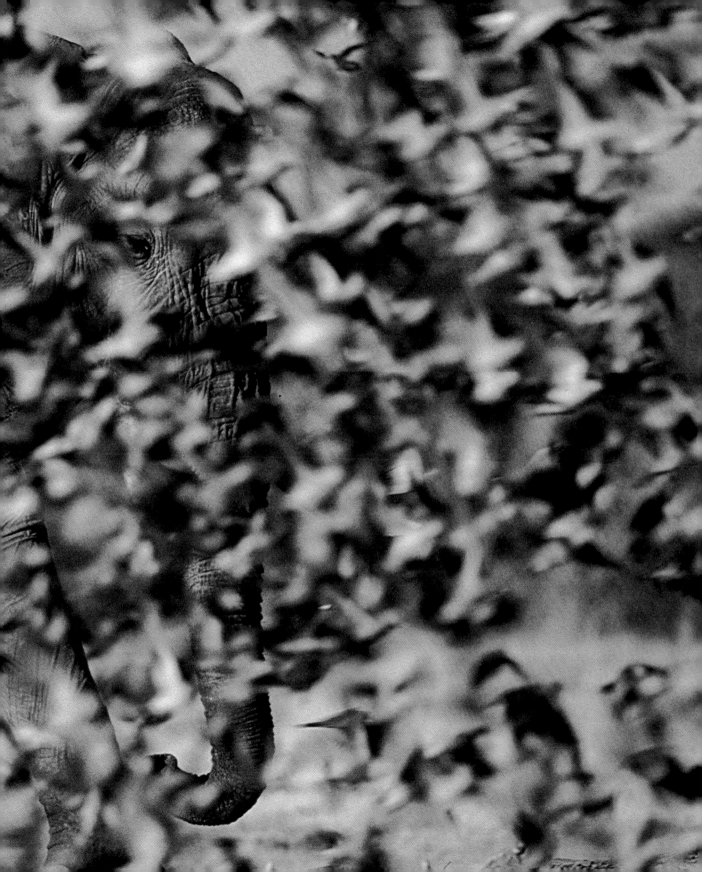

Elephants have this fascination with ivory. If there is a piece around, they will take it. We've seen them smelling and tasting the ivory from one of their own deceased. They also attempt to crush tusks or smash them in trees, which appears to be an ancient ritual, or perhaps something else.

OCTOBER 16, 1993

Today we followed a herd of 50 bull elephants. They seemed to operate just like a regular herd, following along in disciplined order, but I couldn't tell if there was a leader or not. They then went down to the river and, without hesitating, stepped in and started to swim directly into the river and across the wide part of the Chobe. It must have been a 25-to-30 minute swim, and I know how deep it gets there. I'd love to get footage of them under water.

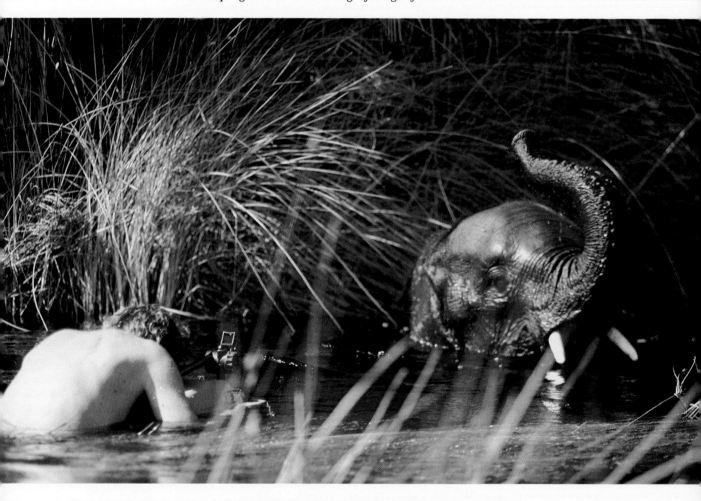

Elephants have no problem swimming. Like the seagoing animals of their shared ancestry, dugongs and manatees, elephants ford Africa's rivers and seem to enjoy being in water. Though one of the largest land mammals on Earth, elephants do float. Their large vacant nasal passages and sinus cavities keep their heads afloat and their fat makes them buoyant. It took years, but we did eventually get underwater footage, which became part of *Reflections on Elephants*.

OCTOBER 3, 1994

We experimented with underwater photography in the wild and with captive elephants before managing to get workable underwater footage.

I quickly reached for the binoculars. Yes, they were still there; gray mounds in the shade, completely relaxed and oblivious to us. I still remember the first time I heard that around midday elephants will—as a herd—lie down to sleep. "Never!" was my incredulous response. Then we rushed off to see for ourselves, immediately leaving camp to go on a seven-hour drive to the Chobe River, all on a rumor. After two blowouts and an overheating radiator (just the usual stuff for a trip), we feasted our eyes again on the deep blue water of the Chobe. It was always the same, an oasis for one and all during the hot dry season.

After dunking our heads and having a bite to eat, we started off in the direction of the legendary sleeping giants.... But suddenly there was something. A gray shape lying half-concealed under a croton bush. Then another. And there it was, an event so bizarre that it still feels like a dream. I got out of the truck and started walking, tiptoeing to get a special shot on film. If I had tripped, it would have been chaos. All around me sleeping elephants snored away!... I was surprised that the thumping in my chest didn't waken the whole herd.

But they would wake soon anyway. Elephants do not sleep for extended periods. They live a long life, 60 years or more, but just a few minutes at a time is an ample nap for them.

For years many wildlife officials and private lobbyists in Botswana have been pushing for a cull of elephants. The proposed number surfaced one day at 12,000! We seriously doubted at the time the reported official total population of elephants in Botswana, but whatever it was, shooting 12,000 elephants would be disastrous.

Our case, in brief, is that elephants within a natural system will find an equilibrium. Their cycles may not fit government schedules, but they will get there. Sometimes, elephant populations may outweigh the bush. When elephant clans gather, they often leave behind flattened vegetation; the ebb and flow of their huge bodies affect some areas more than others. Massive deforestation can be the result. But then they will either move off, adjust their breeding rates (which they are capable of), or die. Either way this is a system that has been going on for millions of

In the water, elephants float
like light-bodied vessels.
They seem to enjoy the freedom of
play in rivers and streams and seek
out water as often as possible.

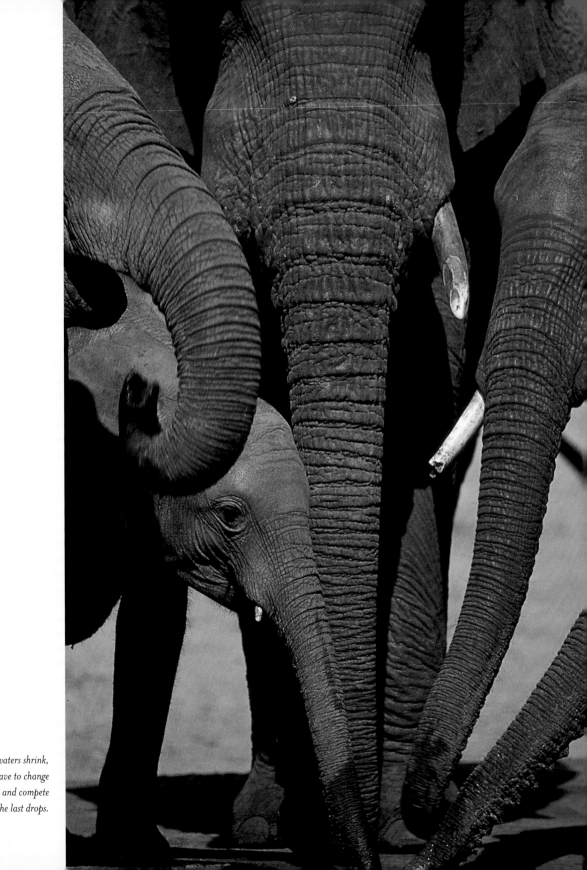

When the waters shrink,
the elephants have to change
character and compete
for the last drops.

years. The death of elephants is certainly sad and the loss of vegetation disturbing, but the death of an entire natural system of cycles because of human intervention is even sadder.

We've looked at other places in Africa where elephants are managed in various ways. In Zimbabwe and South Africa they are culled in large numbers every year to keep the overall population at some research-determined stable number. One argument against that system, besides its cruelty, is that no ecosystem is meant to be stable. Savannas and woodlands are supposed to change, and elephants are an ingredient in that change. But Kruger National Park in South Africa is a fenced "island of conservation," which *is* doomed *unless* managed. I believe that these islands are doomed anyway, and the latest trend in conservation is to open up parks, join them with larger corridors, and bring down fences.

We wrote letters, spoke to officials and other interested people, and finally a conference was called to discuss measures to be taken to manage elephant populations. Ironically, as the debate went on, we found allies in the hunting fraternity. (Hunters didn't want every Tom, Dick, and Harry hunting and wounding elephants in their areas.) As the second day dragged on, I stood up and spoke directly to people whose existence I depended on for film permits.

"I have a management option for you. You have heard that the hunters don't want to see hunting, a government cull will cost you money not make money, the villagers are not being attacked like they are elsewhere, our people don't want to eat elephant meat because it is not in their culture, international condemnation is not what we need.... So...I suggest you leave them alone!"

The timing was good, the sun was going down, and everyone wanted to go home. Culling was put off until the next time. That was in 1987. Since then Beverly and I have lobbied against a cull every year. We have spoken at similar meetings, debated against the great culling proponents like Ian Parker from East Africa, and have been drawn into the elephant debate on an international level. There has been no culling yet, but it is still a real threat to these elephants and the wildness of Botswana.

A few years ago we heard a rumor that Botswana was going to open up elephant hunting. I called to find out and was told by Dr. Doug Crowe, then head of research, "Absolutely not! I wouldn't let those guys wash an elephant, let alone shoot one!" Two months later, the government legalized elephant hunting. Within two years 84 elephants a year were being shot by hunting companies. A deal had been struck with the hunters that gave them exclusive rights to hunt the elephants.

The affectionate nature of
elephants inspired us to do a
feature film about their lives
from their point of view.

We rarely have visitors, as a function of the remoteness, but whenever we do and we visit elephants in our region, it's not long before one of the visitors wonders aloud, "Hmm, I wonder what the elephants are saying?" Most of the time elephants seem self-involved, but communication between them is obvious; it is based on thought processes within a complex social group. Researchers have identified language skills for 25 concepts, different sounds that convey different ideas. Elephants can signal to distant herds, telling them, it seems, that they should vacate when a new clan is coming in. They are also known to deal with problems and have hierarchies to obey or enforce. They have disputes over direction, disputes over whose calf is misbehaving, different responses to friends, and polite rituals with strangers. As filmmakers, we were always looking deeply into the behavior we saw—searching for the very essence of elephants, trying to identify their true spirit, yet trying to hold back from loading meaning into innocent or random actions. Up until now, this has been our role as documentary filmmakers. But things were about to change for us.

After a long process that was actually quite fun and very gratifying, we found ourselves in Hollywood, California, with executives at Disney Studios. They wanted to produce a wildlife feature, a film with real animals, but they also wanted the film to have dramatic structure and to be a story that would appeal to all ages. Our relationship with Disney had started a little earlier, when under the direction of Jeffrey Katzenberg, Disney artists were given the go-ahead to create an animated version of our Savuté films, *Eternal Enemies* and *Lions of Darkness.* A film called *Lion King* was the result (and we received two Lion King sweatshirts as fair reward).

Eventually a deal was struck for a new film and greater creative freedom. We went out to film elephants again. This time, though, we were diving headfirst into the anthropomorphic pond. Still, after years of observation and the lessons of *Reflections,* we believed that there could not be only one species on Earth that was selected to have feelings, to experience love and hate, compassion and self-awareness, language, and both memory and forward thought. So with a conviction to explore that concept without the guilt of a documentary discipline, we leaped into our first feature film.

JULY 15, 1995

After all the preparations, permits, tents, new cameras, and a long list of detailed planning, we declared July 15 the first filming day. We were ready. The new Toyota bounced off into the bush. Its specially built equipment boxes were rattle-free and clean. Beverly even sported a new

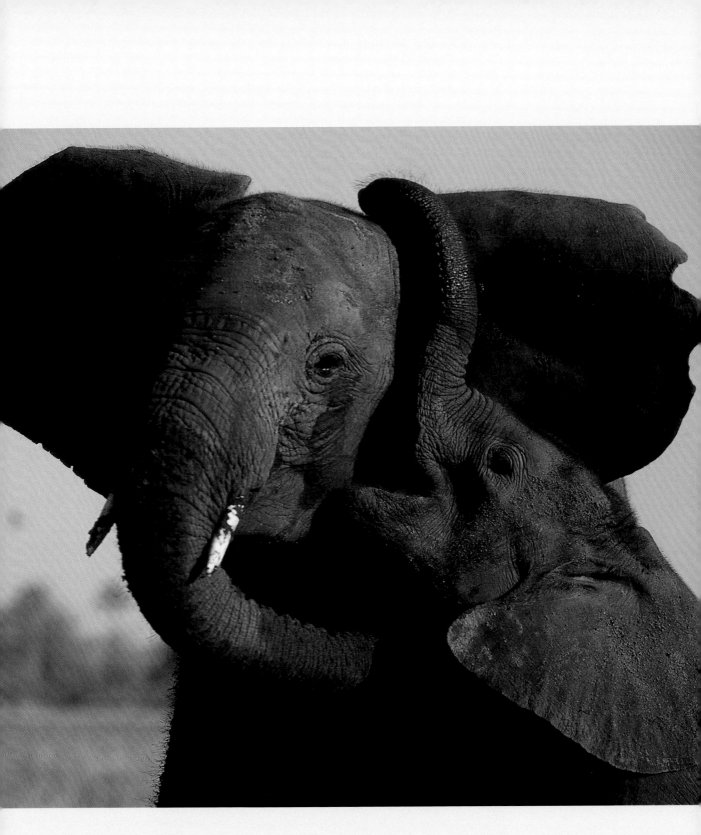

*The Disney film brought us
one step closer to elephants*

Patagonia peak hat. New 35-mm film cameras have been tested and fitted with all the latest and best gizmos because we cannot use a frame of any of our old footage, that being 16 mm.

All we needed were elephants. We drove to the nearest water. The water birds were spectacular. We came across a pride of lions we've known for six years. I doubt they recognized the new vehicle. It was so quiet. We identified all our old friends, made sure they were all fit and healthy, and eventually had to tear ourselves away and go in search of elephants.

With a population of around 70,000 elephants here, you would expect them to be everywhere. By sunset we still hadn't found a pachyderm to film...so we returned to camp, spirits dampened but not defeated.

Nearly 40,000 square miles of wilderness is available to these elephants. Botswana has one of the largest herds of free-ranging elephants left in Africa. But 40,000 square miles is enough to hide a lot of elephants. We went back to camp, to our new cast-iron pot and a new fire grid. (Our needs and pleasures are simple.) The real starting day was to be the 16th it seemed, but this time we'd begin earlier.

JULY 16

To rectify yesterday's limited success, we were out an hour before dawn. This is our favorite time; the bush seems totally relaxed before another day of 100-degree temperatures. Actually, it's damned cold at 5 a.m. in July. No wonder everything is so relaxed.... It's all frozen in place.

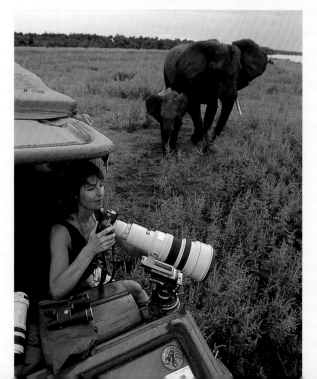

Thankfully we bought those new ski jackets. Everything is new around here...for now.

By midday we were stripped down to not-so-new shorts and T-shirts, and sitting in the shade. At three we heard them...elephants. We got ready and waited. The light was terrible because of the poachers' fires blocking out the sun, making everything look flat.

We once again engulfed ourselves with elephant lore and culture, straining to understand what they really are.

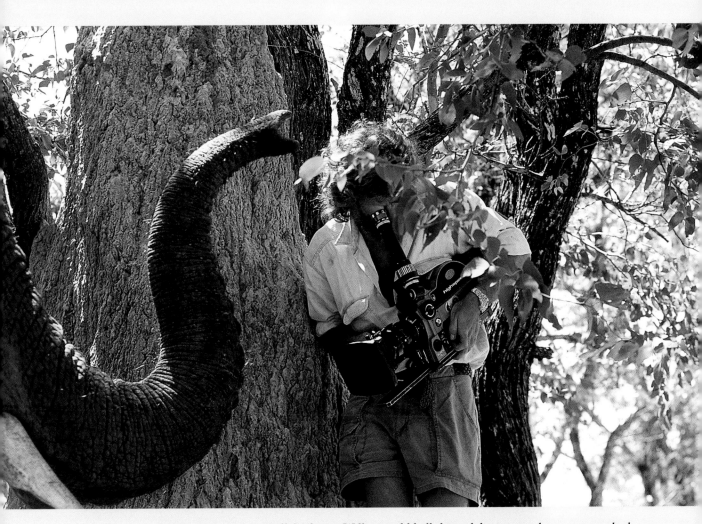

Finally, they came out off the forest. Well, two old bulls limped down toward us...not exactly the teaming masses, but elephants at least. Of course they did nothing, and with more than 15 years of filmmaking behind us, we knew that as tempting as it might be to shoot off some film on these two old boys, it would be a complete and utter waste of time. We had 18 months and many thousands of elephants ahead of us.... I rolled off 300 feet of film anyway.

Philosophy of the day: I'm going to do some good work on this film, and some bad. May as well get the bad stuff done early.

Sadly, as I write this, news of the death of a close friend of many years, Jackson, has just reached us. Jackson, a game guide for many years, was taking care of his father's cattle farm when a herd of elephants broke through. Jackson went out in the dark to chase them off. No one will really know exactly what happened but an elephant cow, no doubt defending her herd, charged and hit him so hard that the shotgun he was carrying was smashed into four pieces. If only we could understand them. If only elephants could speak our language.

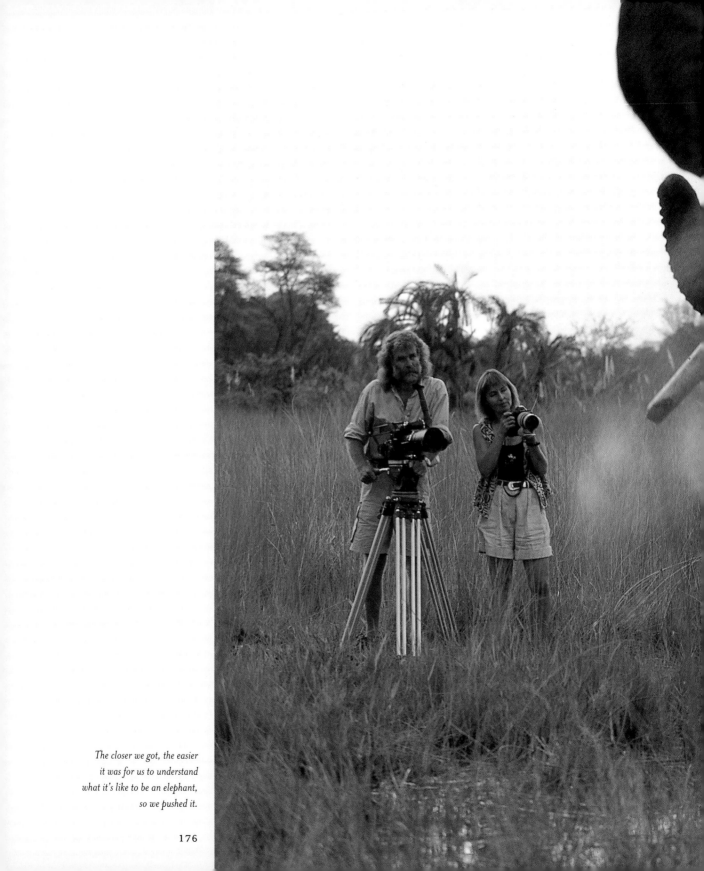

*The closer we got, the easier
it was for us to understand
what it's like to be an elephant,
so we pushed it.*

176

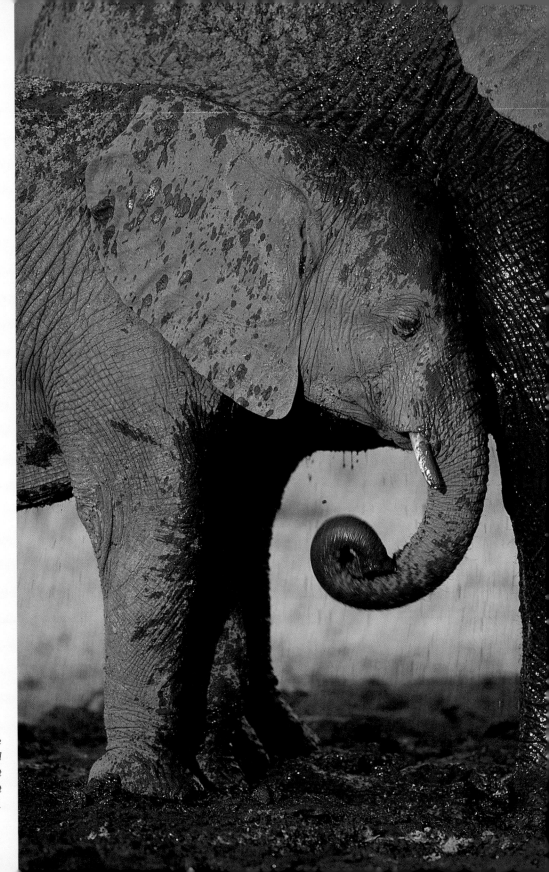

Can it be right to separate families with such close social bonds? The time of arrogant and impassive management may be coming to an end.

Well, we were going to make them speak, if only in a film, and if only we could find some to film! It took us most of the first month just to get into our working groove.

AUGUST 1, 1995

We watched the herd near camp. The elephants stirred after their nap. It was almost silent, with just the flap of an ear, a gentle scraping of skin. But quite suddenly they were all up, not in panic but with solid determination. Someone had given the signal. Of course one of the older females, probably the leader, had used an infrasonic (to us) sound. Clearly, everyone in the herd knew what it meant. And this is really exciting because it shows a consciousness of subtle signals...language.

Also interesting is that this herd is totally behind its leader; the matriarch is totally in control. We have decided to base our first herd in the film on this stable and gentle family.

The matriarch led the way with her newest born, a wobbly calf no taller than three feet; her older calf, a young female of about six; and her first born, another female of about ten or eleven. The other females, with calves in tow, fell in behind this royal family.

As both Beverly and I scanned the herd, even more detail emerged. The oldest of the leader's calves was like a nervous babysitter. As they walked, she fussed around with her trunk, touching the two younger calves, feeling their tails and rumps, occasionally reaching to their mouths. She was definitely a minder of some kind. Elephant cows of this age do become caretakers or surrogate mothers, and today was a textbook example straight out of one of Cynthia Moss's books. [Cynthia is one of the leading elephant authorities, famous for her extensive work in Kenya.]

These near adolescents were often quite highly strung and chased almost anything in an overreactive display of protecting the youngest calves. The herd was headed for the remnants of the Savuté Channel, where a group of over a hundred hippos claimed the last of the water as their home away from home, waiting for the rains that would breathe life back into the channel.

We started up and followed on; the herd didn't care about us at this distance, but we would have to circle around downwind to get close enough to be able to film anything. In some areas this is not necessary, because the elephants are so used to tourists, but around our camp it's different.

AUGUST 25, 1995

Completely fed up with camp issues, water supply problems, and piles of communications with the outside world. On my last flight to town, I flew a long route back, not along the river but inland over some old rainwater pans I suspected might have water. With all these camp problems, we did what every self-respecting natural history filmmaker would do...we packed up and ran away.

By dawn we were 90 miles from camp and, more important, the radio. About 120 miles from camp, we came across the elephants at water holes. I could only find the best of them with GPS tracking. Trees were smashed and long lines of fresh elephant dung now led the way, then, suddenly we were there. It was an opening of no more than 500 yards across, but it was filled to capacity with elephants. There must have been close to a thousand!

AUGUST 31

Smashed a hole in the radiator the size of my fist! At a gray mudhole I pulled the truck up so close that the front wheel was right at the edge of the mud. I pulled out the radiator, fixed each fin, and checked the pipes. At one point as I was lying under the vehicle, I was suddenly splattered with mud. I looked out to see a forest of elephant legs within touching distance. A small family led by a beautiful one-tusked female was drinking fearlessly a few feet from us. Beverly and I slithered out and quietly assembled our cameras, creeping back under the truck to make the most of this rare opportunity—a worm's-eye view of a drinking herd. "Spike" and her herd stayed with us for over an hour, then gently moved off. We felt enriched. Our survival problems were put on the back burners of our minds for a while. Just a while.

"Spike" we recognized again in a few months, then again and again. She eventually worked her way into our subconscious and into our script as a warm and forthright leader, with a very special manner. Joan Rivers was eventually cast to be the voice of Spike in the film.

A few days later we were still mudhole-hopping. I had to remove and replace the radiator about twenty times, the water pump half a dozen times, and we found ourselves at a water hole surrounded by nearly a thousand elephants while we intermittently worked on the vehicle and filmed great scenes of elephants. By now there was a kind of acceptance that we could go on like this forever…or at least until we ran out of film. We would sneak down among the elephants to bathe in the gray but still liquid water, moving huge floating lumps of dung aside as we washed.

As we watched old Spike greet and generally work the water hole, we started imagining a scene in the film: Half Tusk and her sister, Groove, split up. Half Tusk is generally behaving like Patton or Elizabeth I; she really needed a social conscience. Spike just looked so…Joan Rivers. Beverly and I added comments as we filmed her. In the final version, Joan/Spike gave us some amazing lines like:

SPIKE: Wow, you look gorgeous! The truth…have you gained weight?

HALF TUSK: Me? What about you? You're practically a mountain.

SPIKE: Oh, thank you! But you know what they say…you can never be too fat or too gray!

Multifaceted lives intertwine for a moment when two calves meet while their respective herds mingle.

180

Beverly looked out and saw them first—a pair of lions we'd seen the night before. They were hunting warthogs. Although they looked interesting, I saw a plume of dust behind us and knew that at any moment a parade of tourists would be swarming around the lions, especially if they were hunting. We decided for once to move on and leave the lions to their ultimate dust-covered fate for the day. We drove off the floodplain and toward the forest. There was a lone elephant standing at the

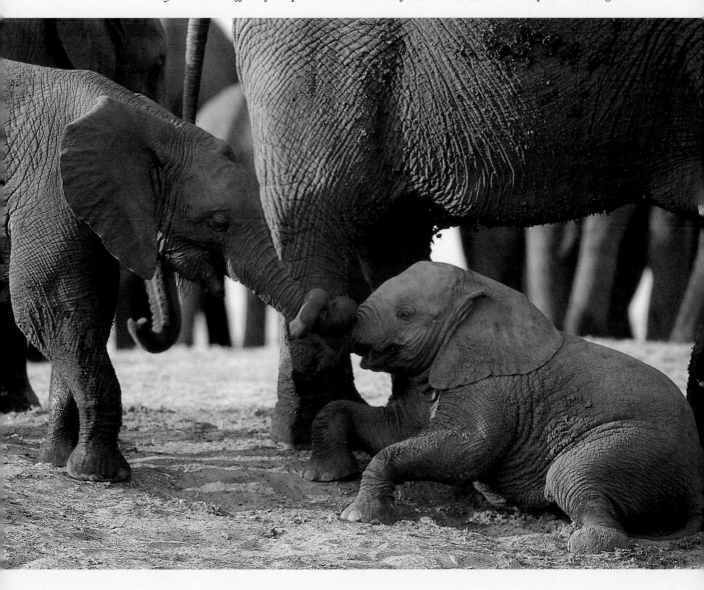

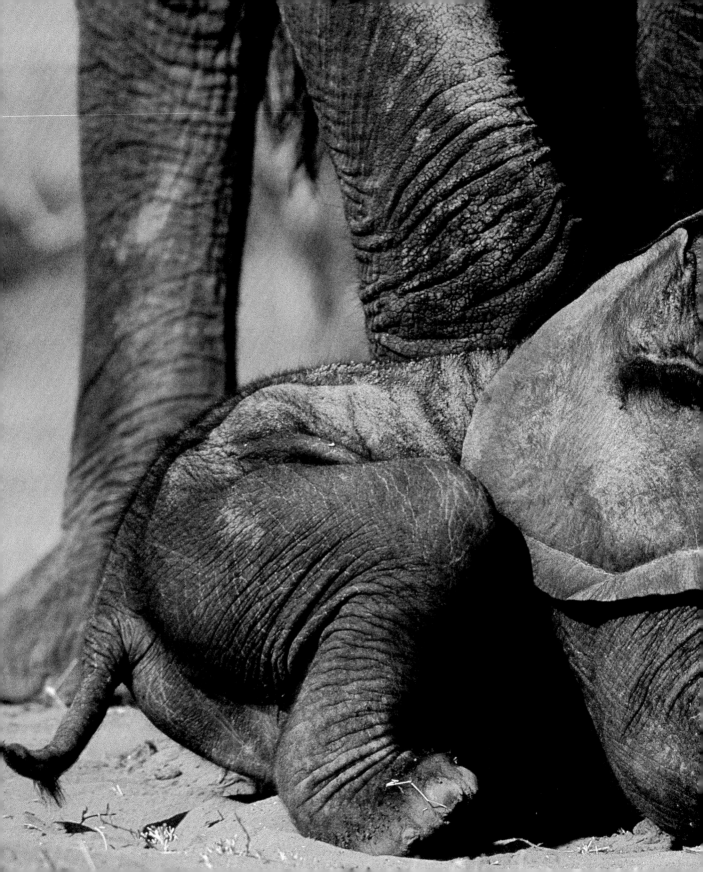

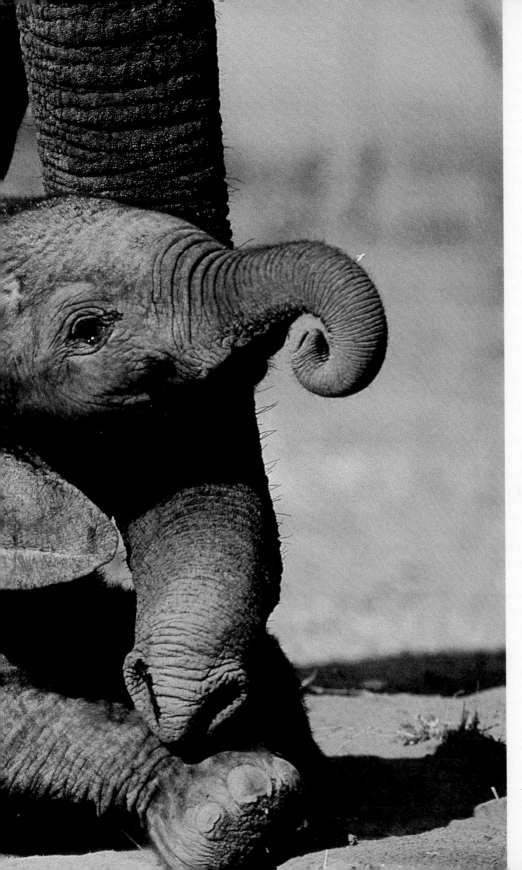

At last, after nearly 19 years in the bush, we came across our first elephant birth. The folded ear is from months of lying curled up inside a warm womb.

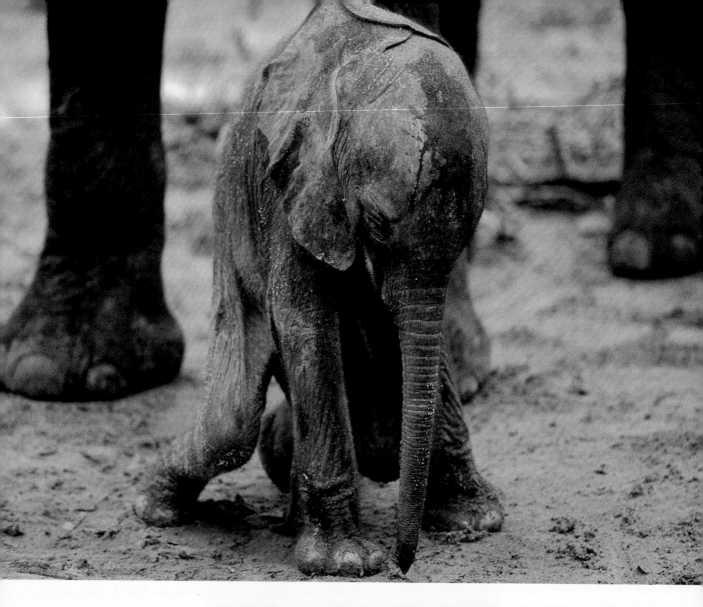

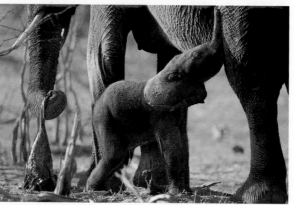

Above: The first steps of a long life.

Left: While the calf tries to find a good suckling point (at the wrong end!), the mother disposes of the placenta.

river's edge. She looked tired and lonely as she slowly started to walk toward us. Half of her body was hidden by a sand dune; out of politeness we stopped to allow her to walk by in front of us even though her pace was really slow and she was some 100 yards away. She stopped and seemed to settle down on her knees, then got up again and turned around. I think we both realized at the same time...she was giving birth!

We had never been at the right place at the right time for an elephant birth before. It felt like a blessing. Certainly a rare privilege.

A tiny bundle of moist elephant no larger than the wheel of our Land Cruiser rolled over and looked up at his mom, and once again we tried to put ourselves in his emotional and physical position.

This was our first elephant birth in over 20 years in the bush. Elephants are usually quite secretive and are careful about who witnesses this most vulnerable moment of life.

We had witnessed the sudden movement to her knees, the baby's first wet head shake, the first footsteps. And what footsteps they were. Like a seriously drunken landlubber on his maiden sea voyage in rough seas, our little baby stepped forward and immediately lost its balance....

The mother doubled back to the birthplace, picked up the placenta, and started to smash it to pieces, dragging it in the sand and even beating it against her head. Finally, she buried it with all its scent.

She hurried back to the calf, whose feet had decided to take it off in another direction altogether. When she got to him, he was lying in a bundle on the ground. She immediately shoved a huge foot into his face and lifted him delicately onto his feet, ushering him step by step away from the buried placenta. We watched with our hearts in our throats. Not half a mile away was a pride of eager lions, all eyes and ears for vulture activity.

Finally, at 10 a.m. she managed to get him going toward shade. By now it was well over a 100°F and our brains were cooked from sitting in the sun all this time

The real Whispers was born in Kruger National Park, South Africa. He was not much more than a year old when a group of men swooped down and killed his mother and her herd. They captured the babies over a year old and killed the younger ones (we were told they are too difficult to keep alive). Three youngsters were to be shipped to a zoo in Brazil; the zoo only wanted two, but at this age, one in three captured or transported elephants dies anyway.

When Randall Moore, who runs Elephant Backed Safaris in Botswana, told us about the calf in Kruger, we reacted immediately. Randall has a herd of trained elephants made up of rescued animals from zoos around the world and from culling programs in Africa. He employs the elephants for safaris, taking tourists into the

bush. We immediately asked Randall to save the third calf bound for a long life of captivity in the Brazilian zoo. A few weeks later, the little calf arrived in Botswana, and Randall called to ask us what to name him. There was no question. In a strange crossover between life and art, we named him after a character in our film— Whispers, or Seba in Setswana, the language of his new home. Seba was as bright as a button.

The dynamics of herds of rescued animals, orphans, and misfits have always been fascinating to me. These herds have as strict a social order as any normal-functioning herd. Within moments, Seba figured out the social system here. Usually calves depend directly on their mothers and the other females in the herd, avoiding the more aggressive males. Seba spent about an hour watching his new family and then walked over to the biggest bull in the herd. From that moment on the bull, Abu, and Seba were inseparable, and no one messed with him.

When we first visited Randall many years before, we were on guard, relying heavily on our senses. As we sat around one day talking, I noticed one of the handlers, David Mabukani, taking a rest too. He sat down on a log. Abu, the lead elephant bull, walked up behind him. I prodded Beverly to watch the reaction, to look for an indication of how the elephants were treated. Abu stepped up and gently rested his trunk across David's neck. David carried on, talking and stroking the trunk now across his throat. It was a rare moment of tenderness between man and elephant. We agreed to use Randall's elephants for filming.

For us Seba provided all the close-ups and character things that we needed to supplement the Whispers out in the wild for the Disney movie. On a daily basis we would shoot scenes in the wild and then make notes on which of the scenes Seba was needed. We were really concerned about working with captive animals, something we don't like or think is ethical for natural history filmmakers to do. Many animals die because filmmakers are usually not professional keepers, and this always reeks of the lazy way to make films, so we avoid sets if we can.

SEPTEMBER 1995

A pride of lions we know quite well from our previous lion work has moved in at the water hole The huge bull elephants here are famous for their docility. They tolerate the lions and the lions are completely used to being right at their feet from day to day, without any fear of aggression from the gentle giants. The lion cubs are also used to ducking away from the huge feet and running between tree-size legs to get to water. At this age, the line between playing and learning is quite difficult to determine, as each mischievous little run and jump can easily turn from mock hunt into successful surprise (for both the victim and the young lion). It won't be long now....

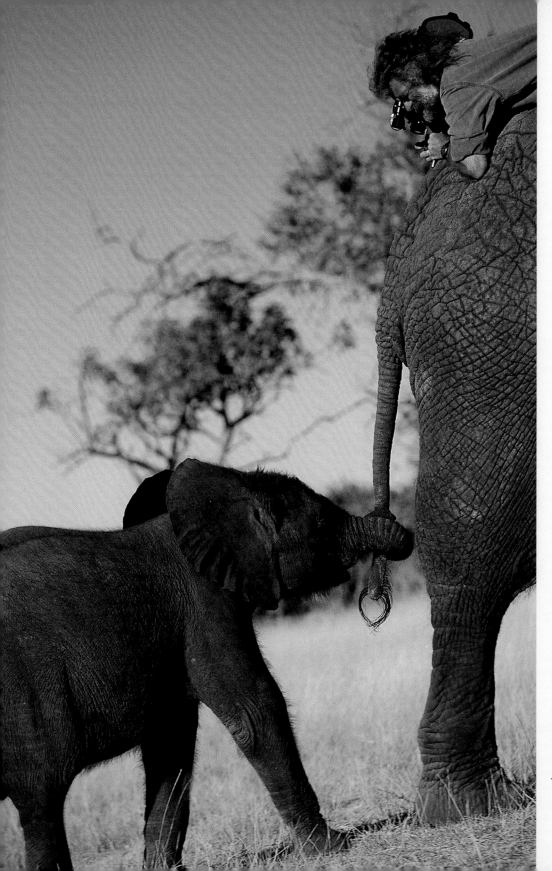

Moving on to work with Randall Moore's elephants, we were able to fill in the gaps of our wild footage. This was a fantasy feature film that allowed us to use tame elephants— and have a little fun.

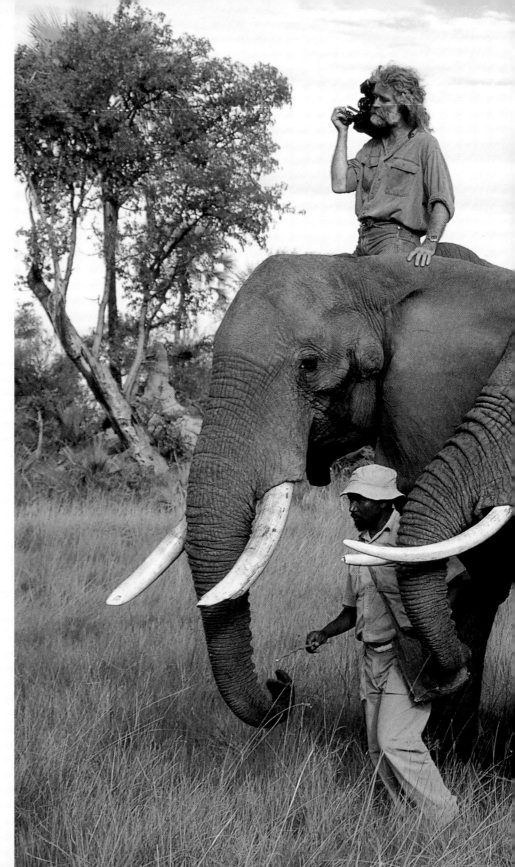

*With friends Abu, Cathy,
and David Mabukane,
who shares a very special
relationship with the elephants.*

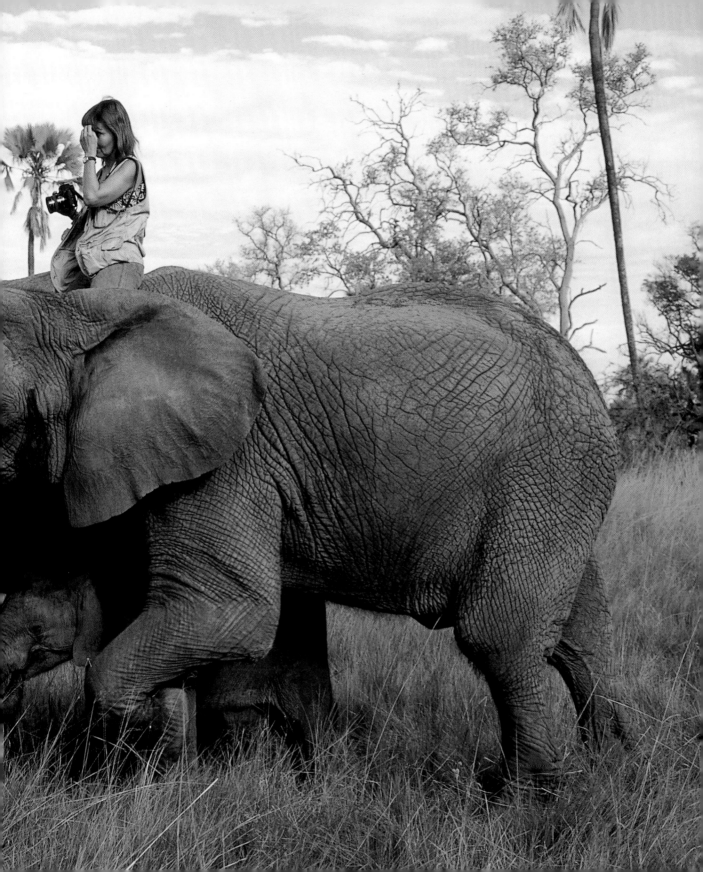

Yet it was not the death of a baby elephant or any elephant, for that matter, that we intended to film. We were interested in covering the hunting behavior, the danger that little elephants experience, the atmosphere of a night alone with lions in the area.

OCTOBER 7, 1995

Last night was a breakthrough. During the usual stinking hot evening, the water hole was besieged by bulls. Perhaps 120 of these big old boys tried to squeeze into the water. It was impossible, of course. The water hole is no more than 100 square feet of open water. I pulled the truck to within 20 feet at dusk, when there were no elephants, and stayed there as they started dribbling in. All of a sudden we were aware of being in among the herd, surrounded by over a thousand tons of elephant. All within touching distance. By now we were feeling guilty about the disturbance we might cause by starting up the engine to back away, so we decided to wait for a lull. Filming was impossible with all the dust, but Beverly recorded 20 minutes of amazing sounds. Huge tusks were moving, quite carefully, within a foot of our heads.

As the numbers built up, the dust kicked up around them and us became so thick that finally we had to back away and out into the fresh air. We needn't have worried about disturbance. They didn't even notice, and our place was occupied immediately by the mass.

Around midnight the first breeding herd of females and calves came tumbling out of the dark, bellowing and pushing and shoving at the water. We looked at the wall of bull rumps blocking the water and Beverly said softly to the incoming females, "Good luck." For the next hour the noise level went up a notch and changed pitch as calves got confused, lost, and bumped around.

At 1:45 a.m. we heard them. The lions from the Setari pride came in at a run. These subadults were not too subtle about their intentions. They ran in toward the water hole and created havoc. The herd bunched together and swirled around in what looked like an attempt to organize. The lions immediately retreated. For the elephants, though, the message was clear. This water hole was no place for them to be. The matriarch lifted her head and pointed the herd out to the west, then set off at a controlled run. We could make out enough of this without lights. The night scope is working well for us now.

As soon as the elephants were off, the young male lions were chasing after them. One bold pursuer did something we had never recorded before. He leaped up onto the rump of an elephant at the back of the group, a young female about 11 years old. The lead elephant turned back to defend her herd and inadvertently knocked over a tiny calf. Other lions raced in.

The herd rallied around the smallest, bellowing like crazy. Lions scattered and regrouped, some trotting along side as the herd finally found its direction again and raced off into the night. Throughout all of this, the bulls carried on, pushing and shoving at the water, apparently disinterested.

Lost calves are vulnerable to lion attack.

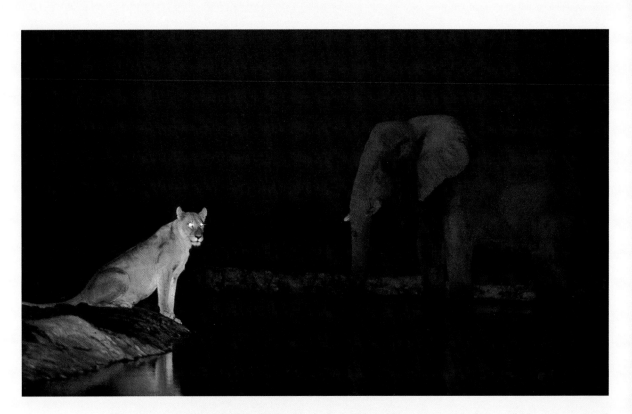

For us it was a scientific breakthrough…but we did not film a frame. Lights would have just caused too much chaos. We will have to wait for a calmer situation. Sometime soon we hope. It would be good to get some sleep this month.

We had not filmed a single frame despite sitting there so diligently through the night. The chase and hunt, the lion's attack on the 11-year-old, and the matriarch's dramatic leadership would only appear in our notes. When we finally saw the red splash of the dawn, our weary eyes adjusted as our world gradually expanded in a widening circle around us. That's when we saw the lions off in the distance feeding—and our worst fear hidden behind the impassive bulls: They had killed the 11-year-old.

We went on night after night like this, waiting and watching, sleeping only when we could not longer stay awake. For two months in 1996 we staked out this water hole and only managed to get about 30 seconds of usable film on lions hunting elephants. The rains finally came and the event was over. We moved to another place in the bush and left behind the bitter memory of those failed nights.

A few weeks later we got our precious 30 seconds back from the lab. Every frame was flashed with a strange red light. It was all useless.

We got a lot closer to understanding both the hunting behavior of lions when they take on elephants and the defense mechanisms of elephants to these attacks.

Night after night we staked out the water hole, waiting for what we knew would happen. The lions killed elephants in the darkness, but we never filmed a useful frame in over two months.

We also learned that whatever we were doing to get this on film was wrong. We steeled ourselves for a long wait until the following season. Same time, same place, a year later.

For this whole experience we decided to break another long-held rule and hire an assistant. We'd first heard Brad squealing as a baby on our very first trip to Botswana. We were staying at P.J. and Joyce's Xakaba Camp. P.J.'s dry intelligence always impressed us, and when he wrote to us about hiring Brad 17 years later, we thought it over very seriously. Finally I wrote back to P.J. saying it was too much of a responsibility to put his son and heir in our hands. So…"No, sorry." By return mail we received a letter from P.J. saying he thought we'd be fine!

Brad started in late 1995. Within a few days we were finding our feet with this new addition and talking him through the rules, rules we had not so much written for ourselves but knew intuitively by now. One rule was: "When Beverly is sound recording, you freeze. These microphones will pick up a sniff or a movement to scratch a mosquito bite. You sit, stand, lie as you are until she says she's done. No movement, got it?"

We're very good with people.

"And for me, if you are going to learn anything, you need to be right here, where I can get a light meter reading from you at any time. Right? Oh, and better be sharp 'cause I make these really irregular and irrational sudden moves and I don't want to bump into you. Right?" And… "Last thing. We get very, very close to animals. Much closer and in much more dangerous places than any responsible tourist guide will. Never run away."

On the second day out with Brad, I saw a herd of elephants about to cross the river. I grabbed the camera and started running toward the river's edge. Brad had to clamber off the back of the truck and follow, but he eventually caught up in a crouch. "F/5.6," he whispered. Good, I thought, it was going to work out…. We got the shot.

Suddenly, not ten feet away from us, a submerged hippo stood up and bellowed. The water welled up and I lifted the camera, waited for the wake to settle, and carried on filming. I saw Brad look at me as if I was seriously deficient in gray matter. We finished and returned to the truck just as the light faded and about 50 elephants came along the water's edge. As a very quiet Brad and I stretched our legs away from the truck, Beverly called out that she wanted sound and started rolling. The elephants moved closer and closer, eventually on a path that came within a few feet of the front of the truck. Fantastic, I thought, good sound here.

It was then that I noticed Brad. He was frozen, according to Rule Number 1, on the ball of one foot a ways from the vehicle—*right in the path of the oncoming elephants!* I crept forward just to be closer in case something went bad, and got to within a few paces of him just as it did. The lead female, a huge matriarch with good tusks, stepped forward, swayed her back, and charged Brad. He stood dead still, and all I could think of was the letter I'd be writing to P.J. "Dear P.J.: Herewith please find a small paper bag in which is your son and heir."

I ran past Brad, pushed him to one side, and yelled at the elephant. She kicked a clod of dirt and pretended to want to flatten us both, but finally stepped back and led her herd away.

New Rule: When it's a choice between ruining a sound take or ruining the light meter around your neck, go with the light meter.

There comes a time in every film when you just know you've got it. It is not always the end, but for us it's someplace along the way when Beverly and I look at each other and say, "That's it. Now everything we do just makes it better." If we don't get to that point, we don't go in. When we made *Reflections on Elephants* and came to the end of our shooting period, although we had enough material, we weren't happy. I called Tom Simon at the National Geographic Society and told him we weren't coming in yet. "Yeah? When will you be in?"

"This time next year."

After a long silence to make sure I wasn't joking, he said, "Oh-kaaay…."

In the last year we got what we needed.

For *Whispers,* we still needed the lion-hunting sequence. We went back to the water hole. We sat two-hour shifts throughout the day and night. Many times a night we woke up behind the camera and lights only to see the animal energy dispersing. We'd go back for a short sleep until the next false alarm.

SEPTEMBER 15, 1996

This morning at 2:45 Beverly woke me and we sprang into action. The Setari pride had come in looking like they wanted to take on the world. A breeding herd of elephants was already in the water hole and panicked as the first lions arrived. The action moved fast. Two females isolated a six-year-old calf and attacked, but the pride male ran in and tumbled the whole pile. The elephant was dead within 15 minutes. And we had a minute of exposed elephant kill. At last. Let's hope we don't have any film or camera problems.

The elephants walked into our soft light without hesitation, but most couldn't get a decent drink because the bulls horded the shrinking water for themselves.

194

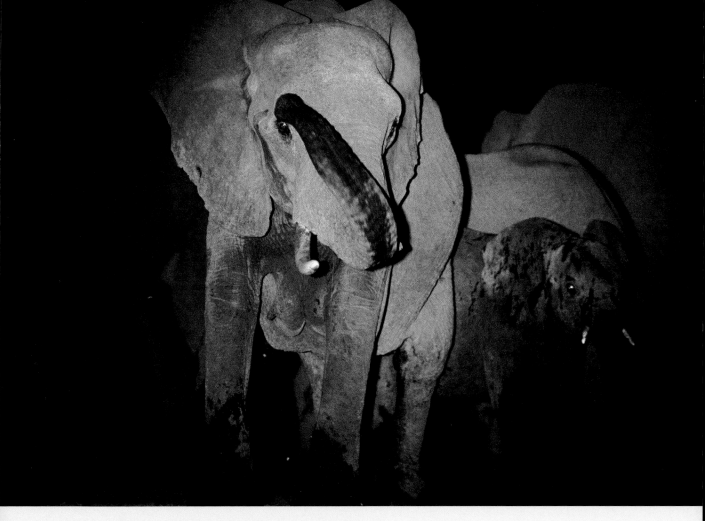

A few weeks later and not as much sleep as we needed…

OCTOBER 9

Beverly, on watch again, suddenly jumped down from the roof, waking me. I was at the camera without touching the ground. A herd had obviously slipped by in the dark and left a straggler. She was a small female but an adult of maybe 20. From the looks of it she was already a mother.

The Setari subadults were all around her. As we watched, they jumped up on her rump and climbed onto her neck. Absolutely amazing. She's an adult! It was a long battle and eight lions eventually weighed her down. She dropped to her back knees…onto a young male lion! He growled and squirmed and generally behaved like a ninny. I suppose a few tons of elephant backside on your head will do that to you. Finally, he bit her trunk and she released him. He stumbled off and lay down on the sidelines looking very sorry for himself for the rest of the night.

The elephant fought on gallantly, then suddenly, the fight went out of her eyes and she stopped, apparently giving up completely. She started to roll on her side. It was over. Even the lions knew this and changed positions and grips.

Then something happened, maybe a call in the darkness. Some hope started to flow back into her soul. Her eyes jump-started again, and she began swinging at the lions with her trunk. Then we heard it, too, another female in the darkness, coming to her aid. The shadows filled with a running shape, and lions jumped and ran. Within a few seconds a certain death became a spectacular rescue, and, as suddenly as it started, it was over. We were left with some very disgruntled lions.

We were also left with a 100 feet of the most spectacular lion-attack footage I had ever filmed, on pristine 35-mm film, well exposed and steady. The whole story was on film. We had it! But because the behavior was so spectacular—lions were hunting adult elephants, a battle of the titans—we kept going, greedy for more information. Filming became secondary; now we wanted research data. So much of our work is about breaking new ground not only in a filming sense. If no one had ever recorded this behavior, we needed to get as much information as possible in case we were witnessing a never-to-be-repeated opportunity.

The lions hunted six elephants that season. Then one morning at 2:30 exactly, I was sitting on top of the truck, watching the darkness, waiting for any sound that might indicate either lions or another breeding herd of elephants were on their way. It was quiet except for the 20 or 30 bulls slurping water about 50 feet away.

The Setari pride took control, attacking and killing larger and larger elephants each week until even the adults weren't immune to attack.

OCTOBER 21, 1996

A large bull passed almost silently a few feet to my left, giant pads softening the footfalls on a carpet of elephant dung. I watched his shape go by. This happens a hundred times a night, so it is almost part of the wallpaper of consciousness. Then another bull stomped by on my right. With no moon, my eyes could just make out his shape...but something was wrong with that shape. I switched on the flashlight and almost dropped it when I saw the illuminated picture. There was a lioness on his neck.

This was a huge old bull, maybe 55 years old and as big as any I'd seen. The lioness was gnawing away at the thick skin between his ears. He was walking fast but didn't even seem to notice her there. (I'm sure he did, elephants have very sensitive skin.) How she got up there, I can only imagine. Maybe she dropped from a tree. Maybe she attacked, clambering her way up his rump. Either way, she was making a single-handed attempt to kill an adult bull. He strode into the water hole. The sight of all the other bulls must have made the lioness realize her folly, and she leaped off, landing with a thud, and disappeared to find her pride. I couldn't identify which lioness it was, but she certainly had my admiration.

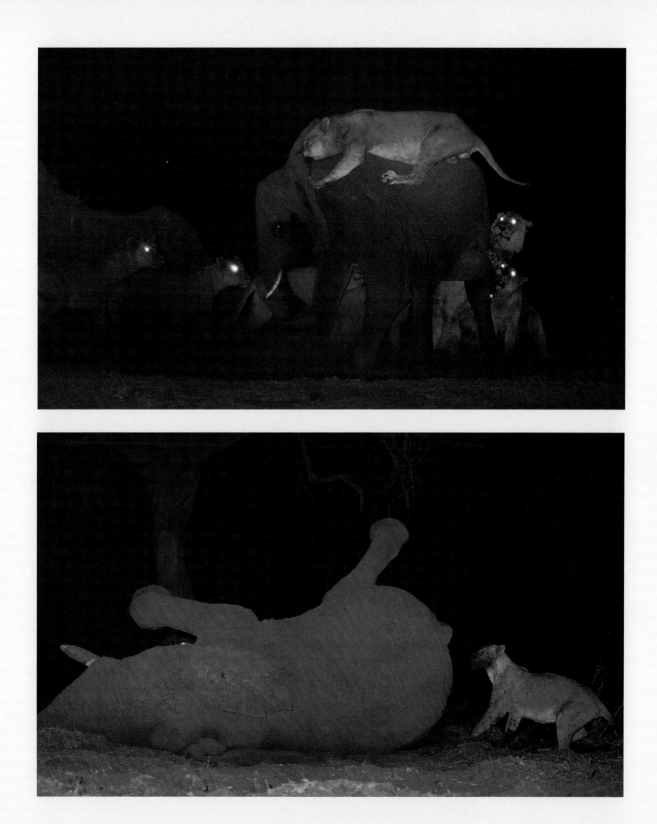

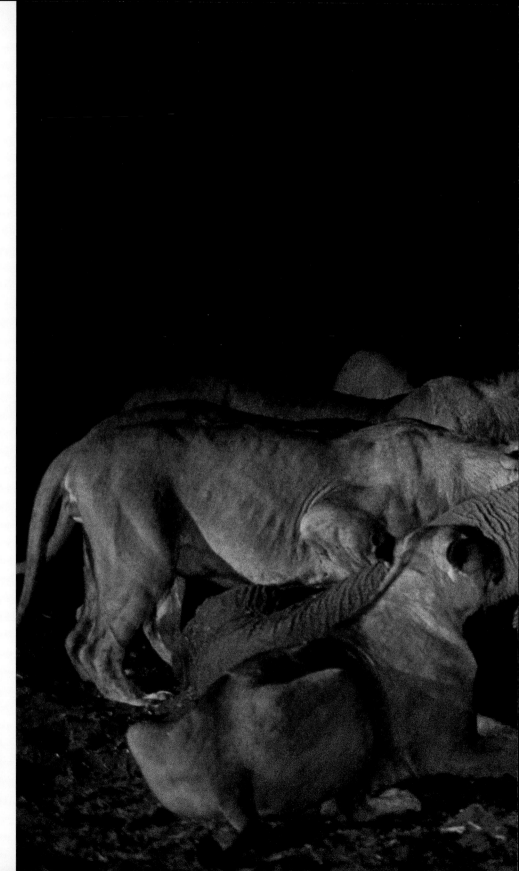

A meal this size can last a week or more, if hyenas don't congregate in large numbers and drive off the lions. The risk of attacking an elephant is worth the reward.

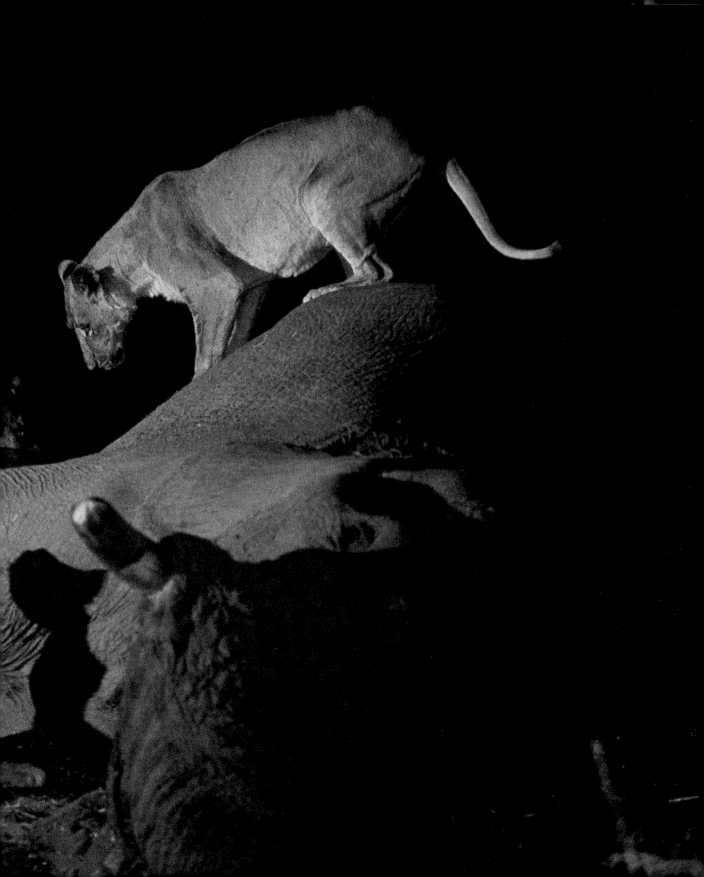

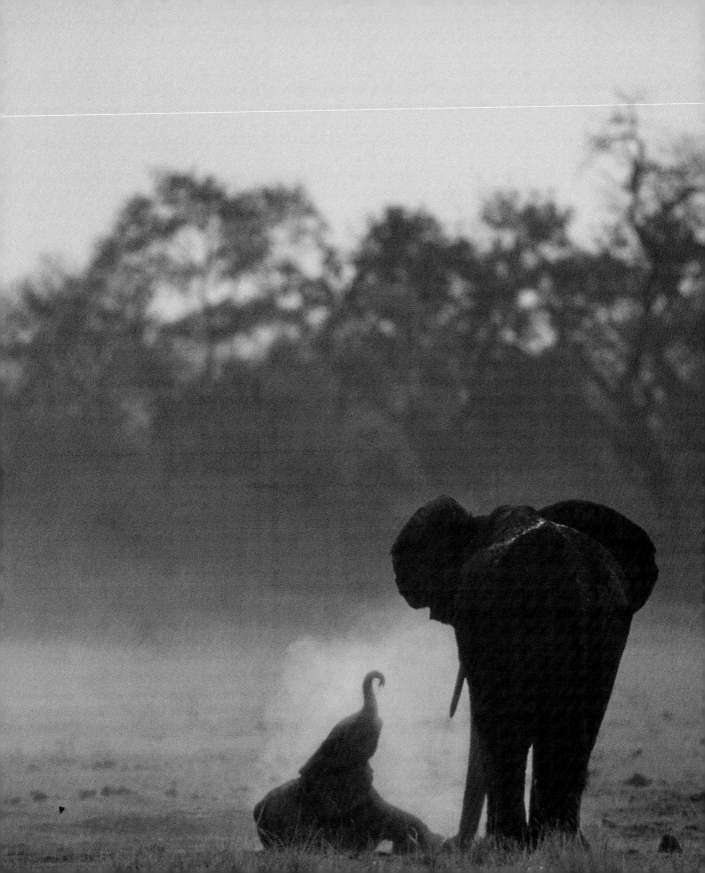

Whispers: An Elephant's Tale was over. The film, a story about one little elephant who survives the poaching of his family and goes on a quest to find his mother, is a unique attempt on our behalf to reveal, or at least try to explore, what it might be like to be an elephant. We tried to get inside the elephant's mind; all references to the world are from an imagined elephant perspective. But we tried also to develop a tale that had strong metaphors for everyone who sees the film. Whispers, for example, has lost his ability to trumpet and feels peer pressure. He goes on a journey with an openness and simple honesty taught to him by his mother. He believes that "a promise is a promise," and through this he reveals to the adults he comes across a certain truth, which makes them think about themselves. Actually, it could be a story about humans…but elephants are more fun to work with!

Filming was over; now all that remained was the post-production, the editing phase that usually takes us about five months. Three years later we limped out of Los Angeles, a lot older and substantially wiser than when we arrived.

The Hollywood studio system is a strange world for a naturalist, and yet it is an easier territory than floodplains and bush on which to explore and understand the creatures that inhabit our Earth. There is a study of vervet monkeys that reveals they are inveterate liars. While at a prime feeding patch, if a "liar" looks up to the sky and gives the "eagle coming" alarm call, all the others run off, and the liar can feed on all the best food, without competition. But the liar hasn't figured out that, by calling "danger" and not running himself, something starts to smell fishy to the others. The studio system to which we were exposed seemed to mimic almost exactly the behavior of those little apes. Our experience living in California taught us a great deal. We learned more about human behavior than we had in our previous 17 years; we came away from this system of life with new, sometimes disturbing insights. Yet for once we enjoyed a "normal" life, living in a house with running water, flush toilets, a kitchen. We developed intricate relationships and social bonds with caring people, without whom we would not have survived in that jungle.

Beverly and I have in fact discovered many things about ourselves over all of the 22 years together. We have learned where our spiritual homeland is and that we desire the wild, untamed world of the bush over the systems of cities and organized societies. We are scouts, wandering the wild Earth with a passion to find truth, the new and unseen, wonders both inspiring and disturbing. These are the stories we tell.

Whispers taught us who we are.
The silent rumble of a content elephant
stills the heart and lets the soul fly.

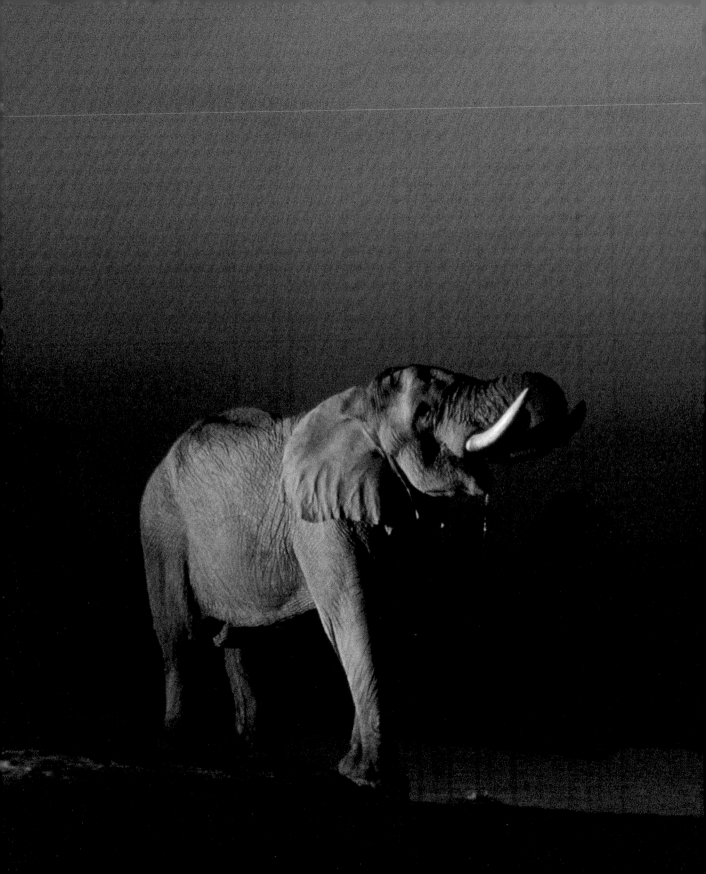

The Wild Places Foundation

There is one overriding message that we must bring back from the wild. While it's an untame and unpredictable place, when we crawl up onto the razored edge of our civilization and consciousness and look beyond, we do see hope.

Almost by default but perhaps by being open to following the wind, we have seen further inside nature and our own natural ways than most people have the chance to. We've stumbled along a path that has led to the individuals we see locked within the animals we work with. We see each individual animal's unique point of view: The mischievous glint in a lion's cat-eye whenever a hyena is in the distance, the look of complete despair as a young bull elephant stands at the rotting carcass of its mother. Science still denies this, but we have seen it over and over again: Animals have emotions, and a consciousness that at least parallels ours. We have seen them thinking about their choices, struggling with their moods, frustrations, fears, and more.

On another level, we have seen that unless we reconnect the broken line between us and animals, between a privileged class and all the rest, unless we throw out the "us" and "them" concepts we live by, we will forever live as we are now…conflicted and alienated by such beliefs.

Recently we approached a community in Botswana with a proposal: "We can help you get long-term but slow benefits from your area that will allow wildlife to grow and your people to prosper." I went on to describe how this could happen and why we wanted to help. It was an emotional speech because Beverly and I passionately believed in what we were saying. The key would be in their acceptance of the fact that hunting these animals and the further depletion of the populations was shortsighted and did not include a vision for the future: Continue hunting and leasing the land to professional hunting companies, and the wildlife will slowly disappear.

The chiefs went off to speak to their communities. What are the chances that a traditional hunting culture would listen to this proposal for their future?

Previous pages: We now fight to allow an elephant bull the right to wander as far as he wants.

Left: Wilderness is probably a concept rather than a place. Sitting around our fire at night, the wilderness opens up to the sky, and seems boundless and untouchable... until a solitary domestic dog howls at the moon and shatters the illusion.

A month later we heard the answer: Eighty percent of the community voted to shut down hunting in favor of our plan! Clearly, they had understood that something needed to be done to ensure their natural heritage and traditional family life. As a result, our foundation, The Wild Places Foundation, hopes to secure other wilderness areas and stop overhunting, poaching, and overmanagement. The foundation raises money to secure wild places because it is ultimately important to all of us, not because we will all get a chance to visit wild Africa, but because it is important to know that somewhere out there, there is an untamed place, wild and remote for us to dream about. Ultimately we want to link these places by corridors, bringing lifelines of new blood to isolated populations and new genes to lion cultures. In the process, unused ancestral elephant paths will once again feel the beat of gentle footfalls. As reward, the new benefits from all of this will go directly back to those intelligent and bold villagers who support the plans.

Even coming from the untame other world we prefer to occupy, we can relate Western civilization to what we know in the lion and elephant world. It would be foolish and glib to say that the real jungle is in Los Angeles or New York or any other big 21st-century city. Among the many things that our civilization has taught us, we have learned to question everything, to understand as much as possible about everyone and all things. Right now we have the chance to question ourselves and the way we deal with wild places, animals who are individuals, people who are different from us, ideas and philosophies that are not ours. I ended our first book, *Hunting with the Moon*, with the words: "Is it possible that this is the last place in all time and space where the elephants will rumble and the great flocks of quelea will dance? Are these the last shapes to slither through the silver grass, from the dappled shade of one tree to the next, hunting with the moon?"

I know the answer now.

No. It won't be.

Sitting at Savuté's water hole again, with huge beasts towering over us, Beverly and I each find our soul, as we have before in this place. It seems that the elephants hardly noticed our absence. Dark shapes shuffle and bump around us; a huge rump scratches the front of the Land Cruiser gently. An eye opens just four feet away from our faces and blinks intelligently. Do they sense our complete acceptance of them and the moments shared? Can they sense our happiness now that we have returned home, read our faces, our body movements? I reach out to stroke the elephant's skin and see a shiver spread from the place I have touched....

We seem to have spent a lot of time waiting to tap into the rhythm of this place, Africa. We could have done it faster, more efficiently, probably better, but we did it the best way we knew how.

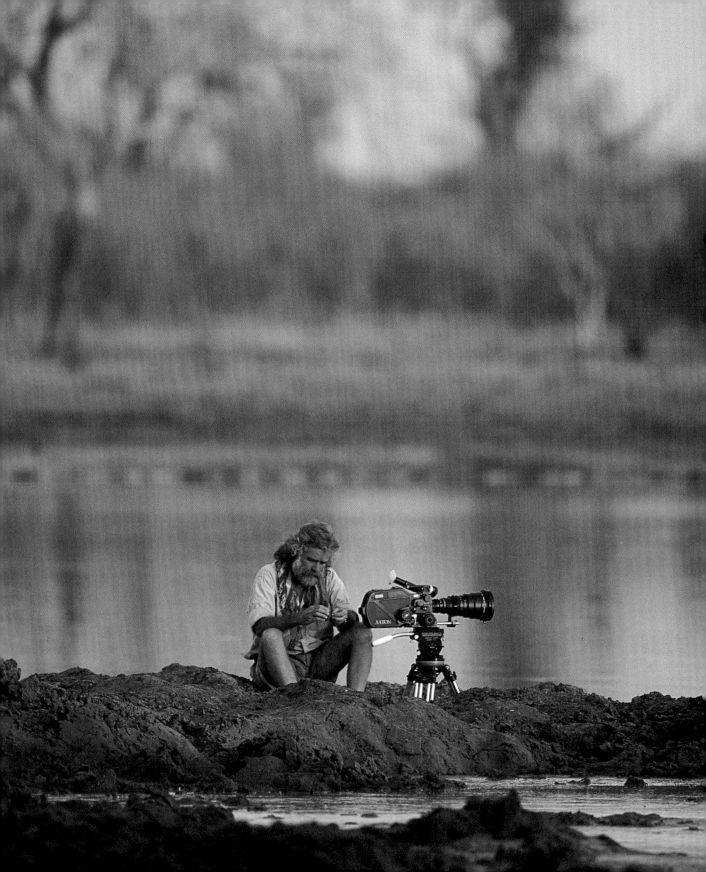

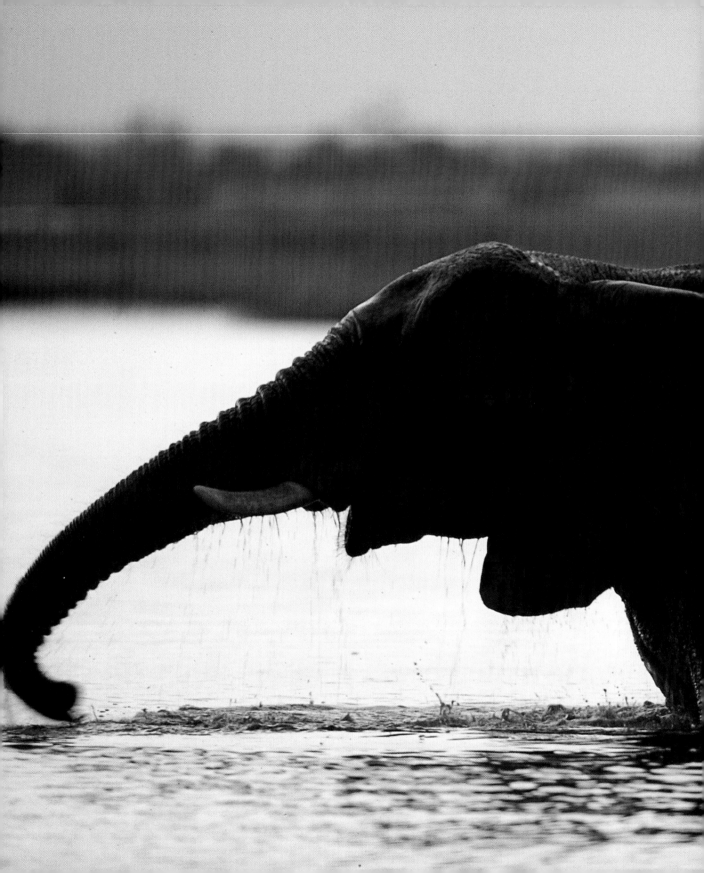

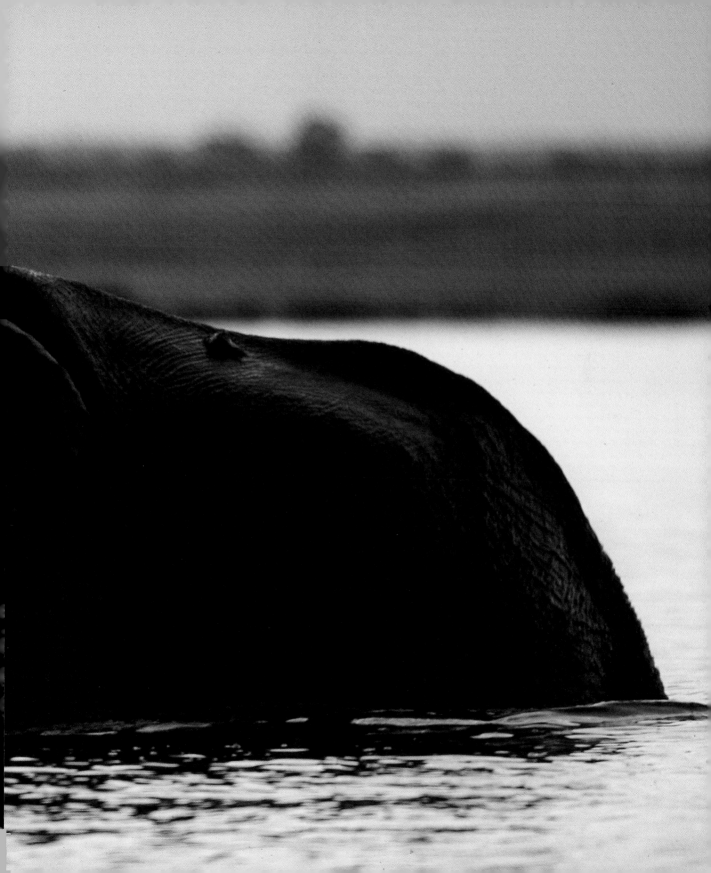

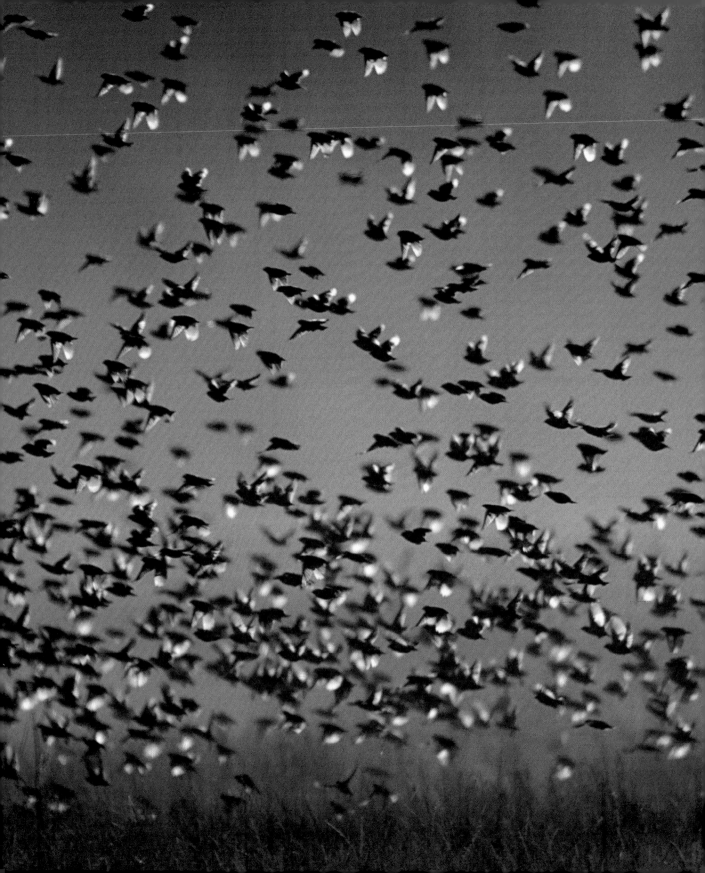

Dedicated to the wilderness in all our souls

Acknowledgments

Of all the evils people do, there is one that is the most incidious: The suppression of the soul by discouraging people who try new things. I don't know whom to thank for showing me this, but they would head up my list of acknowledgments. The leap from game ranger to natural history filmmaker, to directing a film in Hollywood is not a small one. Many times along the way we were told these leaps were impossible. Few phrases inspire us more than "It's impossible!"

Heather and Pat Carr-Hartley are our lifeline in Kasane, the nearest town, keeping us in food, fuel, and fundamental information. Lorna and William Gibson, Beverly's folks in Johannesburg, run our lives when the focus of our attention is in some fantasy world that will materialize later as a film or a book. Without these four people, we would get bogged down in the towns and cities that steal our time and inspiration.

At National Geographic, Lisa Lytton, Kathy Moran, and Patrice Silverstein.

We were adopted a long time ago by a very special family. They accepted us despite our limited credentials at the time. They gave us food and a living, the foundation on which we could build a reputation, a career, and a future. For that, we thank Botswana, the Batswana, the President, and all who make it home for us. Botswana's wild places and gentle people make it possible to feel confident about the future.

Lt. General Ian Khama has been a constant friend, occasional companion, and an ever-present reminder of the way to conduct ourselves with dignity and compassion in this land.

People in Botswana have a way of welcoming you into their hearts and homes. Some of these became our haven for hours of inspiring evenings spent debating sweeping ideas and trivial gossip, all of which saturated us with what it is to be part of Africa. Jonothan and Karen, Lloyd, June, Heidi, Denis, Kath, Keven, Gonda, Kgosi, Peter P., Pauline, and Colin Bell are among many whose support was silent but strong.

We also owe a debt to the Botswana Defense Force soldiers who made sure we didn't need to use their medical facilities.

Thank you all.

Beverly's gallery of how I became a
patient man. I think we spent most
of our time in the bush stuck!

Filmography

THE LONG NIGHT OF THE LION
Filmed in 1982
Aired in 1983
Produced for the BBC

HUNTERS
Filmed in 1985
Directed and produced by Dereck Joubert
Cinematography by Dereck Joubert
Sound by Bevery Joubert

AN ARTIST IN AFRICA: KEITH JOUBERT
Filmed in 1984
Produced for SABC, South Africa
Directed and produced by Dereck Joubert
Cinematography by Dereck Joubert
Sound by Bevery Joubert

A POISONED RIVER (OLIFANT'S RIVER)
Filmed in 1984
Produced for SABC, South Africa
Directed and produced by Dereck Joubert
Cinematography by Dereck Joubert
Sound by Bevery Joubert

RED ELEPHANTS, ETOSHIA
Feature, filmed in 1985
Cinematography, Second Unit, Dereck Joubert

THE STOLEN RIVER
Filmed in 1982-1987
Aired in 1987
Produced for National Geographic and Channel Four
Directed and produced by Dereck Joubert
Cinematography by Dereck Joubert
Sound by Bevery Joubert

OKAVANGO, JEWEL OF THE KALAHARI
Produced for the BBC
Cinematography by Dereck Joubert
Sound by Bevery Joubert

JOURNEY TO THE FORGOTTEN RIVER
Filmed in 1987-1990
Aired in 1990
Produced as National Geographic Special
Directed and produced by Dereck Joubert
Cinematography by Dereck Joubert
Sound by Bevery Joubert

AWARDS
- American Film and Video Festival,
 Blue Ribbon (1st Place), Wildlife category
- National Academy of Television Arts and Sciences,
 - *1990 Emmy Award, News & Documentary*
 - *Outstanding Individual Achievement in Sound*
- Council on International Non-theatrical Events
 (CINE), *Golden Eagle Award*

- Stambecco d'Oro International Nature Film Festival (Cogne-Valle d'Aosta, Italy),
 Best Film, Public Award
 Best of Festival, People's Choice
- International Wildlife Film Festival/Missoula,
 Merit Award for Cinematography
- 11th Banff Television Festival,
 Rockie Trophy for Best Popular Science Program
- Houston International Film Festival,
 Silver Award
- Golden Scissors Award, *Best Editing*

TRIAL OF THE GIANTS/ TRIAL OF THE ELEPHANTS

Filmed in 1989
Aired in 1990
Produced for National Geographic and SABC
Directed by Dereck and Beverly Joubert
Cinematography, editing, and writing by Dereck Joubert
Sound by Bevery Joubert

ZEBRAS: PATTERNS IN THE GRASS

Filmed in 1990-1991
Aired in 1991
Produced for National Geographic, "Explorer"
Produced by Dereck and Beverly Joubert
Cinematography, editing, and writing by Dereck Joubert
Sound by Bevery Joubert

AWARDS
- Houston International Film Festival, *Silver Award*
- Association of Visual Communicators/CINDY Competition, *Gold Award for Best of Festival*
- Golden Ink Award, *Best Script*
- Artes Award, *Best Documentary*

A PASSION FOR AFRICA

Filmed in 1995
Aired in 1995
Produced for National Geographic

A film about Dereck and Beverly Joubert
Some cinematography by Dereck Joubert

AWARDS
- Columbus International Film & Video Festival,
 Bronze Plaque Award (Art & Culture)

ETERNAL ENEMIES: LIONS AND HYENAS

Filmed in 1989-1992
Aired in 1992
Produced for National Geographic
Produced by Dereck and Beverly Joubert
Cinematography and writing by Dereck Joubert
Sound by Bevery Joubert

AWARDS
- National Academy of Television Arts & Sciences,
 1992 Emmy Award (News & Documentary),
 Outstanding Individual Achievement in Editing
- Columbus International Film & Video Festival
 - *President's Award, Best of Festival*
 - *Chris Statuette Award*
- International Film and Television Festival of New York, *Gold Medal (Nature & Wildlife category)*
- Chicago International Film Festival, *Silver Plaque*
- 1993 Jackson Hole Wildlife Film Festival,
 Grand Teton Award for Best of Festival
- Artes Award, *Best Documentary*

REFLECTIONS ON ELEPHANTS

Filmed in 1990-1993
Aired in 1994
Produced for National Geographic
Produced by Dereck and Beverly Joubert

Cinematography, editing, and writing by Dereck Joubert
Sound by Bevery Joubert

AWARDS

- Academy of Television Arts & Sciences,
 1993-1994 (Primetime) Emmy Awards
 - *Outstanding Individual Achievement in*
 Informational Programming for Field Production
 Sound Recording
 - *Outstanding Individual Achievement in*
 Informational Programming for Writing
- University of Georgia School of Journalism,
 George Foster Peabody Award for Best Documentary
- Houston International Film Festival
 - *Gold Award (TV Special/Documentary)*
- Columbus International Film & Video Festival,
 Chris Statuette Award (Science, Technology &
 Travel/Nature & Wildlife)
- Association du Festival International
 du Film Animalier d'Albert, *Prix special du jury*
- Valle d'Aosta International
 Nature Film Festival (ITALY)
 - *Winner of Best Script*
 - *Winner of Best Film Made on African Soil*
- Stambecco d'Oro Film Festival (ITALY), *Finalist*
- Wildscreen (1994), *nominated for category of*
 Reaching New Audiences
- Shanghai Television Festival, *nominated for*
 - *Best Documentary*
 - *Best Photography in the Documentary Group*

THE LIONS OF DARKNESS
Filmed in 1983-1993
Aired in 1994
Produced for National Geographic `

AWARDS
- Cable Ace Awards, *Best Actuality Programming*

WILDLIFE WARRIORS
Filmed in 1994-1995
Aired in 1995
Produced for National Geographic
Produced by Dereck and Beverly Joubert
Directed by Dereck Joubert
Cinematography, editing, and writing by Dereck Joubert
Sound by Bevery Joubert

AWARDS
- Academy of Television Arts & Sciences
 Emmy Awards (Primetime)
 - *Best Music*
- Ark Trust, *Genesis Award*

WHISPERS: AN ELEPHANT'S TALE
Filmed 1995-1997
Premiered October 2000
Feature film, produced for Disney Pictures

Produced by Dereck and Beverly Joubert
Directed by Dereck Joubert
Cinematography by Dereck Joubert
Story by Dereck and Bevery Joubert
Screenplay by Dereck Joubert, Jordan Moffet,
 Holly Goldberg Sloan
Editing by Nena Olwage

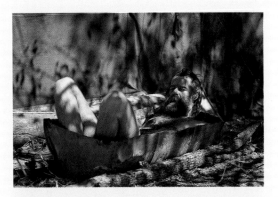

PUBLISHED BY THE NATIONAL GEOGRAPHIC SOCIETY

John Fahey, *President and Chief Executive Officer*
Gilbert M. Grovsenor, *Chairman of the Board*
Nina D. Hoffman, *Senior Vice President, Publications*

The Book Division
William R. Gray, *Vice President and Director*
Charles Kogod, *Assistant Director*
Barbara A Payne, *Editorial Director*

Book Production Team
Lisa Lytton, *Project Editor*
Kathy Moran, *Illustrations Editor*
Patrice Silverstein, *Text Editor*
Melanie Doherty Design, *Design*

Library of Congress Cataloging-in-Publication Data
Joubert, Dereck.
 African diary : an illustrated memoir of life in the bush/
written by Dereck Joubert ;
 photographed by Beverly Joubert.
 p. cm.
 ISBN 0-7922-7962-X
 1. Zoology--Africa--Anecdotes. 2. Zoology--Africa--
Pictorial works. 3. Joubert,
 Dereck. 4. Joubert, Beverly. I. Joubert, Beverly. II.
National Geographic Society (U.S.)
 III. Title.

QL336 .J68 2000
591.9--dc21

00-063821